THE TRI-STATE GANG IN
RICHMOND

···

MURDER AND ROBBERY IN THE GREAT DEPRESSION

SELDEN RICHARDSON

THE
History
PRESS

Published by The History Press
Charleston, SC 29403
www.historypress.net

Cover images: Top row, mug shots of key Tri-State Gang members Walter Legenza and Robert "Bobby" Mais; the Virginia State Penitentiary's electric chair—all three author's photos. Bottom, view of the Richmond City Jail just after the jailbreak on September 29, 1934, courtesy of the Valentine Richmond History Center.

Copyedited by Monica S. Rumsey, Scholarly Editing, Inc., Richmond, Virginia.
Indexed by Emily J. Salmon, Richmond, Virginia.

First published 2012

Manufactured in the United States

ISBN 978.1.60949.523.7

Library of Congress CIP data applied for.

CONTENTS

THE DELICIOUSNESS OF DISREPUTE

Getting the Gang Back Together

When I first learned that Selden Richardson had undertaken the sanguine tale of Mais and Legenza, I was filled with conflicting emotions: first, the topic, long of interest to me, was now plucked; second, though, it had been assayed by a premier interpreter of the city's story. This is reason enough for me to rejoice. I'm in the enviable position of sitting back to let Selden do the driving. And as he'll tell you soon enough, it was a story that he's known his entire life.

The world he takes us into is one that many Richmonders are unaware ever existed. Alongside the cultural foment of the 1930s that ultimately creates the Virginia Museum of Fine Arts and novels by Ellen Glasgow and James Branch Cabell—in that world a part of, yet separate from, Richmond's higher social scene, its clubs and soirées—there existed a criminal underworld, one the shadow of the other. The Tri-State Gang wasn't as large or sophisticated as many of the other crime syndicates of the Northeast and Midwest and, indeed, functioned as a subsidiary of a larger organization. So far, so Richmond.

But Selden's knowledge of the landscape is such that you'll get taken into this time when men wore hats, gangster groupies were known as "molls" and the Depression-era press conveyed on criminals flamboyant nicknames like "Ice Wagon" and, more infamously, "Pretty Boy" and "Baby Face." Yet even a hardened criminal expresses love for his mother by a tattoo, and when a moll comes to the end, in her dying breath she asks that her father not be told what happened. This is a world where Richmonders so disposed could

take a motorcar jaunt to Goochland County (of all places) and the peacefully named Club Forest for a taste of illegal booze, gambling and dancing. (Club Forest was a successor to the more aptly named Club Ballyhoo.) This is the territory of Edward G. Robinson gangster movies and a lantern-jawed comic book detective named Dick Tracy, who struggled with a gallery of archfiends bearing colorful names like Flattop and Lips Manlis.

Unlike the matinees at the Byrd Theatre and the big Sunday *Richmond Times-Dispatch* funny pages, though, these events are quite real. Selden demonstrates this in poignant fashion when he introduces us to the living daughter of a Mais victim. The tragic circumstance shows the terrible toll paid by families affected by violent crimes while making the story as relevant as this morning's newspaper.

Selden studies the mug shots of Walter Legenza and Robert Mais. He asks how these men got this way and what in the world could have brought them to Richmond. The answers, in part, are found in the failed experiment of Prohibition, the deprivations of the Great Depression, and the never-quenched all-American desire to make a fast buck. Mais and Legenza turned outlaw to accomplish that end. And they did indeed cause murder and mayhem in deceptively restful Richmond.

They entered a dark corner of Richmond's lore, and here, for the first time, you'll get the whole true crime story, rendered in page-turning prose.

—Harry "The Hat" Kollatz Jr.
Senior Writer, *Richmond Magazine*
Richmond, Virginia

PREFACE

On the afternoon of February 2, 1935, an eleven-year-old boy was waiting in his home on Richmond's North Side for the arrival of a doctor to cut a cast from his leg. Having already suffered a number of broken bones in his childhood, George Richardson was looking forward to that all-too-familiar sensation of being liberated from his cast. Of all the occasions when the doctor produced his little plaster-cutting saw, however, this would be the one that George would recall most vividly until his death sixty-six years later.

The doctor arrived late, looking wan and tired. He mentioned that he had been at the Virginia Penitentiary early that morning where he removed a cast from the leg of inmate Walter Legenza before the Philadelphia gangster was gingerly lifted into the electric chair.

This association with the notorious Legenza made George Richardson a celebrity among the children in his neighborhood. Just about everyone in Richmond had avidly followed the news and the court case against Legenza and his partner, Robert Mais. The two Philadelphia gangsters represented an unusual extension into the upper South of the same gangsterism that had already run rampant through the Midwest during the 1930s. America's newspapers screamed the latest exploits of bank robber–murderers John Dillinger, Bonnie and Clyde, George "Baby Face" Nelson and their ilk, but the presence of machine gun–toting thugs here in Richmond—on Broad Street, for God's sake—was almost too much to comprehend. Young George must have been wide-eyed with wonder, watching the same plaster

saw work through his cast that the doomed Legenza had also watched only a few hours before.

George Richardson was my father, and I grew up hearing the names Mais and Legenza—names that, to my southern child's ear, always sounded like "Mason Legenza." My father would sometimes take me to lunch at the Hot Shoppes Cafeteria that once stood near the old railroad terminal at Broad Street Station, and before we got back in the car, he would always point out, "There's where the holdup took place." I would look where he pointed, to the east, at a stained concrete arch over the railroad tracks and try hard to visualize an armored car stopped cold in the headlights of Mason Legenza's coupe on the bridge.

For my father's generation, the children who grew up in Richmond in the 1930s, the brief criminal career of Robert Mais and Walter Legenza in their city was one of the most memorable events of the decade, before the coming world war swept everything else aside. Even sixty years later, my father's voice still conveyed a sense of disbelief that such things could have ever happened in Richmond, of all places.

To him I owe my curiosity about those two bad men from Philadelphia, and this book is the result.

—SR

ACKNOWLEDGMENTS

Writing is certainly one of the most solitary of pursuits, but a number of people were of enormous help in producing this book. First, thanks go out to my editor, Monica Rumsey, for her eagle eye and encouragement throughout this project, as well as to my astute indexer, Emily Salmon.

At the Library of Virginia, I'd like to thank my former colleagues—Vince Brooks, Carl Childs, Kathy Jordan, Dale Neighbors, and Tom Ray—for their assistance.

Others who helped with this project were Ray Bonis at the Special Collections and Archives, James Branch Cabell Library at VCU Libraries; Autumn Simpson, research librarian, Valentine Richmond History Center; the staff of the Richmond Public Library; and Dementi Studios. I'd also like to thank James Richmond and J.D. Hollins of Goochland County, who helped illuminate the past of the elusive Club Forest; Sommer Wickham, for his memories of Benjamin Meade; Lieutenant Timothy Morley, Richmond Police Department (retired); Captain Mike Ostrander; and Nicholas Rumsey. Thanks also to Jessica Berzon and Ryan Finn of The History Press for their support and guidance.

Above all, my thanks to my wife, Karri, and our daughter, Lelia, for their love and patience throughout the research and writing of this book.

This book is dedicated to the memory of my friend Max, who unfortunately passed away before the project was completed.

The dead were and are not. Their place knows them no more and is ours today…. The poetry of history lies in the quasi-miraculous fact that once, on this earth, once, on this familiar spot of ground, walked other men and women, as actual as we are today, thinking their own thoughts, swayed by their own passions, but now all gone, one generation vanishing into another, gone as utterly as we ourselves shall shortly be gone, like ghosts at cock crow.

—G.M. Trevelyan *(British historian, 1876–1962)*
An Autobiography and Other Essays, *1949*

Chapter 1

THE VALLEY AND THE JAIL

Richmond has a long history of consigning people it wanted to confine, sell, kill, or forget to the low ground of the Shockoe Valley that splits the city in two. That tradition has continued for centuries, and it is much the same today.[1] Later generations would call the valley floor "Shockoe Bottom"—or, more recently and simply, "The Bottom." The once pastoral valley beside Shockoe Creek has often, both geographically and socially, been on Richmond's lowest rung. For centuries, since Richmond's founding in 1742, Shockoe Valley was where its outcasts—enslaved, imprisoned or condemned—all finally arrived.

Well before the Civil War began in 1861, the valley was peppered with slave jails among its stores and warehouses. From time to time, each slave jail and auction house would raise a blood-red flag, signaling to all that the sale of a group of human beings was about to begin. Black slaves working in the Court End and Church Hill neighborhoods could easily look down from their hilltops into Shockoe Valley. Seeing that unmistakable scarlet signal must have invoked in them a shudder of dread.[2]

The inveterate historian of antebellum Richmond, Samuel Mordecai, recalled "The Cage" that stood in the valley, a sort of open-air drunk tank where criminals picked up the night before were held for adjudication in the light of day. Here, too, stood the town stocks and the post where justice was administered in Richmond, as in many places throughout the antebellum South, at the end of a whip—the public version of what occurred out of sight on a regular basis in the nearby slave jails.[3]

In a parcel of wasteland in the valley near what is now Broad Street was the "Negro Burying Ground," where the bodies of those who died in the human warehouses were disposed of. Fevers and agues would race through the crowded confines where the slaves were held, and many took a wagon ride up Shockoe Valley to their last, and perhaps only, resting place. There they found an anonymous grave along with an unknown number of their race before them.

On this piece of land that no one wanted, by the fetid waters of Shockoe Creek, slaves were buried in the shadow of the city gallows. Among the most famous of those whose last breaths were drawn on the gallows of Shockoe Valley was Gabriel, the leader of an aborted slave revolt in 1800. Gabriel and twenty-seven of his co-conspirators were executed there, as were an unknown number of others swept up in the panic after word of the planned rebellion reached authorities.[4] Young and old, guilty and innocent alike were all shoveled under the gravel of Shockoe Valley.

City officials first purchased land for a jail in Shockoe, near the slave cemetery, in 1799 and shortly thereafter built the first of a series of grim brick structures on the site.[5] The topography of Richmond was then more dramatic than it is today, and many streets in the valley floor, like Marshall Street, simply ended abruptly at the steep hillside. The last jail was built in 1903 at the end of Marshall Street and at the head of Jail Alley, which ran south to Broad Street.[6] It was tucked under the hillside below the Egyptian Building, a now historic medical facility built in the exotic Egyptian Revival style in 1845. Because the jail itself sat just under the edge of Shockoe Hill, it couldn't be seen from the Medical College.

Through the years, the amphitheater-like quality of the valley made everything visible below: slave auction houses, whipping post, gallows, cemetery, jails and—in antebellum Richmond—the scarlet flags ever signaling another tragedy's unfolding. After the war, the occasional execution at the jail could be watched at a dignified distance from the hillside above. Thomas Cluverius, convicted of a sensational murder, was hanged in 1887 in the yard behind the jail. A halfhearted attempt was made to limit the number of witnesses inside the fenced-in jail yard, but the slopes above the gallows provided natural theater seating for hundreds of people who watched Cluverius's hanging. From the city's earliest days, one had only to walk to the brink of Richmond's steep hills to observe a variety of horrors in the valley below.[7]

Far above Shockoe Valley, many of Richmond's grandest mansions were built on the surrounding hilltops, away from the unhealthy miasmas that

carried contagion as they blew through the valley's cobblestone streets below. From those heights, the view to the south was of bustling traffic on the James River, the flour and woolen mills in the city of Manchester on the far banks, and the green hills of Chesterfield County stretching off into the distance. From the valley floor, with dramatic hillsides towering above, the effect was that of constant surveillance and claustrophobic confinement. Below the breezes that brushed past the residents of Church Hill and Union Hill, the stifling stagnation of a Richmond summer was endured by the enslaved in their pens and by generations of common criminals. Like their predecessors for generations gone by, they baked in the valley's still, damp heat and the heavy pall of coal smoke.

The jail that was built in 1903 had a capacity of 350 inmates but frequently held 500.[8] A grim, soot-stained, three-story brick structure, the city jail was innocent of decoration except for a pedimented entrance on Marshall Street. By the time it was opened, the jail was almost immediately declared inadequate for the growing city, and the requirement of segregated housing for blacks and whites made the logistics of incarceration even more difficult. Blacks were kept in the eastern wing and whites on the west side of the jail; except for the black trustees who cleaned both wings, there was little contact between them. A small section was set aside for female inmates on the upper floor.[9]

To accommodate city traffic and the trolleys of the Richmond and Henrico Street Railway, the Marshall Street Viaduct was built in 1911, linking Shockoe Hill and downtown Richmond on the east to Church Hill on the west. The viaduct's steel supports strode across the valley floor on massive concrete bases, linking the two sections of Marshall Street above and straddling its lower segment on Marshall Street below. Half a mile long and ninety feet tall, the viaduct afforded a view to the south over the rooftops of Shockoe Valley, by now filled with light industry and warehouses (in addition to the jail). In the distance, at the mouth of the valley, the ornate Renaissance Revival clock tower of Main Street Station stood silhouetted against the hills of Manchester across the James.

Pedestrians on the Marshall Street Viaduct could look down over the railing directly onto the roof of the Richmond jail and see the small figures coming in and out of the entrance far below, with regular gangs of trustees shuffling out to clean city streets and Capitol Square. A constant rain of trash and dirt fell on the jail from the bridge, and in return, the smokestack of the jail's coal-burning furnace fogged the bridge deck when the wind was right. When the Richmond First Club, a city advisory committee, examined

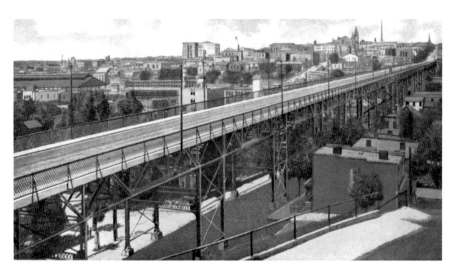

Postcard view of Shockoe Valley, circa 1930, looking west from Jefferson Park. The Marshall Street Viaduct spans the valley in the foreground. At the westernmost end of the viaduct, the city jail stood almost underneath the bridge. *Author's collection.*

the jail in 1934, the members urged that the facility be condemned. One of its principal problems, they said, was the proximity of the jail to the bridge, making circumstances worse by the dirt and debris that blew down into the jail. "This makes it practically impossible," they noted, "to keep the windows open even during the hot spring and summer months." Conditions in the city jail were probably much the same as they had been one hundred years before. A writer in the *Richmond News Leader*, impressed by the sooty and shadowed jail, scornfully termed it "the antiquated city Bastille."[10]

Throughout the day, a thin ribbon of shade from the Marshall Street Viaduct moved slowly across the valley floor, falling over the jail, the warehouses, the railroad tracks, the icehouses, the coal dump, the stables, and the cobblestone streets. The children of the old John Marshall School at Nineteenth and Marshall Streets below the viaduct must have eagerly awaited recess as they watched that shadow move across the buildings and fences of Shockoe Bottom like a meandering sundial. From above, sitting on benches in Jefferson Park, people could find simple entertainment watching the parade of horses and wagons, buggies, streetcars, trucks, and automobiles move back and forth across the viaduct.

For decades, this vista of bridge and valley, trains and warehouses, was largely an unchanging landscape. But the Great Depression that began with

the stock market crash on October 29, 1929, meant that once prosperous Richmond underwent a contraction. An abridgement of hope filled the air, as grand neighborhoods grew a little shabby, and shabby neighborhoods started looking even worse. Peeling paint and boarded-up buildings became the backdrop for discouraged Richmonders as they went about their business, what little business there was. In Richmond, like in the rest of America, hesitation haunted the city while businesses failed, homes were auctioned, and few new cars were seen on the streets.

One measure of relative wealth in the city during this period was the number of telephones in use. This simple gauge of affluence and modernity ascended through the 1920s, and by 1929, Richmond boasted forty-three thousand telephones. This number plateaued during the Great Depression, which began in October 1929, and by 1935, Richmond had a thousand fewer telephones than in 1930.[11] Another indicator of prosperity in Richmond, retail sales, fell by 33 percent from 1931 to 1932. Downtown, the change could be easily gauged by the fewer shoppers on Broad Street, the expressions on the faces of those riding the trolleys and the idle men seen everywhere.[12]

The year 1931 had been grim indeed, with national unemployment in September standing at 17 percent and the Dow Jones Industrial Average at 140, down from 381 in 1928.[13] The Richmond region, as Virginia's capital, was to some extent kept afloat by a diversified economy, a high percentage of state government workers, the ubiquitous railroads, and a booming tobacco industry. But these could not save the city from the Depression's corrosive effects, which unraveled the fabric of the nation and the world. In the second half of 1931, serious gaps appeared in Richmond's ranks of service and industrial workers. Layoffs began, and the city's black population was among the first to suffer. The next year, 1932, was not much better. As money grew tight in Richmond and the threat of poverty pressured black and white families alike, social workers noted an increase in domestic desertion and violence, alcoholism, prostitution, and panhandling. By the cold, bleak days of November 1932, poverty and unemployment prompted a hunger march on City Hall that resulted in arrests and police raids.[14] By the following November, unemployment in the United States had increased to 23 percent, and the Dow Jones stood at 90.[15]

Doubling up on the effects of financial depression was the so-called noble experiment, a federal ban on the sale, manufacture, and transportation of alcoholic beverages that began in 1920. Prohibition in the United States ended officially on December 5, 1933, but alcohol was allowed in Virginia in

stages with confusing restrictions on the kinds of alcohol that could be bought. An article in the *Richmond News Leader* noted the seizure of ten cases of beer near Saltville but speculated, "It is assumed that the beer was of the high-powered class not yet legalized in Virginia." Bootleg liquor was still being turned out in Virginia in large amounts, and in December 1933 alone, 153 stills were destroyed and 280 people were arrested in the Commonwealth.[16] People did what was necessary to get by, and the long years of Prohibition created a mindset that sometimes meant bending or breaking the law.

During the hot summer of 1934, inside the sweltering jail amid bootleggers, burglars, and thieves, sat two men from Philadelphia casually playing penny-ante poker. Robert Mais and Walter Legenza were awaiting death sentences, and under the circumstances, they must have given off an aura of dread. Still, they passed their days like the rest: meetings with their lawyer, enjoying canned food they had mailed to them and, in part, being consoled by visits from Mais's mother, who regularly brought them milk bottles filled with hot coffee. Mais, suffering from gunshot wounds, did not often feel well and, rather than play poker with the others, spent the days on his bunk.

Meanwhile, Legenza would go out on the tier with the other prisoners, talking, listening, and taking note of the staff and the layout of the dirty, aging jail. His startlingly cold blue eyes took in everything, every detail: what he saw when he was taken up the hill behind the jail to court hearings; the guards' shift changes; and the cell doors and locks—the smallest, most incidental procedures. Nothing escaped his notice, and he wasn't impressed or daunted by the prospect of what he knew would have to be done. It had to be done soon, too, as the clock, the sun, and the shadows moved relentlessly through Shockoe Valley during that summer of 1934.

WALTER LEGENZA

The short story "The Captain Is a Card," by American novelist Nelson Algren, is set in the deep shadows of a police lineup and narrated in the gruff voice of a police captain. One by one, the author's characters step into the spotlight to tell their stories to an audience whose reactions range from amusement to horror. Finally, an older convict limps into the cone of light and is introduced by the author: "You could tell he had done his time the hard way. In the hard places." The thug toughs out the questions hurled at him, until he finally breaks down and blurts out, "I been a stumbling block. I been an obstacle to the Republic. I done it all wrong. I got hard-boiled too young. I got kicked around too soon."[17] Those desperate beginnings and the shadowed world of institutional walls also tell the tale of career criminal Walter Legenza. In contrast to the old convict's confession, however, Legenza's mug shot, taken after his capture in Richmond in 1934, reveals a man devoid of such unproductive exercises as introspection or regret.

Walter Legenza looks as though he had just combed his hair for that photo, but it is hard to tell whether it was slicked back with water or damp from the record-breaking heat inside the Richmond jail that summer of 1934. Here is a lean man with a receding hairline, sharp features, and an offset cleft or scar on his chin. On this, the occasion of his being cataloged by the police authorities as number 13715, the fastidious Legenza wears a fresh shirt, although it is obviously too large for his small frame. He is clean-shaven. Months later, when police sheepishly examined the suitcase in his

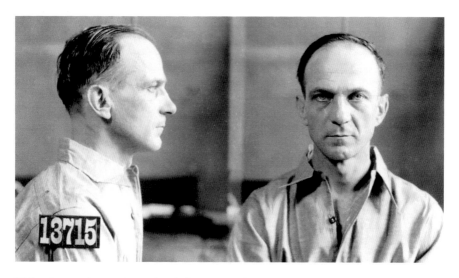

Walter Legenza's mug shot, taken in June 1934 after he was arrested in Baltimore and brought to the Richmond City Jail. Legenza's deadly, impassive expression and his trancelike self-control were often noted in the press. *Author's collection.*

recently vacated jail cell, they saw that it contained only the suit of clothes he was wearing when arrested and his shaving kit—the luggage of a fastidious man who traveled light.[18] Like the contents of his suitcase, Legenza no doubt wanted his mug shot to convey as little as possible about himself. Despite his resolve to the contrary, his impassive gaze and his light-blue eyes tell much about the man, and none of it is good.

A Richmond newspaper called Legenza "a thin, dark little man with cold blue eyes."[19] To dismiss Legenza's eyes as simply cold and blue, however, hardly does them justice. In his photographs, they appear keenly observant, with the nearly feral qualities of opportunism and contempt. In July 1934, Detective Sergeant O.D. Garton had spent many hours sitting across from Walter Legenza and Robert Mais in the confines of a Pullman compartment while he escorted his prisoners by train from New York to Richmond. "I kept my eyes on them the entire time," recalled the detective. "I didn't trust them for anything." Garton, an experienced policeman, regarded the diminutive Legenza sitting across from him and tried to engage him in conversation. Legenza said nothing, Garton recalled, but "sat with his eyes practically shut."[20] In several instances, Legenza's ability to enter a silent, almost trancelike state, with his eyelids lowered, gave him a place to retreat to no matter the circumstances around him. That habit would, in the end, sustain him in his last, dreadful moments.

Consistent with Legenza's intentional opaqueness in his mug shot is his use of aliases during his career. "Donbell" and "Turner" are among them, but "William Davis" is the name that Legenza used most consistently, to the extent that even the official record lists him as William Davis. In a grand jury inquiry, for example, a policeman tried to explain his references to a William Davis: "At that time, this little fellow Davis, as we knew him…we didn't know his name was Legenza at that time." He kept referring to "Davis" until one exasperated juror finally demanded, "Davis and Legenza are the same?"[21] So persistent was Legenza's last alias that it appears on the final document that the Commonwealth of Virginia placed in his file. The superintendent of the Virginia Penitentiary certified that, by order of Richmond's Hustings Court, the prisoner "William Davis" had been executed.[22] Legenza would have enjoyed that last little confusion visited on the authorities, the ultimate lie at the end of a lifetime of evasion.

According to his official description, Walter Legenza was a "white man, 41 years old, 5 feet four and a half inches tall, 130 pounds, small build, light brown hair, blue eyes, dark complexion, faint scar above right eyebrow, scar center of forehead."[23] It must have either been a rare moment of weakness or mere jailhouse boredom when Legenza had a large flower tattooed on his right forearm in blue and red. In retrospect, he knew the authorities would note its presence and add it to his description, and Legenza probably came to dislike the tattoo as much as he disliked the fingerprints, the photographs and the paperwork, all of which always followed him and all of which served to confirm his identity.

Legenza's pale blue eyes, with their lupine appearance, complement a widely held belief that he was simply criminally insane. Today, Legenza would be described in more clinical terms (such as "sociopath"), but in the 1930s, "criminally insane" was a handy term that covered a variety of circumstances and disorders. The word "stir," slang for jail or prison, has been in use since the nineteenth century, but in Legenza's day, one of the many terms for someone who had become unhinged by incarceration was "stir crazy."[24] The *Washington Post* described Legenza as "stir crazy,"[25] and the *Richmond News Leader* repeated the term and helpfully defined it for its less-worldly readers: "Washington police referred to Legenza as 'stir crazy,' meaning that long imprisonment had instilled in him an undying hatred of mankind, that brooding in cells while awaiting or serving sentences had turned him into a permanently antisocial character."[26]

With a lifetime of burglaries, heists, stickups, and hijackings behind him, Legenza had trouble remembering how often and where he had been

arrested and imprisoned. There had been so many cops, so many lineups and so many long nights of questioning, in an era when the police used the truncheon more than the typewriter.[27] "I am 42 years old," Legenza would later recall, "and 30 out of that 42 I have been a gangster and burglar. I have associated with them almost the entire time."[28] That association included many years in jails, prisons, and reformatories, and each period of liberty was followed inevitably with time in "stir" to brood, to harden, and to plot.

Walter Legenza began life far from the eastern United States, which would be his home as an adult. According to official documents, he was born in Poland on June 27, 1897, but grew up in a tiny strip-mining town populated mainly by eastern European immigrants, called Summit Hill, in Carbon County, Pennsylvania. His parents had immigrated to the United States with their children in 1905. Fifteen years later, a census-taker noted that John and Nellie Legenza still spoke only Polish. The same census shows Walter Legenza living in mineworker's housing with his parents, five siblings, and one boarder.[29] Legenza himself recalled that he had come to the United States in 1901. He described his home conditions as "wretchedly poor" and claimed he had just six months of formal education.[30] The only surviving example of Legenza's handwriting shows the childlike loops of someone with a rudimentary education, but in contrast to the innocent-looking script, the contents of that writing sample demonstrate a determinedly obtuse and elusive mind.[31]

During his last days in prison, Legenza shared a glimpse of his childhood with a Salvation Army chaplain who tried to pierce the gangster's hard shell: "He told me as a poor boy he had to help support his family by picking up coal and wood, how they had difficulty often in getting food to eat. He ate an apple in school one day, he said, and for that he was whipped by the teacher, only to receive a second beating when he got home."[32] If this account is typical of his young life, it is not hard to see how such experiences laid the foundation of a personality that divulged little, where disguise and disinformation were the norm. This mindset was perfect for a life of crime and served him well once Legenza fled from his desperately hard life in that tiny Pennsylvania coal-mining town.

Legenza retained the strong trace of an accent from his childhood in a Polish-speaking household, to the point that "Polock Joe" was among the aliases listed in his file.[33] The awkwardness of Legenza's accented English comes through in the verbatim quotations in some news accounts. "I've done a lot of things, but I didn't do any murder," he said in court, and "the only

witness they got shouldn't be believed."[34] During that unusual courtroom interview, his codefendant Robert Mais and Mais's girlfriend, Marie McKeever, solicitously sat beside Legenza, apparently to help him express himself clearly when his English stumbled. Viewing this scene of the two gangsters sitting side by side, a reporter felt that Mais seemed "little more than a boy" in his youthful appearance. Legenza made a much different impression as he sat with his gaze fixed forward and speaking in a clear voice with a foreign accent. "Legenza," the reporter recalled, "appears to be afraid of nothing."[35]

On the 1920 census, the question regarding Walter Legenza's ability to speak English is first marked "yes" and is then scratched out. Another telling fact is that his father, John Legenza, is listed on the 1920 census as being a mineworker, but the space for his twenty-three-year-old son Walter's occupation has been left blank. This is hardly surprising, considering that by 1920 he had already been living a life of crime for seven years. Denying to the census-taker that he spoke English and not stating an occupation are consistent with his reflexive effort to disguise.[36]

Legenza claimed that he "drifted" until 1910, when he was sent to a reformatory in Elmira, New York, for burglary. He also recalled working a real job for more than a year until a detective told his employer that he was an ex-convict. After he was fired, Legenza honed his self-proclaimed vocation as a burglar and never worked an honest job again.[37]

In 1910, calling himself John Woods, Legenza had been sentenced to a term at the Elmira Reformatory for burglary. In 1913, under the name John Donbell, Legenza was given a one-year sentence for larceny and sent to Blackwell's Island Penitentiary. In the following year, he was arrested three times for burglary in Providence, Boston, and Hoboken. In 1918, a Brooklyn court gave him a suspended sentence for burglary. That same year, as Wadeck Legenza, he was sentenced to five months in a workhouse, and again in 1921. In 1923, Legenza was picked up by police in Memphis, Tennessee, and charged as an accomplice to a bank robbery.[38]

In 1926, the chief of police of Middlesex County, New Jersey, made a trip to New York to personally investigate the new man in his jail who called himself William Turner. The chief discovered that this prisoner's real name was Walter Legenza and that his criminal career began when he was barely a teenager. The record was a long catalogue of serious crimes, and no doubt he had committed many others for which he was never accused.

What prompted the New Jersey police to investigate Legenza's record was a series of New Jersey payroll robberies, first of the Merck Chemical

Company on June 26, 1923, and then a robbery of $29,000 from the Castle Ice Cream Company's payroll ten days later, on July 6. A raid on a suspicious house in South Plainfield yielded conclusive proof that the occupants were members of the gang that had committed the robberies, including $2,000 in coins from the ice cream plant job and numerous bottles labeled "Merck & Co." In addition, a sizable arsenal was hauled away from the house: "[N]ine revolvers of different calibers, fully loaded, two sawed-off shotguns, about 20,000 rounds of ammunition, enough nitro-glycerin to blow up a whole community, and about half a pint of nitric acid were included in the equipment."[39]

Legenza was not among the three men arrested at the gang's hideout with the loot and the weapons. Instead, the *Plainfield News Courier* reported that an Officer Gerard had spotted a Peerless automobile on Park Avenue with a license plate number that was on his watch list of cars used by the "Bum" Rogers Gang. When he stopped the driver for questioning, Gerard found Walter Legenza (who identified himself as William Turner) and Legenza's brother, Michael. In the back seat were Michael's wife and daughter. Michael Legenza immediately identified the driver as his brother Walter, who was promptly arrested at gunpoint.[40] This is the last time a family member is mentioned in any documents about Legenza, and this roadside betrayal by his brother to the police may have severed the last familial tie between the young gangster and his family.

After putting Legenza "through a long cross-examination, the police said they were satisfied that Legenza was a member of 'Bum' Rogers's gang who committed the robberies of the ice cream and chemical companies."[41] In the less sophisticated world of law enforcement in the 1930s, the phrase "long cross-examination" would have most likely been a euphemism for a beating. Physical force was a tool used by the police and was probably expected by the criminal as part of the cost of doing business. No stranger to the blackjack, Legenza complained bitterly that the police used "torture" in an effort to extract information from him.[42]

Even a thief has to learn his trade somewhere, and no doubt being a member of the "Bum" Rogers Gang was a formative time for Walter Legenza. The leader, John J. "Bum" Rogers, earned his nickname from his slovenly appearance every time he was brought to court. Rogers's criminal credentials were impeccable, going back to the early 1900s and New York's "Car Barn Gang." This group got its name from its headquarters on Second Avenue, where members famously posted a sign reading, "No Cops Allowed to Pass Through This Street." A massive roundup of the Car Barn Gang

occurred in 1910, with more than one thousand people in the streets and many shots fired, but the teenage Rogers was not picked up in the assault on the gang's headquarters.[43]

Despite his famously shabby personal appearance, Rogers was regarded as a highly educated man who was an inveterate reader, poring over books at least four hours a day.[44] Among the other stolen property found with his gang's arsenal of guns and explosives was a collection of "law books, treatises on chemistry, and books and pamphlets on welding," hinting at the presence of Rogers, the compulsive reader, with his wide-ranging interests in subjects that would help hone his skills in his criminal profession.[45]

In March 1925, Rogers and his partners John "Killer" Cunniffe and William "Ice Wagon" Crowley escaped together from a prison on Welfare Island in New York's East River. The three immediately embarked on a series of crimes and holdups, but Rogers was again arrested and sentenced the following December. Cunniffe and Crowley attacked the guards escorting Rogers by train to New York's Auburn prison, and the newly liberated "Bum" resumed leadership of the gang.[46]

Rogers's protégé, Walter Legenza, was convicted of the robbery of the Merck Chemical Company and was still in the New Jersey State Prison when he was taken to Middlesex County to stand trial with two others for the Castle Ice Cream heist. The jury deliberated fifteen minutes and added seven years to their existing sentences.[47]

While Legenza was in jail in late 1926, he missed some of the most dramatic robberies committed by the "Bum" Rogers Gang. The second heist the gang pulled off in a matter of weeks was carried out on October 14. This one involved waylaying a mail truck in Elizabeth, New Jersey, by blocking the road with cars; the gangsters netted a lucrative $20,000 apiece, the equivalent of $250,000 each in today's money.[48] Rogers's two lieutenants, Cunniffe and Crowley, would not have long to enjoy their cut. Only three days after the robbery, Detroit police were called to an apartment where shots were reported. When the door opened, they were immediately fired on by Crowley, who killed one policeman and wounded two others. Crowley was shot and killed seconds later. In the bedroom, police found the bodies of Cunniffe and his girlfriend with multiple gunshot wounds. Crowley had murdered them both in bed.[49]

Rogers was asleep in New York several weeks later when "twenty-two men, heavily armed, swooped in on the apartment. Guns, pistols, and black-jacks confronted the dazed and seedy fugitive, whose unkempt appearance had long ago earned him his 'moniker.'"[50] On January 14, 1931, after serving

four of the many years Rogers had earned for his various assaults, robberies, crimes, and escapes, the erudite gangster who had been Walter Legenza's mentor hanged himself in his jail cell.[51]

Despite the decimation of Rogers's gang, the story of the highly successful 1926 mail truck robbery was not lost on Legenza, nor was the example of ambushing a vehicle with several blocking cars. For the time being, he would have to continue his criminal education while making license plates in the New Jersey State Prison in Trenton. The 1930 census lists Walter Legenza as a prisoner, noting that he cannot read or write and that his parents were both from Poland. Under "Trade, profession, or particular kind of work" is entered "helper," and "Industry or business" is listed as simply "auto tag."[52]

Keeping Legenza in jail proved to be a problem for the authorities on more than one occasion. In the summer of 1933, he and William Phillips escaped from Lorton Reformatory in Northern Virginia, a prison serving the District of Columbia. By then Legenza was serving ten years for a series of safe burglaries in Washington, and Phillips was doing three years for auto theft. John Allen Kendrick, who was serving ten years for shooting a D.C. policeman, also escaped from Lorton and joined them a few weeks later. Making their way to Baltimore, Arthur "Dutch" Misunas, Morris Kauffman, and Herbert Myers soon joined the three escapees, together with a slight young Philadelphia bootlegger named Robert Mais.[53]

The group would come to be known as the Tri-State Gang, due to its area of operations in Pennsylvania, Maryland, and Virginia. Moving quickly up and down the mid-Atlantic, the gang took advantage of crossing state boundaries to get from one police jurisdiction to another and the fact that police patrol cars lacked radio equipment. Stolen cars and license plates added to their stealth, and hideouts in Philadelphia, Baltimore, and Richmond offered sanctuaries where they could regroup and plan their next action. In the end, it was the same regional scope that gave the Tri-State Gang its name that brought it to the attention of the U.S. Department of Justice's Bureau of Investigation (later the FBI). Their mobility and the crossing of state lines, combined with the sheer audacity of their crimes, would eventually earn Mais, Legenza, and the rest of the Tri-State Gang the personal wrath of the bureau's indomitable director, J. Edgar Hoover.

ROBERT MAIS

Robert Howard Mais had his mug shot taken inside the Richmond jail during the summer of 1934. Inmate number 13716 took a seat in front of the camera immediately after his fellow gang member and inmate, Walter Legenza. Mais wears only an undershirt in the photo, either because of the stifling heat in the jail, or because a heavier shirt would rub against his bandaged back and shoulder. In his profile image, Mais cranes his neck forward at an angle. He looks uncomfortable, perhaps because he is perched awkwardly on a stool that had been adjusted for Legenza, who is shorter. Mais is unshaven but, like Legenza, had recently combed his damp hair back before being photographed. A bandage is visible on his left arm, one of several that cover bullet wounds. Mais's eyes have a pained, liquid quality, and if he was uncomfortable, it was for good reason. Several weeks before, he had been shot six times in the back with a Thompson submachine gun.

The bullet holes in Mais's body came from Baltimore police detective James Downs, who riddled the car driven by Mais and Legenza as they were trying to escape a police raid on their hideout. The Thompson's .45-caliber bullets, though powerful, were notoriously ineffective against the thick steel-and-wood bodies of automobiles of the day, and apparently that measure of protection saved Mais's life. Nevertheless, when he arrived at a Baltimore hospital, his wounds were serious enough that his condition was classified as critical. Ironically, Mais owed his life to numerous blood transfusions from one of the patrolmen present at the raid where Mais was shot.[54]

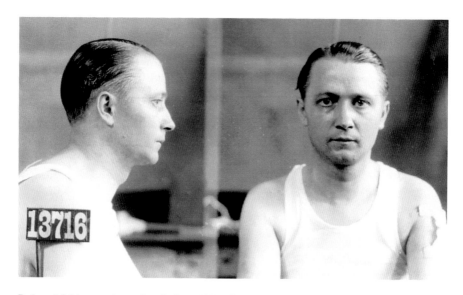

Robert Mais's mug shot, taken in June 1934 after he was arrested in Baltimore and brought to the Richmond City Jail. Note the bandage on his left arm, one of several unhealed bullet wounds courtesy of the Baltimore police. *Author's collection.*

The arc of Robert Mais's life that led him to be a handcuffed and bloody captive of the Baltimore Police Department began with his working-class upbringing in south Philadelphia. From an early age, Mais took a descending path that involved increasingly serious crime. "I have lied, cheated, stolen and broken almost every Commandment," confessed Mais in 1935 in his summation of a short life filled with missteps and mistakes. [55] Just before the end, Mais did not linger on his life as a gangster in a thousand hotel rooms, long nights spent on the highway, or dancing with his girlfriend in a roadhouse, but instead on those more innocent days as a Sunday school student and devoted son in his mother's house on Brewster Avenue, back in Philadelphia.

Robert Mais's adult life was largely colored by the same inept experiment in social engineering called Prohibition that turned thousands of Americans, forced to slake their thirsts with homemade beer and bathtub gin, into petty criminals. The attempt to outlaw alcohol corrupted public officials and the police, filled jails and courts, cost millions to enforce, and unleashed a tide of public disregard for the law. In 1929, when Mais was in his mid-twenties, the United States and then the world entered the Great Depression, sinking millions into a financial crisis of a magnitude not seen in the United States since the Civil War. The odds were against Mais and the young men of his

generation, but few responded to the hardships of their day by taking a path beyond the bounds of decent society and the law. Fewer still were forced to pay the ultimate penalty for their choices.

Robert Mais was born in Philadelphia, Pennsylvania, on June 21, 1905, to Harry Mais and his wife, Elizabeth.[56] The 1920 United States Census indicates that the Mais household at 7701 Brewster Avenue consisted of seven people: Chester Mais, Robert's brother, is listed as the head of the household; living with him is his wife, Susie, and their son, Harry, along with Robert's father, Harry Sr.; Elizabeth, his mother; his sister, also named Elizabeth; and Robert.

Today, Brewster Avenue is an industrial wasteland of vacant lots and trucking companies without a single residential structure still standing, but when the Mais family lived there, the streets were lined with the homes of local industrial workers, most of them recent immigrants to this country.[57] One history of the 1920s calls them the "Ballyhoo Years," expressing the sheer exuberance of the decade.[58] The riotous living of the so-called Roaring Twenties did not penetrate south Philadelphia, where the Mais family lived, and the arrival of the Great Depression in the early 1930s saw their tough existence in their neighborhood, the Meadows, become leaner still.

By the 1930 census, only Elizabeth Mais and her two sons are listed as living at 7701 Brewster Avenue. Her occupation is listed as a "sorter" at the woolen mill, her son Chester (a World War I veteran) is a "beveller" in a glass factory, and her younger son Robert is a "chauffeur" for a private family. [59] The job of "chauffeur" did not carry the cachet it does now, with the implication of a smartly uniformed driver. Instead, the title probably indicated that Robert Mais both maintained and drove a car for some wealthy Philadelphian. In light of his subsequent lifestyle, and the fact that the city was awash in bootleg money, Robert may very well have been driving for one of Philadelphia's newly affluent gangsters. Mrs. Mais later described Robert's place in her struggling household in the Meadows:

> *Robert was my only support. His father died thirteen years ago, and my oldest boy is ill and out of work. My daughter is married, and has cares of her own. I have no one but Robert. He was a good boy until he lost his job and was forced to go into the alcohol business to earn a living.*[60]

Unabashed devotion to his mother might not come to mind as typical of someone immured in the unsentimental business of bootlegging and organized crime. Nevertheless, Robert Mais's 1934 "Wanted" poster

described his only distinguishing mark as a "pierced heart with the word Mother in blue and red tattoo on left forearm."[61] No matter what crimes he committed, his mother was always foremost in his thoughts, to the extent that when he was removed from his bullet-riddled car by the Baltimore police and told he was likely to die, Mais refused to answer any question put to him except to plead, "Somebody please tell my mother."[62]

Although she probably could not afford to travel, Mrs. Mais dutifully took the train from Philadelphia to Richmond to be with Robert during his penultimate captivity and visited him daily, always bringing him and his partner, Walter, a milk bottle full of hot coffee. In return for Mais's stated love for his mother and his sentimental tattoo, Elizabeth Mais would eventually be repaid for her loyalty by being thrown in jail on a variety of charges, including accessory to murder.

In contrast to her completely innocuous existence in Philadelphia, the Richmond newspapers gave Mrs. Mais a wholly new and dramatic persona. Public records hinted of her collusion in her son's crimes if not blatant guilt as an accessory before the fact. One informant told a Richmond policeman a sensational story that he had witnessed: when loot from a robbery was being divided, Elizabeth Mais had "always raised Hell when her son had not gotten his share."[63] Another account noted that when Mrs. Mais was arrested, "$153 in bills and a razor blade were found stitched in her dress."[64]

The first report about Mrs. Mais being a factor in the division of stolen swag is probably the result of overheated newspaper copy. Mrs. Mais was a small, frail woman. The truth may be that concealing her savings and a razor for defense might have been ordinary safety precautions in the tough reality of her hard-luck neighborhood of Philadelphia. Philly was a large city, with a wide range of social and cultural differences—worlds apart from Richmond's comparatively quiet monoculture. What was considered the norm in one place was probably the rare exception in the other.

The image of Elizabeth Mais as a hard-nosed, razor-toting old woman or a geriatric gang member was exotic fare for Richmond newspaper readers. It was an image that could not be sustained, however, faced with Mrs. Mais in person. A grand jury, charged with investigation of a jailbreak, put her on the stand to determine what role she played in the crime. The jury members found it impossible to hold Elizabeth Mais under suspicion once they had interviewed her and heard her nervous, earnest testimony. They listened to the voice of a desperate, uneducated mother as she cried before her testimony even began, "The first time I come to Richmond I didn't know where Richmond was nor nothing else."[65]

There was no guile about Mrs. Mais, and it became apparent that she was nothing more than exactly what she appeared to be: a stricken, feeble mother trying to deal with the judicially planned extinction of her son. This was no purported gangster mastermind like Ma Barker but rather a frightened woman who had been plunged into an inexplicable series of events that was largely beyond her comprehension.

In the end, after the charges against Elizabeth Mais were quietly dropped, she was released from police custody and took the train back to Philadelphia. She would return one last time to Richmond in the winter of 1935, carrying in her luggage a new suit for Bobby to wear.

Philadelphia in the 1920s and early 1930s was a very good place for a young man to be in the "alcohol business," as Elizabeth Mais called it, and there was a lot to learn. New York may have had greater capacity to produce illegal booze, but "nowhere else in the country did the industrial alcohol racket capture its market as quickly and run as smoothly as it did in Philadelphia."[66] This was due in a large measure to the number of chemical companies that sprang up in the shadow of the massive Du Pont factories that lined the Delaware River. The industrial development of the area was mirrored by a very efficient and thriving underworld, the most successful being the Seventh Street Gang, under the direction of gambler and fight promoter Max "Boo Boo" Hoff.[67]

Hoff was the acknowledged king of the industrial alcohol producers in Philadelphia, alcohol that was easily flavored to make a drinkable product. He and his distillers produced 3.375 million gallons of eighty-proof booze in one year, and his organization controlled distillation and distribution as far away as Minnesota.[68] He employed hundreds of Philadelphians in this industry, including many members of the notoriously corrupt Philadelphia Police Department. Given his south Philadelphia background and his experience in bootlegging, if Robert Mais was in the "alcohol business," it is a good bet that he worked for Hoff.

In 1934, when Mrs. Mais looked back on the "good boy" she had raised, her son was at the end of a criminal career that began when Robert was eighteen. An inventory of Mais's crimes shows a pattern of arrests, with charges invariably being dismissed. It began in 1924 with a breaking and entering, which was discharged. In 1925, he had two arrests for larceny and stealing a car, for which he was fined fifty dollars and put on probation for two years. Mais was arrested twice in January 1926, once for robbery and holdup (discharged) and again for operating an automobile without a driver's license (also discharged).

Mais's worst year for encounters with the law was 1927. Then twenty-one years old, Mais scarcely went ninety days without an arrest, but as before, all of his cases were dismissed. In March, there were more charges: robbery by holdup, assault and battery, assault and battery with intent to kill, and carrying a concealed weapon—all were dismissed. A month later, he was arrested for assault and battery by automobile, but then again the charges were dismissed. In July, he was arrested and taken to Chester, Pennsylvania, then just a small town south of Philadelphia, and turned over to police there on a charge of robbery, which was dismissed. Two months later, Mais was arrested for possession of bootleg whiskey (charge dismissed). In October 1927, Mais was arrested on suspicion of robbery and was discharged, but five days later, he was arrested again for robbery and murder. As before, all charges were dismissed.

Mais managed to make it entirely through 1928 without being arrested. He may have had better luck bootlegging that year, or the gap may indicate that he got married and attempted a more domestic lifestyle. As part of his police record, a list was made of Mais's family members and their contact information. Among the names is that of a woman named Anna Doyle, who is listed as "wife, separated."[69] This apparently brief marriage may account for the lull of arrests in 1928. The Bureau of Investigation record is the only place where Mais's former wife is mentioned.

In the spring of 1929, Mais was picked up for reckless driving, but the charge was withdrawn. June 1930 saw Mais arrested for bootlegging and again in July 1931. Both charges were dismissed. He was arrested three more times in 1931 (for breaking and entering, bootlegging, and drunk driving), and all of the charges were dropped. He had one more unproductive arrest, for drunk driving, in 1933.[70] One last and comparatively benign charge remained before that fateful winter before Robert Mais and his fellow gangsters came to Richmond: failing to render assistance following an automobile accident in early February 1934.

Looking back on Mais's criminal record in 1935, the *New York Times* marveled at the lack of convictions in Mais's arrests, and there are two very good and plausible explanations for the man's seemingly miraculous ability to avoid jail time.[71] Daniel Okrent, in his history of Prohibition, noted that there was a tidal wave of alcohol-related cases that swamped the American court system, in large measure because each Volstead Act offender was promised a jury trial. "It was a requirement, it soon turned out, that the legal system was incapable of handling."[72] In Philadelphia, the director of public safety reported 227,000 arrests for liquor violations, indicating that "his men had nabbed 15 percent of the city's population; to anyone else, it indicated

they had arrested the same people over and over and over again."[73] Today, this is known as revolving-door justice. In the 1930s, it was simply the reality of life during Prohibition, and for men like Robert Mais, the handcuffs and beatings, the questionings and denials, the jail cells and the lawyers, were all just part of that "alcohol business."

Another explanation for Mais's apparent good fortune in evading jail is his possible allegiance to Boo Boo Hoff's criminal organization. Mais admitted to running alcohol in the Philadelphia-to-Richmond corridor, so he was probably part of Hoff's well-established gang, which distributed alcohol throughout the mid-Atlantic. As such, Mais would have been the beneficiary of a system of graft that one grand jury estimated to be worth $2 million in payments to the Philadelphia police alone.[74] This could also have ensured speedy bail and the immediate presence of a well-connected lawyer to negotiate Mais's avoiding trial.

Robert Mais's arrests were the experience of thousands of people who, desperate for work in the Depression, became bootleggers out of necessity, working in various capacities, whether it was selling shots of whiskey from a kitchen table or making a little wine in the basement. Thousands of otherwise law-abiding citizens were arrested, and they crowded the courts. For the businessmen of the booming Philadelphia alcohol trade, arrest meant little more than a momentary delay in delivery of Max Hoff's booze to the public. The inadequacy of the legal system to have the time or the jury pool to prosecute such cases, and the subsequent dismissal of those cases, must have given men like Mais utter contempt for the law and its agents.

Much has been made of Robert Mais's youthful appearance, especially in contrast to his vicious reputation. Referring to Mais and his generation, one member of a Richmond Grand Jury remarked:

> *Under the conditions now, the Depression has brought a lot of unemployed young men into the jails and ought to be some way of separating the younger men from the hardened criminals. What impressed me more than anything else when I visited the jail this morning, there were some nice looking fellows with good faces down there and they are going to be herded with fellows like that.*
>
> *A: You should have seen Mr. Mais.*
>
> *Q: A nice looking man?*
>
> *A: A fine looking boy. My wife came down and was sick for twenty-four hours—a nice looking man like that.*[75]

Besides his mother, the only other mainstay in Robert Mais's life was his girlfriend, Marie McKeever. The terse description of McKeever in a 1934 "Wanted" notice describes her as "white, 34 years old, 5 feet tall, 118 pounds, medium build, brown hair, brown eyes, dark complexion."[76] Her personal history and the extent of her criminal activities are unknown, but she was certainly no stranger to jails and courts. We have glimpses of Marie McKeever's past through documents such as a memo from the files of FBI director J. Edgar Hoover, in which he mentions that McKeever has been arrested under the aliases Mary Graham and Mary Lowe, though he does not specify the crimes.[77] A newspaper account from the *Chester* (PA) *Times* of May 1934 describes McKeever as having "a string of aliases." The *Times* reported that "the McKeever woman, according to the detectives, has a long police record and is the widow of a Philadelphia gangster who was killed in a bank holdup several years ago."[78]

McKeever is variously described as Mais's "friend" or "sweetheart" but chose to characterize herself at his trial as his "intimate friend," which was a bold statement for a young woman to make in open court in the 1930s.[79] Publicly defining her relationship to Mais in that way was emblematic of a certain largely unspoken quality of what were termed "gangster molls."[80]

McKeever is often identified in news accounts as a "gunman's moll"[81] and a "gang moll."[82] The general view of the "moll" was a woman who was, using the terminology of the time, "fast." "People assumed she was a sexual creature. This libertine enjoyed freedom. She ran with gangsters, basking in a sordid yet beckoning glamour."[83]

Concealing her past and purpose behind a fashionable façade, McKeever spent considerable time in Richmond aiding her "intimate friend" and his partner, Walter Legenza. Sightings of the infamous McKeever on the street must have been memorable experiences for Richmonders, unaccustomed to celebrity. During the trials of Mais and Legenza, she stayed at the William Byrd Hotel across from Broad Street Station. One might assume that, like everyone else, she took the streetcar downtown to City Hall and the Hustings courtroom.

McKeever's past may have been marred by the Great Depression, during which many women had few options but to leave home and take up menial work. For some, petty crime or prostitution served as an introduction to the world of the moneyed, fast-talking, well-dressed criminal underworld. The public expressed disapproval at this new worldly and dangerous woman who consorted with criminals, but at the same time, people were fascinated with the exoticism of the gangster's moll. The famous photographs of Bonnie

Parker, posing with pistol in hand and a cigar between her lips, personified the moll in the public's imagination. When three girlfriends of Dillinger gang members were captured after a shootout with police in Little Bohemia, Wisconsin, the women were dubbed "Dillinger Molls" in the press. After Bonnie Parker and Clyde Barrow died in a hail of bullets a few weeks later, in May 1934, Bonnie and the Dillinger girls became synonymous with the gangster's moll in newspapers across the country.

The perception of these women by the puritanical J. Edgar Hoover was even worse. Hoover identified feminine wiles as the core problem of crime in the 1930s. In that context, he was referring to the same gun molls who were captured at Little Bohemia, but Hoover could just as easily have been describing Marie McKeever and her kind when he thundered, "Some unscrupulous woman helped Dillinger to escape. Catch the woman who has cheered Dillinger in a career of murder, and you will catch Dillinger. She is more dangerous to society than the desperado himself. It is she and her kind who made him seek a life of crime."[84]

Marie McKeever was likely no blushing innocent when she attached herself to the Tri-State Gang. In the course of only a few months in Robert Mais's company, McKeever had seen another "gang girl" shot before her eyes, had been arrested and questioned on numerous occasions, had been thrown out of Richmond by the police as an undesirable person, had a bounty put on her head by the New York underworld and, ultimately, sat in the courtroom when her boyfriend was condemned to death. She helped arrange one of the most dramatic jailbreaks in American history, as well as the inmates' subsequent escape. Of all the members of the Tri-State Gang, only Marie McKeever escaped, alive, into obscurity.

Throughout all this, however, the resourceful and stylish McKeever often appeared in court and on the streets of Richmond perfectly collected and in various degrees of fashionable makeup and hair color. She was cool and quietly competent, both in court and in planning the gang's activities. The role of gang moll was not lost on McKeever: she was completely cognizant of the trappings needed to play the part and possessed the elusive skill to remain at large. With continued updates of the fates of the three women arrested after the Dillinger gang shootout in Wisconsin, McKeever was even more aware that she had to remain cautious.

In spite of his life of crime and many arrests, Robert Mais was certainly not made of the same stern stuff as his partner, Walter Legenza. Yet the young man who would one day be labeled "Public Enemy of the East"[85] and "Bloody Bob Mais"[86] was much buoyed on his path by Marie McKeever. She

and Mais were inseparable, and it was truly stated, "Wherever you find dark-haired Marie McKeever, you'll find Mais and Legenza near by."[87] Without her, Robert Mais would have probably gone to his fate with none of the notoriety that he finally received.

Despite Legenza's distaste for women in gangs, he, Mais, and McKeever remained the core of the Tri-State Gang throughout its meteoric course across Pennsylvania, Maryland, and Virginia. The gangster, his younger partner, and the girlfriend were loyal to one another in a criminal organization that, like so many others, became famous for killing off its own members. In the end, it was Marie McKeever's intense loyalty to the two men that proved the undoing of all three.

THE MURDER OF MADELYNE WHELTON

As a chronicle of twenty years of crime in the United States, *The Complete Public Enemy Almanac* notes 150 significant dates in 1933, many with multiple major crimes happening on the same day.[88] These include dozens of dramatic robberies, shootings, jailbreaks, kidnappings, killings, and arrests—and those are only the ones that were covered in the national press. The combined social and economic pressures of the Great Depression and Prohibition created a wave of crimes, great and small, that washed across the United States in the early 1930s. Daily reports of successful crimes by celebrity bandits like John Dillinger, Lester Gillis (also known as "Baby Face Nelson"), and Charles "Pretty Boy" Floyd shook Americans' faith in the institutions of the law. Prohibition, with its bathtub gin and homemade beer, further blurred the once strict demarcation between the world of the upright citizen and that of the common criminal.

In the days before television and the Internet, people avidly read the newspapers to follow lurid accounts of repeated robberies, shootouts, and killings across Texas and Louisiana, where police were on the lookout for infamous gang moll Bonnie Parker and her gun-toting boyfriend, Clyde Barrow.

In May 1933 alone, a massive breakout from a Kansas prison released Oklahoma killer Wilbur Underhill and ten other violent prisoners.[89] Notoriety did not, however, ensure success in crime. In September of that year, a robbery gone wrong in Chicago by the Barker-Karpis gang resulted in the death of a policeman and the theft of nothing more valuable than a pile of cancelled checks.[90] Three months later, Tri-State Gang members

Walter Legenza, Robert Mais, and Arthur Misunas had the same problem when they discovered that the sacks they stole in a dramatic robbery at Washington, D.C.'s Union Station contained nothing but worthless revenue stamps. A guard who attempted to stop the robbery was shot and wounded by Misunas.[91]

In the middle of 1933, however, a botched attempt by gangsters to rescue one of their own created an important response, one that would have national implications for both law enforcement and the men and women they chased. The June 1933 shooting in Kansas City, Missouri, quickly became known in the press as "the Union Station massacre," during which four policemen and the prisoner they were guarding were all shot to death outside the Kansas City train station. Robert Unger's *Union Station Massacre: The Original Sin of Hoover's FBI* makes a powerful case that J. Edgar Hoover, then director of the Department of Justice's Bureau of Investigation (as it was then called), used the event to muster public opinion and eventually obtain funding to build the modern FBI.[92] In that pivotal year of 1933, when American gang activity had reached its peak, a newly professional and systematic federal institution was being assembled that would eventually help stem the tide of lawlessness.

For Richmond, Virginia, still very much a quiet southern city, the crimes that took place elsewhere in 1933 and the winter of 1934 were a cultural and social shock. Before films at the movie theaters, people watched dramatic newsreels in horror as machine gun–wielding robbers were pursued by grim and determined policemen, while the newspapers were filled with daily reports of spectacular crimes in Chicago and New York or in the Midwest. These were distant and exotic places compared to sleepy little Richmond, dozing on the banks of the James River, where most folks were more concerned with getting through the cheerless winter than worrying about gangster activity on their tree-lined streets. Going to the Byrd Theatre in the near West End, or catching a matinee at the Lowe's Theatre downtown and watching the newsreels—where stern-faced policemen were shown on another manhunt—was as close to the crime sprees of the 1930s as most Richmonders ever wanted to get. Certainly, the city had its crime, and the Richmond jail was full, but mostly with minor bootleggers and petty thieves—small fries, indeed, compared to the likes of the decade's most notorious outlaw, John Dillinger.

Richmonders, like all Americans, closely followed the Dillinger manhunt in the newspapers, and news of the Indiana bad man was always front-page material. On December 22, 1933, on the same page of the *Richmond Times-Dispatch* as another Dillinger story, was a brief report of a jailbreak in

The Murder of Madelyne Whelton

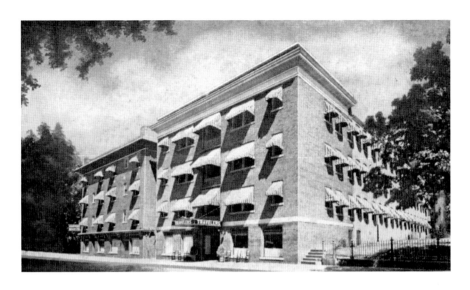

The Traveler's Hotel, 8–10 West Main Street, Richmond, 1935 postcard view. A room on the second floor at the Traveler's Hotel was home to at least two members of the Tri-State Gang. The same room was the site of Madelyne Whelton's fatal shooting in January 1934. *Author's collection.*

Richmond. Two prisoners in the city jail had shoved past their guards, burst out of the unlocked front door, and made a dash for freedom as they flew down the steps and around the corner of Marshall Street and Jail Alley.[93] One prisoner was quickly recaptured, and the other was found two weeks later, but the ease of their escape apparently did not impress the authorities because there was little inquiry as to how it had even been possible in the first place.[94] In retrospect, the escape of the two men seemed an amateur feat, but the event foretold that the city lockup would soon return to the headlines.

Below the crust of Richmond's southern gentility and its reverence for tradition was a comparatively small criminal element, largely unseen and enjoying relative anonymity. Its world was defined by the cheap apartments just west of downtown, the tourist camps on Route 1, and the city's flophouse hotels and boardinghouses. The men and women who lived on this tier of society quietly congregated in kitchens and garages, on back porches, and in smoky pool halls. They circulated with the bootleggers, car thieves, and burglars, and they were hard cases largely known only to a few detectives, lawyers, parole officers, and bail bondsmen.

Joe Williams, a notorious hijacker, was described as "one of the worst criminals we have in Richmond."[95] Another was a man named Faye Green who, while out on bail, still found time to make mysterious visits to Robert Mais and Walter Legenza in the Richmond jail in 1934.[96] These were minor players compared to those who occupied the national headlines, and their histories were largely unknown except among themselves and their contemporaries. There was a tacit understanding among those who cast their lot among the lawless that these men were connected to a larger, darker entity, one that was seldom seen but certainly felt and talked about along the back streets, in the nip joints, over billiard tables, and at games of craps. To cross these guys, whoever they were, could be fatal.

Richmonders, basking in their naïveté, assumed that it was other cities that always furnished the dark soil of fear on which gangsterism grew and flourished; whatever toxic quality those other places had, Richmond surely lacked. How resonant and frightening, then, that the gradual revelation of Richmond's underworld should begin with a scene that seemed to come straight from a lurid gangster movie: a pretty girl who knows too much gets shot in the gut and bleeds to death in a cheap Richmond hotel room.

Her name was Madelyne Whelton, age twenty-three, and she lived with her widowed father, Florance R. Whelton, above the family's grocery store at 3145 West Cary Street, in the part of Richmond now known as Carytown. It was the winter of 1934, and Madelyne had been dating Herbert Brooks since the previous summer. Madelyne's father would later disingenuously describe Brooks as "a nice young man, and he seemed devoted to her."[97] Brooks was, in fact, a worldly guy in his late thirties and appeared a suitable escort for Madelyne. He had money and drove a new car, but his exact occupation was a little hazy. Nevertheless, Madelyne liked him.

It was a cold Monday afternoon on January 15, 1934, when Brooks, Madelyne, and her friend Nylah Roach said goodbye to Mr. Whelton as they left the apartment over the grocery store. Whelton might have seen the three pass by the store's front windows, bundled against the winter's chill and damp. If so, then that was the last time Florance Whelton saw Madelyne, because less than twenty-four hours later his daughter was declared dead at the city's Memorial Hospital.[98]

The Traveler's Hotel at 10 West Main Street, near Foushee, sat literally and figuratively in the shadow of Richmond's much grander, more illustrious Jefferson Hotel. As the Traveler's name might imply, its clientele consisted largely of those who could not afford the luxury rates at the Jefferson. Herbert Brooks and James Winn had been staying at the Traveler's for a

month, and both worked outside the city at the Club Forest.[99] Theirs was a lengthy commute to rural Goochland County from downtown Richmond. In those days, Goochland was, for the vast part, a rural county with perhaps a grocery store or a gas station at the main crossroads, but there were few other attractions except for the booze, gambling, and dancing at Club Forest. Goochland County was not where the two roommates at the Traveler's Hotel wanted to live, but they were willing to make that drive for good money.

At the coroner's inquest following the Madelyne Whelton's death, Brooks's roommate, James Winn, presented an exquisitely crafted description of what had taken place in room 202 of the Traveler's Hotel. Winn testified that he, Madelyne, Brooks, and Madelyne's friend Nylah Roach had entered the hotel room around midnight, where he was sleeping on one of the room's twin beds. Winn got up, and the four of them drank a pint of moonshine, after which Winn took Nylah to her home on East Franklin Street, in Church Hill. Winn said that Madelyne had cried disconsolately as Nylah got ready to leave, ostensibly because her friend was leaving for Washington, D.C., the next day. When Winn returned to the hotel, he said that Madelyne and Brooks were still in the room, but he went back to bed. [100]

According to Winn, he awoke abruptly with the sound of gunshot, looked over, and saw Brooks sitting on the edge of the other bed. There, Madelyne was struggling to get up as she exclaimed, "I am shot." Winn went over and saw that she was bleeding heavily. A .38-caliber bullet had gone completely through Madelyne's body below her ribs, through the mattress, and imbedded itself in the wooden floor under the bed.[101] In Winn's testimony, Brooks had apparently just shot Madelyne and inexplicably helped her get her shoes on. But when the couple started toward the door to leave the room, the girl collapsed. Winn testified that Brooks said virtually nothing after that but simply fled down the stairs. Winn concluded with the highly improbable disclaimer that, even though he had known Brooks for the past year and even though they had lived together in the same hotel room for a month and even though they worked at the same place, "I don't know anything about his business."[102] Winn, of course, knew who Herbert Brooks really was, but he also knew that the less he said about Brooks's real "business," the better off he would be. Having seen Madelyne Whelton's blood soaking the bed next to his was proof enough that this was not the time for candor. He stuck to this perfectly composed but unlikely story, despite repeated questioning by the police.

Sergeant I.G. Cousins, who responded to the call from the Traveler's Hotel, testified that when he arrived and saw Madelyne, "I asked her who

shot her; she told me to carry her to the hospital and then she would tell me the whole thing. I asked Winn who shot her and he said he could not tell who did."[103] Calvin Perry, a janitor at the hotel, recalled events differently. In Perry's version of the shooting, Winn had shouted down the hall, "Brooks, come back here and help take this woman out. Don't leave her here." Brooks, clattering unsteadily down the stairs to the hotel's front entrance on Main Street, called back, "I can't do it," ran out the door and disappeared. Perry also described his recollections of Sergeant Cousins asking Whelton who shot Madelyne and testified that she said, "Take me to the hospital," to which Cousins replied, "We're not going to take you any place until you tell us who shot you." Madelyne, her mind racing and blood soaking her clothes, gasped nothing more than, "I did it myself."[104]

An ambulance couldn't be found, so Sergeant Cousins and James Winn took Madelyne in a cab to Memorial Hospital at Broad and Twelfth Streets.[105] The bullet had cut two major arteries in her abdomen, but she remained conscious the entire time in the cab and at the hospital during an emergency operation to stem the bleeding.[106] The same undercurrent of fear apparent in Winn's fabricated account of the shooting kept Madelyne from saying what really happened in that hotel room, even knowing that she could be dying. So powerful was the dread that kept her silent, Madelyne's last words were a plea to the hospital staff to not tell her father what happened to her.[107]

Madelyne Whelton was buried on January 17, 1934, at Richmond's Mount Calvary Cemetery following a funeral Mass at St. Benedict Church.[108] By February 1, the story of the murdered girl had sunk below the fold on page two of a Richmond newspaper. It noted only that Winn, who had been held as a material witness to the shooting, was now released and that there were no clues or progress in the case.[109] No one was ever prosecuted for the shooting of Madelyne Whelton. For those who know the story of her short life that ended so violently, the epitaph "Rest in Peace" carved on the murdered girl's tombstone doesn't describe a state of grace so much as it does an anguished father's most fervent prayer.

At the inquest, when it came time to unravel what happened to Madelyne, James Winn was a useless witness. He could not be moved from the ludicrous story that he was sound asleep in that small hotel room with Madelyne and Brooks and only awoke from his nap "by a noise which I suppose was a shot."[110] The powder burns on Madelyne's clothing that were noted in the coroner's report and the fact the bullet went directly through her body and the mattress and into the floor under the bed indicate that Brooks must have been holding the gun directly to her stomach and shot her while she lay in

Headstone of Madelyne Whelton, Mount Calvary Cemetery, Richmond, Virginia. Madelyne's murder in January 1934 was the first indication of Richmond's impending crime wave. *Author's photo.*

the bed, only a few feet from Winn. Winn and Nylah Roach, his companion the night before, both swore that they were mystified as to why Brooks might have shot her. The pair had been dating for some time, and anyway, as Nylah maintained, "Brooks and Madelyne had not been quarrelling when I left."[111]

Although Nylah primly stated in her testimony at the coroner's inquest that she was married and carefully signed her deposition "Mrs. Nylah E. Roach," it was apparent that this was no ordinary Richmond housewife and was most definitely a woman who knew when to keep quiet. Roach testified that she rode from the Traveler's Hotel out to Club Forest (about thirteen miles away) at 9:30 p.m. that evening but was careful to state that she did not go inside. Winn later drove her back to her home on Church Hill, where she arrived at 11:30 p.m. Nylah admitted that the two couples had been drunk when she left Winn's room after they finished a pint of moonshine, and she repeated the detail of Madelyne being upset and crying when Winn left to take Nylah home because Madelyne knew that her friend was leaving for Washington the next day.[112] Nylah, perhaps having received some advice

at Club Forest that night, made herself scarce after her long trip out to Goochland, where she said she inexplicably just "sat in the car." Perhaps Nylah Roach had found out what was in store for her friend Madelyne and was told that this would be a good time to leave town. Whatever the case, she boarded a train for Washington as soon as she could and was later described as "having quickly left the city."[113]

Drunk and perhaps angry with Brooks, Madelyne may have made an ill-advised threat to talk to the police about his real identity or about something she had seen or heard earlier at Club Forest. If she had been dating Brooks for several months, she must have known that he was more than an employee of a rural dance hall. She may have known that he was an escapee from prison. Madelyne may have learned about the series of cigarette truck hijackings credited to the Tri-State Gang in the fall of 1933 and early 1934, robberies that yielded $60,000 in stolen goods, worth about $1 million today.[114] One such holdup occurred four days after she was murdered.[115] Whatever the motive for killing Madelyne Whelton, it is certain that she was genuinely terrified of saying anything about Herbert Brooks and his friends at Club Forest.

No one else connected with Madelyne's murder seemed to have had any illusions about Brooks and his business, but all still refused to talk to the police or the press. Indeed, there seemed to be an implicit understanding that Brooks represented a larger threat or force capable of violent retribution against anyone who squealed. Brooks's connections were known, as demonstrated by another girlfriend of Madelyne (never identified by name) who was quoted in a newspaper story about the murder. She said she had introduced Madelyne to Brooks and at the same time made an injudicious remark about his underworld connections: "I have known Madelyne all my life and Brooks is an old friend of mine, but I have been told not to talk because the detectives might try to make me appear in court. But there is one thing of which I am certain—they'll never get Brooks if he had time to catch a plane. He has too many friends in New York and Chicago."[116]

Madelyne's father, although mourning the death of his daughter, was completely cowed by the idea of Brooks and his "friends." Florance Whelton was quoted as saying that he did not intend to prosecute his daughter's killer, even if he could be found. Rather than a father's white-hot rage at the man who pressed a .38 revolver against his daughter's stomach, shot her in cold blood, and left her to die, Mr. Whelton meekly remarked, "If he did shoot her, I am sure it was an accident."[117] Whelton surely knew the implications of saying anything more about Brooks, and they weren't good.

Someone may have visited the grocery store after the shooting and spelled out the consequences to Madelyne's father, just in case he misunderstood the situation: he had other children to protect, and because his home and business were in the same building, he was doubly vulnerable. It can only be assumed that a friend of the Tri-State Gang must have delivered a threat to Whelton because there is no other plausible reason for Whelton to make such innocuous statements about the man who murdered his daughter.

Florance Whelton had no illusions about Herbert Brooks. Neither, apparently, did the savvy staff of the Traveler's Hotel. Even though Brooks had lived there for a year, employees of the hotel would not identify him when the police showed them mug shots of the man they knew as Brooks.[118] All of them clammed up, and what really happened in room 202 at the Traveler's Hotel will never be known. Nevertheless, the incident represents a recurring motif in the story of the Tri-State Gang: someone knew too much about the gang's activities, was identified as a potential liability, and therefore had to be eliminated. The gang was infamous for disposing of fellow gang members, and this was particularly true of any women who attached themselves to them. Dead and dying women were left up and down the East Coast—in hotel rooms, rooming houses, and shallow graves—simply because they knew too much.

As gangster Walter Legenza later famously remarked, "I don't like women in gangs. They always get you in trouble."[119] Madelyne was the first of several women who discovered how disposable they were to the men of the Tri-State Gang. Only Robert Mais's girlfriend, Marie McKeever, was allowed into their inviolate inner circle.

Chapter 5

THE CLUB FOREST

The Goochland locals may have been blissfully ignorant of any danger as they smoked, drank, and danced under the lights at the Club Forest nightclub, but for any Richmonders at the bar or the card tables who knew the real name of Herbert Brooks, that knowledge alone would have been enough to scare them into silence. Madelyne Whelton's boyfriend, the Herbert Brooks of whom her father had spoken so highly, was actually a career criminal from New York named Herbert Myers, and he was already married. Myers was a member of William "Big George" Phillips's gang in Philadelphia, and when the gang extended its territory south, it became known as the Tri-State Gang for its activity in Pennsylvania, Maryland, and Virginia.[120]

Myers had taken part in the gang's holdup of the mail truck at Union Station in Washington, D.C., in December 1933. His accomplices were named in the press as Walter Legenza, Robert Mais, and Arthur "Dutch" Misunas.[121] Another gangster who had helped to establish and run Club Forest was John Allen—actually John Allen Kendrick, one of Legenza's fellow escapees from the Lorton Reformatory in Northern Virginia.[122] Club Forest, described as "Richmond's gayest hi-de-ho center of night life," was only acknowledged as a gangster hangout when police "Wanted" circulars were distributed, offering a reward for Brooks (aka Myers).[123]

Although Madelyne Whelton's poor choice in men had been a fatal mistake, her shooting at the Traveler's Hotel was not the first time her boyfriend had killed someone. Herbert Myers was already wanted for a murder in Baltimore in 1932.[124] When Madelyne first met him as Herbert

Brooks, Myers had been a fugitive for a decade following his escape from a Maryland penitentiary where he had been serving a ten-year sentence for auto theft.[125]

Apparently to help him evade capture, the Tri-State Gang sent Myers to the relative backwater of Richmond, Virginia, to establish a beachhead for a new wave of crime in untapped waters there. Nightclubs were often used as criminal hangouts and hideouts, but Richmond itself was far too staid to permit such clubs inside city limits. Parts of surrounding Henrico County were already quite urbanized, and police surveillance there might be just as rigorous. But a site just west of the Henrico line, in rural Goochland County, proved to be ideal for the gang's purposes: Goochland offered access to the tobacco factories in Virginia and North Carolina, so that hijackers could easily intercept trucks filled with valuable cigarettes; Goochland was also accessible to Route 1, the main north–south highway by which gang members could move alcohol, guns, trucks, and men wherever they were needed up or down the East Coast. At the same time, cargos hijacked in Virginia could be quickly transported north for sale in Washington, Baltimore or Philadelphia.

The gang's considerable investment in its criminal headquarters in central Virginia took the form of a complex of buildings just east of Route 288. A two-story filling station stood close to the road, but behind that, in the woods, was an expansive pink stucco structure with nightclub, bar, stage, and billiard room.[126] Club Forest was one of several dance halls and roadhouses on the outskirts of the city that became popular as Richmond navigated its way through Prohibition—from ratification of the Volstead Act in 1919 until its repeal in 1933 and beyond.

Another popular, but less infamous, dance hall just over the Henrico County line in Goochland County was Club Ballyhoo. Only Tanglewood Ordinary, built in 1928, still stands along Route 6 (Patterson Avenue), and it is now used as a restaurant. Not only did these places offer alcohol and gambling, but they were also a powerful draw for fun-seeking Richmonders willing to drive into the countryside to have a few drinks and dance. For many, Club Forest was a place to get away from everyday life well beyond the notice of their neighbors and the police. Traveling bands and orchestras often provided live music, and the gambling parlor added a certain allure of exoticism and danger for Richmonders who otherwise fancied themselves conservative sophisticates. The real menace at Club Forest, however, was in the form of the men who sat and talked in the club's back rooms, at the bar, or in the apartment above the gas station—men making plans for their next heist, plotting escape routes, and cleaning their guns.

Club Forest was just off what was then called the "New River Road" (now Patterson Avenue), which extends westward, straight as an arrow, through the old Patterson family plantation and beyond. But the bootleggers and fugitives who drove out from the city to the "resort" in Goochland would probably not have taken Patterson Avenue. It was too open, too straight and too easily monitored. A car could be seen a couple of miles away from the crest of the many ridge roads that intersected it. Instead, they probably took Cary Street, a quiet residential route, far easier to drive through without being noticed.

Under its canopy of trees, Cary Street passed the growing number of homes owned by Richmond's elite in the new planned community called Windsor Farms. It ended at an intersection near the Country Club of Virginia, where it continued on as River Road and dropped downhill, crossing a small bridge below the University of Richmond. From that point on, there were few houses, and the old road dipped and curved along a path rich with history. After passing the boyhood home of Thomas Jefferson at Tuckahoe Plantation, River Road swung north to intersect with Patterson Avenue. Just east of there, the hepped-up sounds of jazz and swing could be heard in the evening breezes, and the lights of Club Forest could be seen twinkling through the trees—an improbable beacon in the otherwise stygian darkness of rural Goochland County.

Although Herbert Myers had established Club Forest and contracted for its construction, he deeded over his interest in the property shortly after it opened.[127] There is no way to trace the source of money that built the nightclub or to estimate Myers's profit from the venture, but he still remained a managing partner at the club. One newspaper article described Myers

DANCE and DINE

AT

CLUB FOREST

Richmond's Most Exclusive

NIGHT CLUB

Located on Patterson Avenue
8 Miles From the Boulevard

GOOD MUSIC

Tonight and Saturday Night
By Henry Bryant's Orchestra

Newspaper ad for Club Forest, 1934. The nightclub established by the Tri-State Gang often placed advertisements in Richmond newspapers, inviting patrons to drive out of town and enjoy dining and dancing (not to mention drinking and gambling) at "Richmond's Most Exclusive Night Club," under the stars and among oak trees of nearby Goochland County. *Author's collection.*

simply as "bouncer" at Club Forest, but his actual role is unknown.[128] It was obvious, though, that he personified the power and muscle behind the hideout, bar, and dance hall that sheltered the Tri-State Gang—including Mais and Legenza—in the remote Goochland countryside.

The fact that a serious East Coast gangster like Herbert Myers could be found in rural Goochland was finally confirmed by Richmond's chief of detectives, Alex S. Wright, who was forced to concede, "Gangsters who have fled from Northern cities to escape capture by police authorities have been operating in an around Richmond during recent months, using night clubs in the vicinity of the city as their rendezvous."[129] The *Richmond News Leader* described the second floor of the filling station beside Patterson Avenue as "furnished as living quarters, and Brooks [Myers] is believed to have used it as a hideout after the slaying of Madelyne Whelton."[130] It was the only place in Richmond for the killer to go, having turned his hotel room into a bloody crime scene. He found shelter at the headquarters created for just such an event, until he could flee Richmond and return to his native New York City.

Even after places like Club Forest were identified as gangster hideouts and Herbert Myers (still known locally as Brooks) had been spotted on the streets of Richmond a week after Madelyne Whelton's murder, no arrests were made.[131] By early February 1934, news of the murder at the Traveler's Hotel was reduced to a small item in the *News Leader* that simply stated that no progress had been made in finding her killer.[132]

Earlier that year, in late January, newsreels and newspapers had focused on the arrest of America's most famous outlaw, John Dillinger, while the exploits of criminals like Bonnie and Clyde in the Midwest seemed a world away. The shooting of a young girl in a cheap Richmond hotel quickly faded from the public eye.

The arrival of March in 1934 brought no hint of the warmth of spring. To Richmonders, the murder of Madelyne Whelton at the Traveler's Hotel in January seemed an isolated incident, and other than the disquieting talk of a criminal element in those outlying beer joints and dance halls, the city seemed immune to the national crime wave.

Certainly holdups were furthest from the minds of William Harvey Cogbill and William B. Jones as they turned up their collars against the cold on March 2 and trudged up the hill from Main Street to the Federal Reserve Bank on Ninth, facing Capitol Square. Cogbill, an armed messenger for State Planters Bank, carried a canvas satchel containing $60,000 in small bills. As they looked down to navigate the icy sidewalk, the two men were

The Ninth Street alley holdup site. This modern photograph, taken at the mouth of the alley on North Ninth, near Bank Street, shows where two couriers for the State Planters Bank were relieved of their satchel containing $60,000 in a successful daylight holdup on March 2, 1934. *Author's photo.*

annoyed when they saw a dark Essex touring car abruptly pull out of an alley across from the Hotel Rueger, blocking their path.[133]

The car's doors opened abruptly, and three well-dressed men in suits and overcoats jumped out, grabbed the bank messengers, and hustled them out of sight behind the Essex, now idling in the alley.

Cogbill, age fifty-five, and Jones, described as an "elderly porter" for the State Planters Bank, first thought that they were the victims of a joke—until they saw the men's pistols pointed at them. The two were so surprised and shocked that they hardly looked in their captors' faces. Jones was obviously shaken. As he said later, "I never had seen such big guns."[134] One robber told another to look for Cogbill's revolver, which was removed from the messenger's holster as a third man pinned his arms behind him and then shoved him down onto the slush-covered cobblestones behind the car. The robbers grabbed the satchel with the money, dove back into the car, turned

left out of the alley and immediately turned right on Bank Street, rounding the corner by the Hotel Rueger. They were never seen again.

Richmonders hardly had time to digest the audacity of the daring daylight holdup on their own city streets when that crime was supplanted by even more sensational news on March 4, namely the account of John Dillinger's astonishing escape from a jail in Crown Point, Indiana, the previous day. Below the headline, the *Richmond Times-Dispatch* featured a photo of Dillinger standing with the hapless official whose "escape-proof" jail had just lost custody of America's most famous prisoner. Sheriff Lillian Holley grimly warned, "If I ever see John Dillinger, I'll shoot him through the head with my own pistol."[135] Richmond, like the rest of the country, was astonished that America's most famous criminal had broken out of jail, driving away in the sheriff's own car, and that the authorities were clueless as to where he was.[136]

In competition with such electrifying headlines, and with the insurance company's immediate replacement of the stolen bank funds, Richmond's $60,000 Ninth Street robbery was quickly forgotten. The Tri-State Gang was named as having carried out the robbery, but that claim was later discredited and no one was ever prosecuted for the crime.[137] Meanwhile, the *Times-Dispatch* quoted Ohio attorney general John W. Bricker, blasting the jail officials who had Dillinger in their charge: "Either cowardice, corruption of public officials or ignorance permitted John Dillinger to escape."[138] Before the year was out, the same volleys of blame and recrimination heard after the Indiana jailbreak would echo in Richmond, but under far bloodier circumstances than in John Dillinger's escape.

Chapter 6
HEIST ON BROAD STREET

As twilight settled across Richmond one late winter's day in 1934, store windows and streetlights began to wink on, adding a small measure of cheer to the darkening day. At eight o'clock that evening, March 8, 1934, a Model T Ford panel truck ground slowly up the Ninth Street hill from the Federal Reserve Bank, passed the State Capitol and turned left onto Broad Street. The driver was Ewell Huband; his assistant, Benjamin Meade, was in the passenger's seat. The tall, boxy truck rumbled west on Broad Street through Richmond's main shopping district, passing brightly lit restaurants and theater marquees.

The movies offered folks a brief and inexpensive escape from the hardships of the 1930s, and now, thanks to "the talkies"—with the sounds of actors' voices and dramatic musical scores—they were even more fun. Huband and Meade chatted as they drove past the city's many movie houses: the National was showing *Good Dame*; the Colonial featured Edmund Lowe and Victor McLaglen in *No More Women*; the Strand had Frederic March and Gary Cooper in *Design for Living*; and the Capitol, across from Broad Street Station, offered Clark Gable and Claudette Colbert in *It Happened One Night*.[139]

The great dome of the railroad station was silhouetted against the night sky as the Model T turned onto a service road toward the Railway Express depot behind the station. There, a concrete overpass above the railroad tracks afforded a good view of the waiting trains and trackside platforms. Above the rail yard, light streaming from the windows on the station's grand concourse glistened on the tracks below.

Postcard view of Broad Street Station, circa 1934. The Tri-State Gang often entered and left Richmond by way of the classical-style terminal, always with fatal results. *Author's collection.*

As the truck crested the overpass, the two bank employees came upon a Plymouth sedan with New Jersey license plates blocking their way. A second car, a late-model Pontiac, blocked the left lane, and the panel truck lurched to a stop. Huband and Meade were dumbfounded.

Four men stood near the two parked cars and peered over the bridge. Meade later recalled that when he first saw them looking down onto the rail yard, he thought they might be police looking for bootleggers.[140] As the panel truck approached them, the men stepped off the curb and surrounded the truck as it came to a stop.

Arthur Misunas, a heavyset man in an overcoat, moved to the middle of the road. He clutched a Thompson submachine gun under his coat as he nervously scanned the street in both directions. "Dutch" Misunas had recently shot a man during a mail truck robbery at Union Station in Washington, D.C., so he was no stranger to the Thompson and knew how to use it. The slight figure of Robert Mais, who held a pistol, stepped to the front of the truck and watched for any vehicles heading toward them from Broad Street. Their gang leader, "Big George" Phillips, sat at the wheel of the getaway car.[141] The last two, Walter Legenza and Morris Kauffman, moved behind the truck, grabbed the door handles and jerked them open. "Don't move!" shouted Legenza as he immediately raised his automatic pistol and fired into the back of the truck.

Huband and Meade sat frozen in their seats. The sudden, unexpected flash and roar of a gunshot in the back of the truck was both deafening and

53

disorienting. Legenza fired again, the bullets striking the frame above the windshield, just missing Huband's head. Meade, frozen in terror, covered his head with his hands and dropped to the floorboards. That instant, Huband reflexively turned to the right. He may have glimpsed a man silhouetted against the lights from Broad Street, but before that image fully registered, it was replaced by an explosion. Legenza's third shot hit Huband in the right temple, killing him instantly. With a groan, he slumped over onto the terrified Meade.[142]

From his position on the floor, Meade could hear someone outside say, "We got that fellow," then heard them pulling out the truck's cargo and tossing it into the getaway car. Crouching under Huband's dead body until the car pulled off, Meade stumbled out of the truck and screamed for help.[143] Later, still in shock, he recalled that when Huband's body was finally picked up off the floor of the truck, "his brains fell out in his hat."[144]

Tri-State Gang member Arthur Misunas later maintained that Legenza simply shot Huband because he hadn't put his hands up fast enough.[145] In fact, Legenza was determined to kill the driver as soon as the truck doors opened, and he fired two more shots because the first had no effect, even though Huband had not made any defensive moves. In the end, it was cold, calculated murder.

As the robbery unfolded, L.N. Palmore, who worked for the Universal Motor Company on Broad Street, had just driven up to the scene from the opposite direction. Coming upon the blocked roadway, he sat in his car, stunned, as the crime unfolded in front of him. The man in the getaway car noticed Palmore and ran up to his car.

"Sit where you are!" he yelled.

"That's what I am doing!" Palmore stammered back.

"Goddamit, you are going with me," the man with the pistol threatened, but when he saw that his comrades had finished looting the truck, he turned and jumped into the Pontiac and it roared off. Palmore recovered his wits and followed it down the overpass and as far as the train station driveway, where he parked and called the police. Meanwhile, the Pontiac sped west on Broad Street. The car was seen roaring through a construction zone on West Broad Street, splashing mud on people along the sidewalk and then disappearing in the distance. Meade, standing on the sidewalk beside what would later be called the "Death Truck," gasped, "That was the first time I was ever held up, and I don't want nothing like that to happen to me again. It was the most awful experience I ever had."[146]

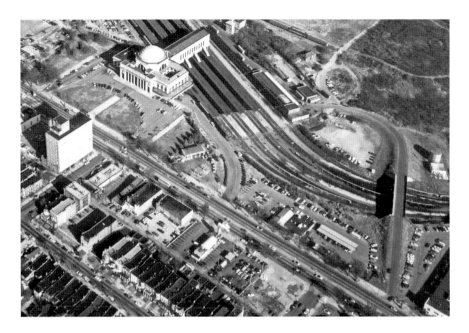

Aerial view of Broad Street Station and surroundings, circa 1950. The robbery and murder of Federal Reserve Bank courier Ewell Huband on the evening of March 8, 1934, took place on the bridge over the tracks to the right. The tall building to the left, just across from the railroad station, is the former William Byrd Hotel, where gangster girlfriend Marie McKeever stayed during the trials of her sweetheart, Robert Mais, and his cohort, Walter Legenza. *Library of Virginia.*

Huband had died for nothing. The unarmed delivery driver was simply carrying sacks of paperwork to the Broad Street Station express office. The stolen bags held nothing more than cancelled checks and other securities and documents destined for area banks. For sacks and sacks of worthless paper, Ewell Huband's murder turned the robbery into a death sentence for all five robbers—if they were ever caught.

In a press conference the next day, George Seay, head of the Federal Reserve Bank, revealed the contents of the stolen sacks and tersely added, "If they had been as experienced and intelligent as we are led to suppose criminals are in these days, they would have known that nothing of value to third persons would have been either sent to the express office or to the mail trains unless guarded in a more formidable manner."[147]

Seay's remark about the robbers' lack of intelligence is understandable. Nevertheless, the earlier theft on Ninth Street made it seem that Richmond authorities had a naïve and cavalier attitude in handling large sums of

money. If two men, only one of them armed, had been walking along a Richmond sidewalk with a satchel of bills totaling $60,000, how much more would there be in a truck full of bank sacks? For the opportunistic gangster, the answer to that question was an irresistible temptation. For the public at large, and Ewell Huband's family in particular, the loss from this horrid mistake was enormous.

Fifty-eight years later, in 1993, Huband's daughter, Dorothy, still remembered her mother's hoarse screams ringing through their Highland Park home on Bancroft Avenue. The passage of time could not suppress her memory of that awful night nor soften the depth of her sadness after her father's murder. The dull ache of that loss welled up as Dorothy Huband Rhodes recalled, "It didn't take long for the news to spread…. They'd killed Daddy." In an instant, she realized how the Huband household would be thrown into poverty by the loss of their breadwinner. Young Dorothy would have to withdraw from high school and instead take a job to help her mother support herself and the other two Huband children. "It was the most vicious, ugliest thing anybody had ever heard of in Richmond," she choked, "to come up behind an unarmed man and shoot him in the head."[148] The gangsters' escape only added to the tragedy, and their disappearance left people across Richmond frustrated with police in their failure to bring the criminals to justice—or to keep citizens safe.

Before these crimes started happening in Richmond, the shootouts and robberies in Oklahoma, Kansas, Texas, and Illinois were spectator sports for the citizens of this quiet tobacco town. Between radio reports, newsreels, and newspapers, the national crime wave became constant, titillating entertainment for thrill-seekers on the hunt for details of the latest offense. John Dillinger's jailbreak on March 3, 1934, made headlines in the *Richmond Times-Dispatch* read more like a poster for a cowboy matinee. "Dillinger, 'Cop Killer,' Waving Wooden Pistol, Escapes Indiana Jail," it proclaimed; "Desperado Makes Good Threat in Prison Delivery Unmatched for Cold Daring, Cunning."[149]

The robbery at Broad Street Station, by contrast, was simply a vicious crime, made all the more horrific by Huband's senseless, bloody death. There were no dashing villains in Huband's murder, no hardhearted wisecracks or daring deeds. Huband was simply shot out of hand, and when news of the robbery got out, all of Richmond recoiled in shock. The concept of justice at that time meant only one cure for perpetrators of this sort of crime. One can assume that, in their outrage, most Richmonders agreed with Baltimore columnist H.L. Mencken, who wrote grimly about the violent summer of

1934, "I see no objection to parole for amateur or accidental criminals…but it is manifestly absurd to turn loose professionals. The only fit dose for them is death."[150]

Huband's killing had not occurred in a back alley or shadowy barroom. It had taken place in plain sight of Richmond's hub of travel and commerce, on the city's main boulevard. For a staid town like Richmond, it was a terrible affront, and the sheer violence of the attack instantly catapulted Robert Mais and Walter Legenza beyond the realm of empathy enjoyed by more colorful, yet more distant, criminals like John Dillinger and Charles "Pretty Boy" Floyd.

One historian of the gangster period noted, "Whereas racketeers were becoming deliberately anonymous in the 1930s, bandits were acquiring a more human face through theatrical news coverage of their crimes and the nostalgia for an invented rural past that it invoked for urban audiences."[151] Another author described such celebrity gangsters as Dillinger, Floyd, and Bonnie and Clyde: "Their notoriety stemmed solely from their value as news subjects, and the bloody childlike violence of their lives. Depression society, weary of corruption in government and apathy in business, welcomed the stories of banks held up and policemen baffled."[152]

One account of a 1934 bank robbery, "Dillinger Puts on a Show," described the admiring crowd in one Iowa town: "But the people had a good show. Some of them had never seen a bank robbery. Some like the looks of the boys doing the robbing. They were young. Some were handsome. They had a lot of nerve. You had to give them credit."[153] This admiration of the young, handsome bandits was awarded to only a few of the robbers of the day, and primarily in the context of the American Midwest.

The lack of motive or empathy in the Huband murder ensured that there would be no public sympathy for Legenza's hardscrabble youth or Mais's evolution from his mother's "good boy" to reckless bootlegger and cold-blooded murderer. In the public's mind, there was a boundary that, once crossed, put some 1930s gunmen in a category of criminals beyond the pale. The most famous was Vincent "Mad Dog" Coll, who had accidentally shot and killed a five-year-old child on a New York street in the course of a gangland row. Coll earned his moniker from New York mayor Jimmy Walker, who tagged him a "mad dog." Although Coll was later acquitted of the murder, the nickname stuck until he was finally machine-gunned to death in a telephone booth in 1932.[154] In contrast to his benign nickname, George "Baby Face" Nelson was widely known as a remorseless killer who had little compunction about shooting down police and bystanders alike.[155]

Robert Mais, Walter Legenza and the rest of the Tri-State Gang were thrust into the same category as these "mad dog killers" at the moment the sights on Legenza's jerking, roaring pistol finally settled on the side of Ewell Huband's skull.

The combined holdups in Richmond—the Ninth Street bank messenger robbery on March 2, followed on March 8 by the vicious killing of Huband—instilled an unaccustomed wave of fear in Richmonders, who saw those crimes, like so many assaults that had historically battered the city, as emanating from "up north." With their Italian names, foreign accents and "fast" women, these well-dressed men in their fancy touring cars must surely be Yankees, and worse. "Thugs Being Driven Out of Larger Cities Are Coming South Is Claim," read one alarming headline in a Richmond newspaper, further raising expectations that the Virginia capital was soon to be the scene of the same crimes that had run rampant in the Midwest.[156] T. McCall Frasier, director of Virginia's Department of Motor Vehicles, stated that northern communities had warned him "that they were running out racketeers who might shift south."[157] Richmond audiences, numbed by the two holdups and murder that had descended on their otherwise quiet city, watched news of shootouts, robberies, and kidnappings with new attention.

These were no longer events that took place in some distant state. Now these bloody events were unfolding on the streets of Richmond. News accounts that the escaped John Dillinger was spotted as close as Baltimore ("Report of Killer and Negro in Car From Frederick Spurs Police to Action") only intensified fears.[158] Taking in a gangster movie after watching a crime-laden newsreel brought home the reality of bank robberies and shootouts in the Midwest. That, coupled with breathless radio news flashes, must have only further electrified the city. Anyone seen driving Richmond's streets in vehicles with northern license plates must have immediately been suspected to be the southbound bandits Richmond had been warned about.

That relentless drumbeat of American crime, heard on radio news bulletins, seen in newsreels, and read in newspapers, continued unabated in 1934. The crimes came hard and fast: March 2, robbery of the State Planters Bank messenger in Richmond; March 3, Dillinger escapes jail in Indiana, and Oklahoma police kill notorious robber Ford Bradshaw; March 4, a killing by "Baby Face" Nelson in Minneapolis; March 6, bank robbery by Nelson; March 7, Texas bank robbery, bank employees taken hostage; and now, March 8, the Richmond bank truck robbery and Ewell Huband killed. Richmonders, like people across the country, were pummeled by details of these sensational crimes. The terrifying news that

flashed across Richmond demanded the murderers' immediate capture, but that was not to happen.

As police combed central Virginia for the Broad Street Station robbers, an editorial in the *Richmond Times-Dispatch* noted that, by coincidence, just as Huband was being robbed and shot to death, the Richmond City Council was questioning Mayor John Fulmer Bright and Public Safety Director James R. Sheppard Jr. as to the adequacy of police protection in Richmond. Decrying seven vacancies on the police force, the newspaper called for filling those positions as the very least that could be done to ensure Richmonders' safety: "The terrible effectiveness with which these bandits have done their dirty work would at least suggest that some attempt should be made to increase the efficiency of the Richmond police system."[159] Uneasy Richmonders couldn't agree more, and for the first time in print, they saw the recent robberies and murders in Virginia labeled a "crime wave."[160]

Next to the *Times-Dispatch* editorial, an editorial cartoon by Fred Seibel showed Richmond being shot in the back by a sinister figure holding a black automatic pistol. The bullets were labeled "holdups, robberies, murder," and in the background is the dome of Broad Street Station. Referring to Dillinger's jailbreak, using a dummy handgun that he supposedly whittled himself, Siebel's drawing is soberly titled, "This Is Not a Wooden Pistol."[161]

There was more than a hint of sarcasm in a *Times-Dispatch* article the following day when it described the police raid of an empty house in South Richmond in a search for the Federal Reserve truck robbers: "Constabulary duty was done Friday morning by the Richmond police and residents of Devonshire Road."[162] Like the State Planters Bank robbery on Ninth Street, there were no clues in the Huband murder. "These criminals, too, escaped," reported the newspaper glumly, "the police, apparently, have no clue to their whereabouts."[163] The disappearance of Huband's killers would not be the last time the Richmond authorities were tested by the Philadelphia gangsters, nor would it be the last time the city's police and detective response proved to be completely inadequate.

Chapter 7

ESCAPE FROM RICHMOND

Once a sleepy southern capital, quiet and content, by 1934 Richmond had become the hub of a serious crime wave. It began in mid-January with the outrageous shooting death of pretty young Madelyne Whelton. Next came a brazen bank heist in broad daylight and then a robbery and shooting near the city's major railway terminal. Now, two murders and two bank robberies drove Richmond police to find the culprits. Clues were slim and witnesses even harder to find. But luck was on their side.

The first break in the March 8 robbery at Broad Street Station came a week later, when eighteen-year-old James Taylor was walking along the railroad tracks in an industrial section west of the station, near Richmond's Methodist Orphanage, at 3900 West Broad Street.[164] As Taylor walked past the open doors of an abandoned oil company garage, he noticed a late-model black Plymouth sedan parked inside, a specter emerging from the gloom. The newspapers had run a detailed description of the robbers' getaway car, so he couldn't resist going in for a closer look. As soon as he saw the pile of open mail sacks, he knew that he must have stumbled upon the getaway car, which was just a mile from the scene of the crime. The Federal Reserve Bank had posted a $25 reward for the return of each of the thirteen stolen sacks, so he quickly gathered them up and turned them in. Taylor collected a handsome $325 for his efforts, the equivalent of more than $5,000 in today's money.[165]

There is no way to know what was said in those first few minutes as the Tri-State gangsters sped from the scene of their latest heist. Many details

would be recounted in later testimony, but nowhere is there a record of the angry, panicked words that would have flown between Walter Legenza, Robert Mais, William Phillips, Morris Kauffman and Arthur Misunas. Perhaps the recriminations and anger began inside the getaway car before it even turned off Broad Street, because they all knew that, unless they were extremely careful or lucky—or both—the trigger-happy Legenza had just put them all on a path to the electric chair. Their rage could only have flared again when they ripped open the sacks and found them filled with worthless bank documents instead of tens of thousands in cold, hard cash.

Perhaps like oil prospectors, they always assumed the risk of a dry well. It was part of the price in that line of work. Just that past December, the robbery at Washington's Union Station, during which Misunas had shot and wounded a guard, turned up nothing but a pile of cancelled revenue stamps.[166] But they all knew that actually killing a man in the course of a robbery, as Legenza did, would have far greater consequences. Now they all needed to get out of Richmond fast—and no matter where they went, they knew they would be on the run for the rest of their lives.

Planning ahead for the heist, they had bought a flatbed truck in Washington, D.C., several weeks before, drove it to Richmond and left it, loaded with empty egg crates, in the abandoned shed where Taylor later found the Plymouth. As Misunas later testified, "We drove to an empty garage about a mile away [from the robbery]. There we opened the mail bags." His matter-of-fact tone gave no hint of the frustration and fury that must have exploded at that point. Still stone-faced, Misunas continued: "When we discovered there was no money in them, we got into the truck and started for Baltimore." Phillips and Kauffman climbed into the cab of the truck; Mais, Legenza, and Misunas hid in the back, under the egg crates.[167]

That night, the truck headed north on the Richmond-Washington Highway (now U.S. Route 1). In the wake of the robbery, Virginia State Police had already stationed patrol cars along the main routes out of Richmond, and inevitably the flatbed truck was pulled to the side of the road. The officer looked hard at the two men in the cab of the truck, now dressed as produce dealers.[168] "My God, they've got us," muttered one of the men in the back when he heard the officer questioning Phillips just inches away in the dark. "We might as well shoot it out here," whispered Misunas. The three nervous men in the back each had a .45-caliber Thompson submachine gun, so any hint of their discovery by the police would have ended in the lawman's sudden death. "The officer asked us where we were going. He looked at the egg crates on the truck, then told us

to move on," continued Misunas. "I got out of the truck on the outskirts of Baltimore, walked about a mile, then took a taxi to a hotel." [169]

Back in Richmond, there was hell to pay for the lack of police radios in the department's patrol cars. The sudden retirement of Captain Alex S. Wright of Richmond's Police Detective Unit shortly after Huband's murder underscored the severity of the situation. Despite his age and antiquated training (he had joined the police force in 1894), Wright had already demonstrated ample foresight before the shooting by urging that the department obtain police radios and teletype machines to counter the coming assault from well-trained, heavily armed professional criminals. Unfortunately, his call to arms had not been answered soon enough. But now, the lack of progress in finding Huband's murderer only made the problem more apparent and the solution more urgent. [170]

In the early 1930s, it would have been no surprise that radio was proposed as a crime-fighting tool. Since 1925, when the newfangled medium first came to Virginia, radio had already become Richmond's primary source of broadcast news and entertainment. [171] When word went out that police needed radio communications in order to help keep the city safe, Richmond's premier station, WRVA, offered its services to the police if the city could manage to equip its cars with radio receivers. [172] Grasping at a cheap solution to Richmond's lack of funds to purchase the more specialized police-band radios, Richmond Mayor J. Fulmer Bright wrote to Larus and Brothers, the tobacco company that owned WRVA, proposing to run a wire from the radio's transmitting plant and studios at Twenty-first and Main to police headquarters across the street from City Hall. The plan was to broadcast police calls between the radio station's regular programming. [173]

Because the two big Richmond holdups occurred almost simultaneously— the first on Ninth Street, March 2, and the second at Broad Street Station, March 8—police proceeded on the assumption that the same men must have been involved in both crimes. To prove their theory, Richmond detectives asked William Jones, the State Planters Bank porter who witnessed the Ninth Street robbery, and Benjamin Meade, Huband's assistant, to go with them to Baltimore to view the body of a robber recently killed there by police. Shivering in the dread and cold of the Baltimore morgue, the two Richmond men said the dead man "resembled" one of the robbers but that they could not make a positive identification. [174]

The murder of Madelyne Whelton and the two spectacular robberies were bad press for Virginia in general and Richmond in particular, especially with the Dillinger escape fanning the flames of outrage toward

what by now seemed widespread incompetence among police forces across the country. Colonel Leroy Hodges, director of the Virginia Chamber of Commerce and a member of the state prison board, claimed that five years earlier the chamber had predicted that organized crime would finally sweep into Virginia. Hodges blasted the lack of arrests in recent crimes and the "dismayingly blank entries on our state and local police records."[175] Perhaps because of increasing anger about the recent crimes and lack of results in the robbers' capture, both the police and the public became understandably edgy.

In downtown Richmond, a secretary in the Postal Inspector's office looked out his office onto Main Street and noticed a Plymouth sedan similar to the description of the getaway car. He immediately called the State Police. The two occupants of the Plymouth, according to the *Richmond Times-Dispatch*, "were nabbed when they returned to their machine." The hapless pair turned out to be J.P. (Country) Harmon and G.A. Brawley, two self-described novelty salesmen from South Carolina who admitted to being out of work for some time.[176] Even after being subjected to what was termed "a rigid quizzing" at police headquarters, the two denied any knowledge of either of the Richmond robberies.[177] Harmon and Brawley were, in the ungainly words of the *Richmond News Leader*, "held technical on a charge of being suspected of having a stolen motor vehicle in their possession" while the police investigation continued.[178] A photograph of the two being led from the Henrico jail to the State Penitentiary to be fingerprinted was featured on the front page, and in the next column, U.S. Attorney General Homer S. Cummings again rang the alarm of an impending and overwhelming crime wave. "America's underworld has more armed men," Cummings thundered, "than the United States army and navy combined."[179]

One of the great engines that drove that alarming wave of crime was about to be disassembled: the illegal liquor trade. The National Prohibition Act, which had been in effect since 1919, was officially repealed in December 1933. In the spring of 1934, the nascent Virginia Alcohol Beverage Control Board announced that it would oversee legal sales of alcohol to the public, beginning in drugstores. "Many druggists today were enlarging their stocks of beverages to take care of an increased demand, laying in wines, brandies and liquors as well as whiskey."[180] Richmond's daily newspapers covered every aspect of the state's incremental preparations for the sale of alcohol, and on March 21, the first day of spring, a bold headline at the top of one front page alerted its thirsty readership: "Board to Issue Beer, Wine Licenses First."[181]

While Richmonders waited for access to alcohol and the newspapers remained silent about any progress in the police robbery investigations, there was still plenty of exciting copy for Richmond newspapers to report. The *Richmond News Leader* in particular delighted in showcasing sensational goings-on, both locally and around the world. On March 21, 1934, the *News Leader*'s front page recounted a suicide—jumping from a downtown Richmond hotel and landing on the Broad Street sidewalk—a thwarted assassination attempt against German Prime Minister Wilhelm Goering, the death of a 640-pound woman in Pennsylvania, and President Roosevelt's progress with labor unrest. There was also a report by the Virginia Prison Board that single persons were much more likely to commit crimes, as well as news of the issuance of a peace pledge between the United States and Japan. This torrent of information was crammed onto the front page.[182]

By contrast, the announcement of a series of anticrime bills passed by the U.S. Congress received little fanfare in Richmond, although this legislation is often cited as the turning point of a lawless decade. In effect, it established what was then known as the U.S. Department of Justice's Bureau of Investigation, the premier opponent of American racketeering. Among the new laws were widespread measures to make transportation of a stolen vehicle across state lines a federal crime; a measure to severely curtail ownership of machine guns, sawed-off shotguns and silencers; and a law to make it a crime to aid and abet criminals. These and other legal measures proved to be fundamental tools for the invigorated Justice Bureau's investigative arm.[183]

Months later, looking back on the rise and fall of the Tri-State Gang, the *Washington Post* recognized that "what police and guns in the hands of other gangsters didn't do to end the careers of several of the mobsters, women and misfortune did."[184] Misfortune came in the form of the girlfriend of Tri-State Gang leader William "Big George" Phillips, and that woman would later become one of the star witnesses for the prosecution in the murder trial of Robert Mais and Walter Legenza. Phillips had been arrested in Ottawa, Canada, on a burglary charge and was sentenced to six months in jail. After serving his sentence, he was deported to the United States, where he met Walter Legenza in the District of Columbia penal facility in Lorton, Virginia. He and Legenza escaped that facility in 1933.

Phillips had met Lenore Fontaine, the French Canadian wife of a steelworker, while he was in Ottawa. After extradition to the United States and his escape from Lorton, he contacted her. The couple rented an apartment in Washington, and as Fontaine later explained, "I couldn't

marry Phillips because I'm already married. I lived with him because I loved him."[185] At their Washington apartment, Fontaine met the rest of Phillips's gang, including John Kendrick, Robert Mais, Walter Legenza, Arthur "Dutch" Misunas, and Morris Kauffman. Fontaine also met other gang members, such as Herbert Myers (who was still being hunted for the Richmond murder of Madelyne Whelton), Sam Berlin, John "Slim" Dunn, and Dewey Jenkins.[186]

Using the alias "Jerry Reid," Phillips rented a pleasant cottage for the gang at Crystal Beach in northeastern Maryland. From there the men launched a series of crimes beginning in late 1933, while Fontaine herself settled into the life of a gang moll. She watched impassively as Phillips and friends left the tiny resort town to rob a car barn (a trolley car garage) in Baltimore of $2,000, held up a Baltimore brewery, and then made a similar brewery heist in Washington, D.C. They also robbed the messenger of a People's Drug Store, a Washington-area post office, and a bank in Baltimore and then hijacked a truckload of cigarettes valued at $30,000 (equal to roughly $500,000 in today's currency) near Petersburg, Virginia.[187] Feeling a bit more daring after this string of thefts, the gang next attempted to blow open the safe at the Bank of Bowie, Maryland. However, it ended in an especially vivid failure, as the burglars accidentally set the bank on fire with their acetylene torch and had to flee the building as it burned down around them. The men who would become known as the Tri-State Gang were also credited with several more unsolved crimes in the Philadelphia area. There were rumors in the underworld that the gang had kidnapped an important Baltimore gambler and successfully ransomed him for $25,000.[188]

In January 1934, Virginia police were investigating a series of hijackings of trucks that carried unusually valuable cargos of cigarettes. Fontaine's boyfriend Phillips and his associates were making regular "business trips" to southern Virginia to waylay these trucks on the main north–south artery, U.S. Route 1. On January 20, two truck drivers emerged from the woods of Caroline County north of Richmond with their now-empty cigarette truck and told police they had been stopped seventy miles away, near Colonial Heights, by a car that had come alongside their truck. The description of the attack was consistent with Legenza's deadly habit of screaming a command and immediately shooting before getting a response, as he did when he shot Huband. From the truckers' description of the hijacking, Legenza was likely the one on the passenger side who shouted for the truck to stop and then immediately fired a shot through the front door, narrowly missing the driver. The truck stopped, and the two truckers were dragged

out and bound with wire and then shoved to the floor of one of the two cars used by the hijackers.[189]

Seven hours later, down a dirt road just west of Route 1 near the tiny crossroads community of Chilesburg, the two truck drivers were tied to a tree and left with Kauffman and Legenza after their truck had been looted of its cargo. Despite their desperate situation, the two hijack victims had the opportunity to look at the faces of the two gangsters, who were aware of the risk this presented. Legenza, as usual, was in favor of wrapping up any loose ends with the most effective way he knew, and he and Kauffman got into a shouting match over murdering the two bound men. In the end, Kauffman prevailed, and he and Legenza simply left the truckers tied to the tree. The two gratefully listened as the sound of the gangster's car roared off in the distance, leaving them and their empty truck in the dark. At a hearing on April 3, the truckers testified to the Washington police and positively identified Kauffman and Legenza as the men who had argued their life or death as they stood, tied and helpless, in the dark Virginia woods.[190] As the *Washington Post* later described it in the summer of 1934, "The principal dumb play, from the gangster's point of view, was leaving behind—alive—two men who could identify members of the gang."[191] Leaving living witnesses was a mistake that would be made once more, this time by Robert Mais, and would prove a fatal one for the gang.

Before long, a tip came to the U.S. Department of Justice from Winston-Salem, North Carolina, that an automobile with a certain license plate had been used in one of the truck hijackings.[192] The source of this information was not identified, but the point of origin in a tobacco town like Winston-Salem indicates that it was likely someone inside the cigarette industry—someone who may have decided to end his relationship with the gangsters and turn them in. The story of the two truckers and their near-death experience in the woods may have been the alarm that prodded whoever had been tipping off the Tri-State Gang about northbound cigarette shipments. One newspaper's characterization of the gang as "a more serious menace to life and property than the Dillinger mob" was vivid enough to cut the flow of information about cigarette trucks.[193]

The hijacking car's license plate number was shared with police up and down the Atlantic seaboard, and the car was located in Washington, D.C., parked on Adams Mill Road, on April 11, 1934. At noon, Phillips and Legenza emerged from a building and got in the car. When they tried to start it, nothing happened. The police, who had been watching it for hours, had disabled the starter.[194] When the officers approached the car, Phillips

jumped out and took aim at one of the police, Sergeant John A. Canton, with a .45-caliber automatic pistol. The gun failed to fire, but Canton got off a shot, hitting Phillips in the chest and killing him instantly. Legenza, jumping out the other side of the car, took aim at Canton with his Thompson submachine gun. To Canton's amazement, Legenza's weapon also jammed. Throwing it aside, he fled down an alley.[195]

"We are dealing with one of the most desperate and vicious bands of criminals in the country," concluded the Washington chief of detectives as the police combed the area for Legenza and another gang member, John Kendrick, who had fled before the shooting started. Meanwhile, the body of Lenore Fontaine's boyfriend, William Phillips, with the motto "Live hard, fight hard, die hard" tattooed on its leg, was left unclaimed in the Washington morgue.[196]

Fontaine later testified that the life of a gun moll was not the excitement and romance she imagined when she left her husband and home in Canada. In the breathless words of a Winnipeg newspaper, "So the story goes on and on with all the lurid lights of a melodrama. From hotel to hotel, [she followed] the forays of the gang in robbing banks, U.S. mail trucks, warehouses, and stores. Killings and shootings of policemen and guards, more and more knowledge of criminal activities, frightened of the gangsters, frightened even more of the police, no money, and even her clothes taken away at times."[197]

With Phillips's death, Lenore Fontaine became both excess baggage and a serious liability for the Tri-State Gang. Knowing that Legenza wanted to kill two truckers simply because they could identify him must have seriously frightened her, especially because now her boyfriend was no longer there to protect her. According to Fontaine, Robert Mais and his girlfriend Marie McKeever were put in charge of her and kept her in a series of hotel rooms, never letting her out of their sight. One newspaper recounted that Fontaine, "who police describe as 'on the level,' decided to return to her home, to the mob's displeasure, who feared she would 'squeal' on them."[198]

On April 27, two days after Phillips's death, they took Fontaine to the Philadelphia suburb of Upper Darby, where they planned to kill her. Legenza had now assumed leadership of the gang and invited Fontaine to go with him to "get some air." They drove off and spent the entire time, she said, parked across from a bank, noting the arrival of deliveries and traffic. She was asked to take another ride the following day, but Fontaine balked, telling the gang that she knew what they were planning and wasn't going to go along on a robbery.[199]

With that, Legenza and Mais held what was termed a "council of war" and decided that Fontaine should go with Legenza to New York. It probably wouldn't take more than a glance into Legenza's impassive blue eyes to realize that she would never return from a car trip with him, and Fontaine refused to go.[200] While it is not hard to imagine Legenza "snuffing out" Lenore Fontaine somewhere on the way to New York, the killing was instead assigned to Mais and Marie McKeever. They staged a drinking party at the apartment where Fontaine was being held, and at some point, the drunken Mais steeled himself, stood up, and abruptly shot Fontaine in the chest.

Lenore Fontaine on the witness stand. The attractive French Canadian mistress of Philadelphia gangster William Phillips sits in the witness chair at the Richmond Hustings Court in August 1934. She is ready to testify and is out for revenge. Though Robert Mais had shot her in the chest and left her for dead in Philadelphia's Upper Darby in April 1934, Fontaine later recovered to testify against her would-be killer. *Dementi Studio, Richmond, Virginia.*

"I looked up and both of them had pistols," said Fontaine. "It was a loud noise. Mais came over and asked me if I wanted another one to the head to finish things. I said 'No.' Just before they left, he said he ought to shoot me in the head before leaving, but [Marie] said I'd bleed to death anyway, and they'd better hurry.... They ran away, and I got up and stumbled out the front door. I got across the yard to the next door neighbor's and they called the police."[201] Thanks to the trio's quick exit, Fontaine survived and was taken to a hospital under police guard. The *Washington Post* melodramatically recorded the wounded woman's words as she was being wheeled into the operating room: "'Big George'—gasped Mrs. Fontaine, calling the nickname of sweetheart of William B. Phillips, the tattooed gunman who was slain in a pistol duel...as she struggled for life."[202]

Throughout her brief notoriety in the months that followed, Fontaine was careful to paint herself as an innocent girl who was swept up in the gangster life. A newspaper photograph of Fontaine in her hospital bed, dramatically

clutching a rosary, was captioned: "With a bullet in her lung, this poignant photo shows lovely Mrs. Lenore Fontaine, an innocent member of the Mais-Legenza gang, who was put on the spot for fear she may talk. After winning her desperate fight for life, she talked—plenty."[203]

Less than a month later, another of the Tri-State Gang's liabilities was silenced forever when Morris Kauffman's body was found slumped behind a boulder in the Squirrel Hill section of Philadelphia. Kauffman had one bullet hole through the palm of his hand—in the last moment of his life, he must have tried to ward off the inevitable—and two bullets in his head. A news account of Kauffman's death stated that he was linked with Philadelphia's "Meadows Mob," and the chief of the Secret Service called him "a known machine-gunner and hijacker."[204] One account said that he was "muscling in" on local gangsters and that is why he was given the classic one-way ride. More likely, it was Kauffman's argument with Legenza that had left two witnesses tied up in the cold January woods that sealed his fate in Philadelphia five months later.[205]

By May 1934, the Tri-State Gang was gone from Richmond, leaving behind an apartment at 15 North Henry Street that had been shared by William Phillips and Walter Legenza (then known by his favorite alias, George Davis). "Dutch" Misunas and Robert Mais had often visited there, but now the place was vacant.[206] The "heat" in Virginia continued unabated. Returning to more familiar haunts—Baltimore, Philadelphia, and New York—the group was now generally referred to as the Tri-State Gang. After William Phillips was killed, the gang was defined as a loose and shifting group that surrounded the core gunmen (Mais, Legenza, and Misunas) with an assortment of secondary players, usually recruited in Philadelphia. Some of them—like James Winn, whose unbelievable testimony shrouded the murder of Madelyne Whelton, or Madelyne's friend, Nylah Roach—played their parts and wisely were not heard from again. Others, like Madelyne Whelton and Morris Kauffman, joined a long list of people killed to ensure their silence, a criminal security tactic that can be credited to the gangland ethic of one man: Anthony Cugino.

Cugino, also known as "Tony the Stinger," was the *éminence grise* of the Tri-State Gang. He was born in 1898, and by 1934, Cugino had risen rapidly and violently through the ranks of his hometown's crime world. He was named "Public Enemy No. 1" in Philadelphia's first formal police bulletin issued in February 1934, locally known as the "murder primer."[207] His role is uncertain in the crimes that Mais and Legenza committed in Virginia. He is never documented as having been seen in Virginia and was never

arrested in that state. However, *The World Encyclopedia of Organized Crime* lists Cugino with his fellow Philadelphians Mais and Legenza as co-leaders of the Tri-State Gang. It also notes, somewhat vaguely, that at one point Cugino "controlled the Tri-State Gang from a distance." In retracing the history of the gang and Mais and Legenza's later activities, it seems obvious that they not only acted with Cugino's help and planning but also adopted his merciless methods of dealing with possible informants.[208] While Robert Mais may have had his moments of doubt, Walter Legenza was perfectly suited to Cugino's straightforward philosophy of cutting off loose ends and eliminating potential liabilities.

"Tony the Stinger" got his nickname from his well-deserved reputation for killing those who posed a danger, even a perceived danger, to the gang, a policy of protection that extended to his fellow gang members. This is not to say that others didn't die by Cugino's hand. Among his victims was a Philadelphia policeman whom Cugino shot in July 1933, as well as John Horn, who, although Cugino had just married, was believed to have been killed by Cugino in an argument involving another girl.[209] In April 1934, Cugino shot and killed a police detective on a New York street. That August, he killed another gang member, Anthony (Musky) Zhangi, who had a falling-out with Cugino over a counterfeiting operation.[210] Among other murders and robberies credited to him, Cugino killed seven people who were either gang members or their girlfriends. Such was the relationship between Mais, Legenza, and Tony the Stinger's murderous ways that even Madelyne Whelton's murder could be added to that list of felonies. Mais and Legenza themselves were apparently the only members of the Tri-State Gang who were completely trusted, and in return, Cugino's true loyalty "lay only with Mais and Legenza."[211]

Like Madelyne Whelton, many of the girls who attached themselves to the men of the Tri-State Gang were regarded as liabilities and threats and were often caught up in a bloody purge. In December 1933, Cugino and Salvatore Serpa were wanted in the shooting of Edward "Cowboy" Wallace and John Zukorsky. The two outlaws were part of a four-man crew wanted for killing a Philadelphia policeman in July 1933.[212] The other two robbers were not identified, but the assumption was that they were Cugino and Serpa. Wallace's bullet-riddled body was found in some woods near Camden, New Jersey. Zukorsky was wounded in the same fusillade but recovered consciousness, staggered out onto a road and hailed the driver of a passing car, who took him to a hospital. Knowing Cugino's methods and terrified of what he knew must be happening in his absence, Zukorsky

begged the police to hurry to a rooming house and save his and Wallace's girlfriends. Rushing to the address, officers found that Ethel Greentree and Florence Miller had already left with two men matching the descriptions of Cugino and Serpa. Three weeks later, the bodies of the two girls were found in a shallow grave in a cornfield in rural Pennsylvania. A postmortem showed that both had been shot; one of them had been buried while still alive.[213] "The Stinger" had just cleaned up two more loose ends.

Serpa himself was dead by the following July, having been "taken for a ride," killed, and his body dumped into a Chicago street from a moving car. When the police turned Serpa's body over, they found that he had been stabbed in the skull with a sharp instrument. Cugino was again credited with Serpa's elimination, ensuring one less leak, one less "rat" to worry about.[214] The two girls lying in that shallow Pennsylvania grave and Serpa's vicious murder in Chicago, with a dagger to the brain, demonstrate how Anthony Cugino earned his fearsome reputation and underworld moniker.

The fact that even under Cugino's close scrutiny Mais's girlfriend, Marie McKeever, was never considered a liability speaks volumes about her determined, hard-boiled nature, making her perfectly suited for the life of a gangster's moll. In late 1934, the desperate duo of Cugino and McKeever began to work together against the clock, beginning another shocking, bloody chapter in the story of the Tri-State Gang.

RETURNED TO RICHMOND

No more was heard of the Tri-State Gang for some weeks after the bullet-riddled body of Morris Kauffman was discovered in Philadelphia. With the news that Robert Mais and Marie McKeever had botched the killing of Lenore Fontaine, the gang had to wonder about her condition and what she might be telling the cops. The answer came on June 5, 1934, when Baltimore police surrounded a cottage on the northwest outskirts of the city. As they watched, Robert Mais and Walter Legenza drove up in an automobile. Police called out for them to surrender, but instead of stopping, Mais mashed on the accelerator. The careening car was riddled with bullets, shooting out all the windows and one tire. The two gangsters leaped out and ran for the nearby woods, but Mais was caught in a burst of submachine gun fire and fell with six bullets in his back and arms. Legenza emerged from the bushes nearby, his hands raised.[215]

When he arrived at the hospital, seriously wounded, Robert Mais was told that he would probably die. Police tried to interrogate him, but he only gasped, "Somebody please tell my mother," and gave her address on Brewster Avenue in Philadelphia. Mais was kept alive in the next critical hours by blood transfusions. A Baltimore policeman named Busick gave blood for a first transfusion and offered to give blood again when Mais's condition worsened.[216] As Mais clung to life, Legenza (booked under the name George Davis) and Marie McKeever, whom police found in the rental hideout, were taken to the Baltimore jail. A search of the cottage where the trio had been staying yielded four automatic pistols and two Browning

automatic rifles, stolen from a National Guard armory in Hyattsville, Maryland, the previous weekend.[217]

In an attempt to defuse any prior testimony by Lenore Fontaine, Marie McKeever agreed to make a statement almost immediately. She claimed that she and Mais had not harmed Fontaine but rather that Fontaine had shot herself.[218] This story echoed Madelyne Whelton's grunted assertion to the Richmond police as she bled to death that she had shot herself in the belly. While McKeever cobbled together a story, three cities—Washington, Richmond, and Upper Darby, Pennsylvania—all filed papers with the Baltimore police for custody of Mais and Legenza,

Marie McKeever, "Wanted" poster photograph, 1934. As Robert Mais's girlfriend, McKeever witnessed her share of murders, shootings, robberies and narrow escapes. In the end, she remained the only core member of the Tri-State Gang who was not jailed, murdered, or executed. *R. Pry Collection.*

no doubt based on information provided by Fontaine. Federal warrants were taken out for Herbert Myers, Arthur Misunas, and John Kendrick. Meanwhile, Baltimore police worked to link Mais, Legenza, and McKeever to holdups at the Globe Brewery, the Maryland Biscuit Company, and a bank in west Baltimore.[219]

Richmond Police Captain Alex S. Wright noted that gangsters from the North now tended to congregate in Richmond, hiding at various nightclubs on the outskirts of town. He did not mention Club Forest, but he did say that Herbert Myers (Madelyne Whelton's boyfriend, "Herbert Brooks") was a part owner of the club.[220] Furthermore, it was revealed that Myers had also killed a Baltimore gambler named Frankie Lample in 1932. Wright said that Myers and fellow gang member John Allen Kendrick had acted as bodyguards for "Red" Wynne, another notorious gambler who operated out of Club Forest.[221]

Back in New York, Herbert Myers—the apparently nice young man who had first so impressed and later frightened Madelyne Whelton's father the

previous year—was found by the police. New York police shot Myers in the stomach outside his wife's apartment door, and he was taken to the prison ward of Fordham Hospital in the Bronx.

The quiet, tree-lined streets of Richmond must have seemed like another lifetime to Myers, once termed the "broker" of the Tri-State Gang.[222] Gone were the pleasant strolls, window-shopping on Cary Street where Madelyne lived, movies at the nearby Byrd Theatre with Madelyne on his arm and, of course, the action at Club Forest. All gone. There was nothing left for Myers in his sweltering hospital bed other than a lingering death, and he welcomed the end. Myers refused to let doctors remove the bullet from his abdomen or give him a lifesaving blood transfusion. He knew that if he survived, all the crimes he had committed would lead only to a death sentence. Instead, in the best Hollywood gangster tradition, Myers simply told the doctor and police officers, "Let me die." They did, on July 21, 1934.[223]

On August 1, 1934, Henrico County police officers stopped a car outside Richmond and questioned three South Carolina men inside. Searching the car, police found guns, deputy sheriff's badges, spare license plates, handcuffs, and other "paraphernalia." The trio was housed in the Richmond jail pending an investigation, but readers of the city's *News Leader* gathered that some new horror in the city—a robbery or a shooting—had been averted.[224]

The summer's heat in Richmond was front-page news by late July 1934, and the *News Leader* reported more than eight hundred deaths nationwide from the heat wave. Damage ran in the billions of dollars in the Midwest, where temperatures were expected to reach 117 degrees Fahrenheit.[225] In a Richmond newspaper article, the severity of the heat shared first-page space above the fold with a photograph of John Dillinger's coffin being loaded into a hearse for its return to his family in Indiana.[226] Perhaps even more riveting to Richmond readers than the coda to Dillinger's career and the almost inescapable heat was the announcement of the arrest of Arthur "Dutch" Misunas in San Francisco and his subsequent extradition.[227]

Misunas later claimed that he had left the Tri-State Gang in April and gone to San Francisco, intending to "go straight," working as a counter man in a restaurant that he was operating with his mother. "I was trying to make an honest living when the officers got me," the big gunman declared. "I had made up my mind to have nothing more to do with the gang." According to the innocent-sounding account given by Misunas's wife, it was only when she and Misunas visited Reno in June that they discovered that he was wanted for crimes in Washington, Baltimore, Philadelphia, and elsewhere.[228]

When interviewed in San Francisco, "the burly gangster" said that he was "forced" into a life of crime because of hard luck and the Depression. He was living in Atlantic City when he planned his first heist: his wife was ill, and he needed money to pay doctors' bills. He also freely admitted that it was he who shot the mail truck driver at Washington's Union Station the previous December.[229] Despite Misunas's claims that he had moved to California and quit his life in the underworld, his old pals back east apparently didn't forget about him. The word in criminal circles said that Misunas's location on the West Coast was provided by unnamed "underworld enemies" in Baltimore.[230]

Misunas was described as "a large, florid man, [who] appeared unperturbed as he posed for photographers in Commonwealth Attorney [T. Gray] Haddon's office."[231] Newspaper photographs taken at the time show Misunas wearing a double-breasted suit, his light-gray eyes gazing directly into the camera as he smokes a cigarette. A close look at his left hand reveals two things: an anchor tattoo at the base of his thumb, and a gauze bandage protruding from his left jacket sleeve. The anchor was likely a souvenir of his service in the Merchant Marine; the bandage marked his suicide attempt on the train taking him back to Washington. Officially, the gangster was suffering from a "skin infection," but it was later learned that he had slashed his wrist with a safety razor on the train between California and Chicago.[232] Misunas had used a razor concealed in his pants cuff, perhaps put there for just such an eventuality. After being treated for the cut in Chicago, Misunas was put back on the train and continued east. On the way, he opened up to the detectives who accompanied him and made a full confession about his involvement in the Tri-State Gang.[233]

In a calm voice, Misunas began to talk to his escort about his involvement in the robbery at Broad Street Station. Legenza (still being referred to as William Davis) was the one who shot Huband, Misunas said. He called Legenza "crazy." Misunas said that the crew at the Broad Street Station robbery included Davis (Legenza), Mais, Kendrick, Phillips, and Kauffman. All were named as the men who, along with Misunas, waylaid Huband's Federal Reserve truck in the twilight of March 8, but Legenza was definitely identified as the triggerman.[234]

Meanwhile, Robert Mais spent six weeks in the Bronx hospital, recovering enough to be taken to trial.[235] As Misunas made his cross-country confession, the Maryland attorney general signed extradition papers for Mais and Legenza to be returned to Richmond.[236] Orris Garton, a detective sergeant with eleven years on the Richmond police force, recalled that "Richmond Judge Haddon came to me and Sergeant Bosquet and told us, 'I want you

to get to Baltimore just as quick as you can and use all precautions in the world in getting those fellows away from there.'"[237]

On July 26, the two gangsters were put on a train from Baltimore to Washington, the first leg of their ride to the Richmond jail. Richmond officers Garton and Bosquet must have been impressed with the escort—a special squad armed with riot guns and submachine guns—that met them and their prisoners at the Baltimore train station. Garton handcuffed Legenza to the wounded Mais, who was not likely able to run. The Baltimore officers sat on the train, carefully regarding Mais and Legenza until the last minute. Only when it

Arthur "Dutch" Misunas waits to testify against his former fellow gang members, Mais and Legenza. Note the bandage on his right wrist covering his attempted suicide while he was being returned to Richmond for trial. *Dementi Studio, Richmond, Virginia.*

started moving out of the station did they swing off onto the platform and leave officers Garton and Bosquet with their new charges.[238]

Garton was especially interested in finally seeing Mais and Legenza in person because he had been working the case since the Huband shooting in March. In the course of his investigations, he had talked with Lenore Fontaine, who had cautioned him that both men had guns with them at all times and were ready to shoot anyone who attempted to stop them. "She did warn us," recalled Garton, "in fact, we were warned by everybody that we had any contact with relative to these fellows about them being dangerous and that was for our benefit."[239]

Once the train arrived in Washington, a special squad of Thompson-carrying police officers formed a squad car convoy that sped to the jail in Alexandria. There, Mais and Legenza were housed in separate cells at

different ends of the tier and were watched constantly by Alexandria officers, while Garton and Bosquet went off to find lodging for the night. The following morning, another escort by the Alexandria police took Mais and Legenza to Union Station. Garton recalled that neither of the handcuffed men sitting opposite him on the train had much to say, but Legenza was the less talkative of the two. The detective had been somewhat unnerved by Legenza sitting silent and perfectly still, with his eyes half-closed.[240] Garton, determined to get some reaction from his taciturn prisoners, waited until the train stopped briefly at Broad Street Station and motioned out the window to the overpass above the tracks. "That's where you killed your man," he pointed out. "They did get a little nervous and pale," recalled the detective, "but they didn't say anything."[241]

Richmonders had their first look at the gangster pair arriving at Main Street Station the following day when a photograph of the two ran in the *News Leader*. Legenza, bareheaded and handcuffed to Mais, looks ahead resolutely, his eyes appearing white in the camera's flash. Mais looks toward the camera with a slightly worried but level gaze, showing no sign that he had been shot six times with a machine gun. Like all the policemen surrounding the prisoners, he is wearing a straw boater hat, the requisite headwear for men during the summer's heat in the American South.[242]

When the two were finally taken the few blocks from Main Street Station to the Richmond City Jail, local police examined them and sized them up. According to the newspaper report, "'Mais and Legenza, who were brought to Richmond from Baltimore yesterday, are lodged in a special cell at the city jail. They are not allowed to receive visitors or communications from the outside, and precautions have been taken to prevent their under-world friends from attempting a jail delivery,' Police Chief R.B. Jordan said."[243] Captain Wright was not impressed, either. "Uncouth and inexperienced" were the words he used to sum up the two Philadelphians. Wright said that Huband's killers were "jittery amateurs" who became excited and shot the truck driver before he had a chance to react. The noted Richmond criminal attorney Charles W. Moss was hired to represent the two gangsters when Legenza went to trial on August 13.[244] Moss asked for a delay in the trial, claiming that he had little time to prepare, but his request was denied. Interestingly, Moss did not indicate exactly who was paying for his legal services—Mais and Legenza themselves or "outside sources."[245]

Meanwhile, "Dutch" Misunas and Lenore Fontaine were ready to bury the surviving members of the Tri-State Gang with their testimony. For his part, Misunas believed that making a full confession was the only thing that might

save him from sharing a trip to the electric chair with Mais and Legenza. Fontaine was happy to testify to the gang's crimes as revenge for their having shot her and left her for dead in Pennsylvania. As a Canadian newspaper predicted for Misunas and Fontaine, "Between his confession and Mary Elizabeth [Lenore] Fontaine's story, Mr. Mais and Mr. Davis are on their way now to what the underworld euphemistically calls 'the hot squat.'" The newspaper added paternalistically, "[T]hen Mary Elizabeth can go home to peaceful Canada."[246]

In the gangster movies of the day, several visual conventions expressed the violence of gang warfare in cinematic shorthand. One was a close-up of the muzzle of a machine gun producing a roar of smoke and muzzle flashes. The other was the thrown bomb that blows out the entire façade of a store or bar with a flash and a roar, as glass and wood erupt into the street behind a fleeing sedan. Imagine, then, the shock of a gang-related bombing as the next affront to Richmond, just as the alleged criminals are behind bars, their gang destroyed. The bomb's message was that other men and other criminal forces were still abroad in and around the city. Suddenly, bombings no longer happened in the dark of a Broad Street movie house; they were now a reality in Richmond.

The Club Forest had been closed for some weeks while Legenza was on trial, but Joseph C. Herbert, the new owner, planned to reopen the Goochland County "resort" by Labor Day. Two of the club's employees—Edward Bailey, a cook, and Buddy Williams, the watchman—remained with the new owner and stayed at the club overnight while it was still closed. On the night of August 1, masked men prodded the two men awake with shotguns. Bailey and Williams, wearing nothing but their underwear and shoes, were told to run for the woods and not look back.[247]

Williams said that he had gotten about fifty feet from the building when he heard a thunderous explosion behind him, turned, and saw Club Forest engulfed in flames. Soon, there was nothing left but the charred pink stucco walls. Predictably, Joseph Herbert was unable to supply an explanation but hastened to add that he knew of no connection between the bombing and the trials of Mais and Legenza.[248]

The attack on Club Forest seemed a signal to Herbert and all concerned to keep quiet. Many thought that the violence, especially the timing of the bombing, may have been directed at Lenore Fontaine and "Dutch" Misunas, who was housed in the Henrico County Jail, biding his time before testifying. The *News Leader* reminded its readers, "It was pointed out that the story of the bombing of the vacant resort appeared in the newspapers at exactly

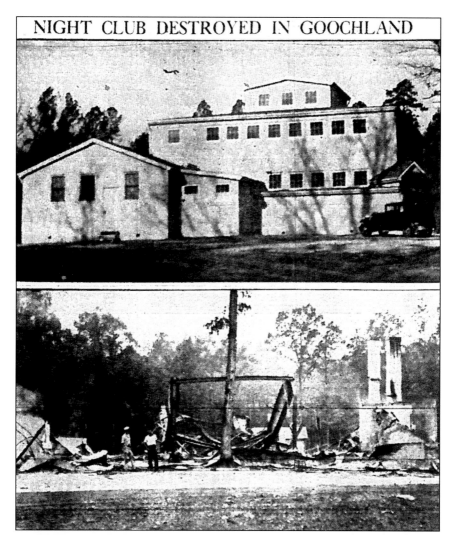

NIGHT CLUB DESTROYED IN GOOCHLAND

Before and after newspaper photos of Club Forest. The men who dynamited the popular Prohibition-era nightspot were never found, but the destruction of the Tri-State Gang's Richmond headquarters was seen as an attempt to influence witnesses for the prosecution and thus affect the outcome of Mais's and Legenza's murder trials. *Author's collection.*

the psychological moment, and that its demolishing entailed very little risk, whereas any attempt to reach the two witnesses would bring about almost certain capture."[249] Others theorized that the new owner, J.C. Herbert, may have been approached for money to pay for Mais and Legenza's defense but refused, and that was why the club was blown up.[250] The extensive dance

hall and poolroom complex was never rebuilt, and the Goochland woods eventually reclaimed what was once called "one of the gayest resorts in the vicinity of Richmond."[251]

Meanwhile, Charles Moss, Legenza's attorney, desperately fought for postponement while trying to produce three witnesses who would testify that Legenza was in New York at the time of Huband's murder. One was the manager of a hotel, who was expected to testify that Legenza was a guest there when the murder took place; two others would testify that Legenza was having dinner with them on March 8 at the time of the holdup. Without these witnesses to tell their story, Moss said, Legenza would be seriously handicapped in his defense. "When the life of a man, and the integrity of Virginia laws are at stake," Moss said grandly, "I felt justified in asking for a postponement."[252]

Nothing was going to stop Lenore Fontaine from testifying against her late boyfriend's former gang members, and the leveling of a nightclub in rural Virginia was not going to weaken her resolve. She had been kept in a secret location in Washington and, just before the trial, was being driven to Richmond by official escort to ensure her safety. During that trip on August 13, both Fontaine and the two guards were injured when their car turned over on Route 1, north of Richmond in Hanover County. The U.S. postal inspector and Washington policewoman who were in the car were sent to Johnston-Willis Hospital and treated for cuts; Fontaine, who was only bruised, remained as determined to testify as ever.[253]

The Commonwealth's other star witness, Arthur "Dutch" Misunas, confirmed through his wife that the bombing of Club Forest was gang-related. After her husband's arrest in San Francisco, Mrs. Misunas pawned her engagement and wedding rings to pay for her trip to Richmond. She said she was fearful that her husband would either be sent to the electric chair for his role in the Huband killing or else would be killed in jail for turning state's witness. The frantic Mrs. Misunas told the *News Leader* that she understood that underworld friends of Mais and Legenza might "put her on the spot" if she talked but that she was willing to testify about the gang's activities if it meant a lighter sentence for her husband. "The club still would be there," she said of Club Forest. "Nothing would have happened at all. It was because Arthur is sitting in his cell, and Arthur will have to take the stand at the murder trial…and Arthur knows too much, and has talked."[254] When asked if her husband knew who bombed the club, Misunas's wife shook her head, and "her eyes filled with fear." As she was quoted, "I came here to help my husband in every way I can. If I talk, something may happen to him—or to me," she said. "Our lives already have been threatened."[255]

The chief of detectives for the Washington police dismissed the idea of any threat on behalf of Mais and Legenza, saying that he believed all the principals of the Tri-State Gang had been captured and the danger was past. "Of course, there may be little fellows," he said reassuringly, "but as far as we are concerned, the mob has been pretty well cleaned up. We've got everybody we want in the case."[256] The citizens of Richmond were not feeling as sanguine as the Washington chief. In her interview, Mrs. Misunas, obviously frightened, continued to suggest the presence of other, unnamed "friends" of Mais and Legenza. The glaring headline in the Richmond newspaper, "Misunas Hints Gangmen Behind Club Bombing," unmistakably put Richmonders on edge, and the burned, collapsed walls of Club Forest only confirmed their fears.[257]

A criminal element was surely moving in and around Richmond, protected by the knowledge of what these men had done in the past and could do again. Newspaper coverage in Richmond wove a fabric of fear, from Madelyne's own reluctance to tell authorities who shot her, even as she bled to death, to her father's bland reaction to the suspect, the false testimony that defused the inquiry into Madelyne's murder, the cool reaction of the owner of Club Forest to the bombing (saying it had nothing to do with the upcoming trials of Mais and Legenza) and the naked terror of Misunas's wife, torn between her knowledge of the gang and her fear for her husband's welfare. The effect was to create, in the public's eye, a nameless, faceless power in the city, operating with impunity and beyond the law.

LEGENZA ON TRIAL

Old City Hall, a stately granite structure, is one of the few Richmond buildings still standing that was well known to Walter Legenza and Robert Mais. When the two gangsters first saw it in 1934, City Hall had already housed both city offices and courts for forty years. The Hustings Court, on the second floor, tried major offenses in the city of Richmond; the Police Court, in the basement, often operated all night and adjudicated petty crimes.

Mais and Legenza would have been brought into the building by way of the Police Court entrance under the eastern stairs of City Hall and from there walked to the elevator, no doubt held for them by the operator and a policeman. On the second floor, the visitor today can make the same left turn from the elevator, walk along the arcade around an ornate central atrium, and then continue on to the doors of what was once the Hustings Court. It is not hard to imagine Legenza, loitering under guard outside those doors, smoking a cigarette and perhaps chatting with reporters. No doubt he was scanning the building as he smoked, always making mental notes, looking for a break, a weakness, an out. His guarded glances would have invariably fallen on the long stairway to the first floor in front of him, knowing that he'd never make it down all thirty-four steps before somebody stopped him—or shot him in the back.

Mais, always edgy but stooping in pain from the wounds in his back, may have shot a glance upward at the building's ornate interior. The two accused men, manacled together, would have been surrounded by a tight group

of guards as they waited for the elevator. Legenza, however, would not have wasted his time scanning the rococo surroundings. Years of being escorted down corridors, up stairs, handcuffed and then uncuffed would have left him well practiced in the drill of being transported under guard. His pale, unflinching eyes did not record the scenic or the sentimental; he had no time for anything but business.

As his trial got underway, Legenza sat motionless, eyes fixed on Lenore Fontaine on the witness stand. A court reporter noticed his unflinching focus: "[A]ll the while Legenza, impassive for an occasional nervous twitch of his right eye, looked stonily at the witness…. His face was pale. But his blue eyes were expressionless."[258]

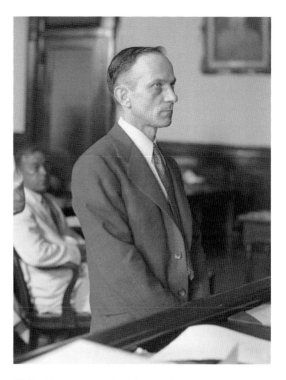

Walter Legenza stands before the judge, in August 1934, during his trial for murder in the Richmond Hustings Court, in present-day Old City Hall. *Dementi Studio, Richmond, Virginia.*

Unaffected by Legenza's withering stare, Fontaine was described as a "slender 'gang girl' and confessed sweetheart of a slain mob leader."[259] Her testimony came in a thick French accent, to the point that members of Legenza's defense team complained that they couldn't understand her.[260] Fontaine recalled how she had first met members of the Tri-State Gang. She met the gang's leader, William "Big George" Phillips, at a New Year's Eve party in December 1932 and met Legenza in Brooklyn in September of the following year. Fontaine first saw Arthur Misunas at the house in Crystal Beach, Maryland, and met Mais in Richmond and Morris Kauffman at the Club Forest, after her first trip to Richmond in December 1933. She stated that she, her boyfriend Phillips, and Walter Legenza later rented an apartment at 15 North Henry Street. From 1933 to 1934, Fontaine often

traveled between Richmond and Washington, D.C. She and Phillips were in Washington on March 2 when Legenza, Mais, and Misunas arrived, saying that they had to leave town in the wake of the $60,000 robbery in Richmond on Ninth Street. There had been too much police attention, and it wasn't safe to stay there.[261]

On one of the return trips to Richmond, she testified, Legenza, Mais, and Fontaine went to the Railway Express office behind Broad Street Station. Turning north from Broad Street, they would have driven up the incline to the overpass above the tracks, passing through what would be the scene of the ambush and Huband's murder only a few days later. At the express office, Legenza went to the counter to mail a package and pointed out to Mais a truck that pulled up with "Federal" on the side. Fontaine identified Benjamin Meade, Huband's assistant, as the man she saw unloading the truck. Mais and Legenza stood to the side, she said, watching him and counting the mail satchels.[262]

Then, she said, she and Phillips returned to their Washington apartment. On March 8, Mais, Legenza, and Phillips all left early in the morning and did not come back until after eleven o'clock at night. Mrs. Misunas came over and stayed with Fontaine until the men returned. The two women were listening to a radio broadcast about the holdup and murder in Richmond when Legenza and Misunas came in. Legenza walked straight to the radio and snapped it off. "His face was very white," recalled Fontaine. "He asked me for a cup of coffee."[263]

Fontaine was careful to imply throughout her statements that Legenza was the leader of the Tri-State Gang.[264] She also lied on the stand and tried to implicate Legenza in the $60,000 holdup on Ninth Street. Legenza, Fontaine testified, told Phillips that he was one of the robbers in that job a week before the holdup at Broad Street Station. Legenza knew Fontaine well, having shared numerous apartments with her and spending hours in the car with her on the highways across Virginia, Pennsylvania, and Maryland. Now sitting in court in Richmond, staring stonily at her, he must have realized that this woman would say anything to ensure his execution in Virginia's electric chair.

Lenore Fontaine was a formidable young woman. She had left her husband in Canada and fallen in love with a member of one of the most vicious criminal gangs of the day. In the past year, she had been a witness to the planning of several robberies and was connected with the murder of Huband. Perhaps she had also met the Philadelphia gangster boss Anthony Cugino and heard of his vicious treatment of real or perceived traitors.

Fontaine had seen her boyfriend killed by police, had been shot in the chest and left for dead in Pennsylvania, recovered, survived an automobile accident, learned that a building was bombed where she once danced with her gangster pals, and now sat face-to-face with a man whose violent death she was hoping to ensure. She knew, without even looking at Legenza, that if he could, he would readily kill her with his bare hands. She also knew that if he somehow survived he would make sure that she was killed in revenge. Lenore Fontaine wasn't fazed in the least by anything that had happened so far, and she made sure that her testimony, even in faulty English, was complete and damning.

Lenore Fontaine had moved many times and was used to a life of cheap motels and apartments, droning along down narrow highways, and stopping at barbecue stands, roadhouses, and beer joints outside so many East Coast cities. With the death of her boyfriend, however, the excitement fell away. But more than that, she became a liability to the Tri-State Gang. "After Phillips was killed, I had to do what I was told."[265] The newspaper reporters covering the story loved the hard-luck bad girl with the French Canadian accent.

In a feeble attempt to link Fontaine with the Broad Street holdup, the defense tried to discredit her by accusing her of masquerading in Virginia as a man. She admitted that she had once hitchhiked to this country from Canada and visited Virginia on that trip. However, "I did not wear men's clothes," Fontaine stoutly replied. "'I wore trousers, but they were not men's clothes. They were women's clothes,' she said with some spirit."[266]

The cross-examination also attempted to impugn both Fontaine's testimony and Misunas's by painting them as lovers. Asked if she and Misunas had not once been sweethearts, Fontaine flared up. "Dutch Misunas? I should say not!" she retorted and then smiled as if amused by the idea.[267] She did concede that Phillips had once slapped her for dancing with Misunas at Club Forest, but that was the only admission the defense managed to wring out of the pretty, hard-boiled Lenore Fontaine.[268] "The jury and court were greatly entertained throughout Mrs. Fontaine's testimony," reported the *News Leader*, whose reporter was among those charmed in the courtroom. "She seemed to make quite an impression on the audience."[269]

Misunas's reaction to his dismissal out-of-hand by Fontaine was not recorded, but newspaper coverage of his testimony noted that "big, florid Arthur Misunas, known as 'Dutch' to his companions, next took the stand and produced the dramatic fireworks of the day when he described the hold-up and named Legenza as the man who shot and killed Huband."[270]

Nothing more was said of Misunas's slashed wrist, but neither did he attempt to hide the bandage that could be seen from his coat sleeve. Whether his attempt at suicide was the work of a genuinely remorseful criminal or a ploy for sympathy will never be known. Still, Misunas comes across as both utterly pragmatic in his criminal trade and having at least a dim sense of honor.

In his testimony, Misunas states that he met Legenza (whom he knew as George Davis) and Phillips in Baltimore in August 1933. He said he only met Mais and Kauffman later, in December. When Misunas made a remark about coming to Richmond to rob a cigarette truck with the gang, Haley Shelton, assistant for the defense, leapt from his chair and asked for a mistrial. With Shelton overruled, Misunas continued his testimony, recalling how he pitched in $100 to buy a truck loaded with empty egg crates that would be used for the getaway from the robbery they planned for Richmond.[271]

On the day of the holdup, Misunas said that he and Kauffman rode from Washington to Richmond on the train, no doubt getting off at Broad Street Station and within sight of the overpass where the robbery would take place later that day. They met the others at a restaurant on Broad Street, where he and Mais switched coats. Misunas needed a long overcoat to conceal his Thompson submachine gun—not for the purpose of shooting, he hastened to add, but for "intimidation."[272]

Mais drove the car that blocked Huband's truck on the overpass. Phillips waited in the getaway car, and Misunas was stationed on the bridge with Legenza and Kauffman. When the Federal Reserve truck came to a halt, the three of them rushed the back of the truck and yanked open the doors. Misunas said that he saw Huband stoop down for the parking brake, and Legenza thought he was going for a gun and shot him in the head with a .38 revolver.[273] But that testimony was weak, as Huband was shot in the right side of the head as he looked over his right shoulder toward the rear of the truck.

Misunas knew that his own testimony would determine if he was going to the electric chair with Mais and Legenza, and in his desperate attempt at being earnest, the big gangster clearly became emotional on the witness stand. Misunas still had no assurance that he would earn the court's leniency, and under cross-examination, the big gangster insisted that the confession he made on the train from San Francisco was voluntary. "In one dramatic moment, he assured the jury solemnly that he 'wanted to get the whole business off his mind…I've told the whole truth, so help me God,' he said dramatically, clutching his knees with both hands. His face was working with

emotion. 'I'm man enough to stand up and take anything they give me,' he went on. 'I'll take the whole consequences.' A moment later he said, 'I'm not afraid of death.'"[274]

Misunas then continued to recount that, after the robbery, he took Legenza aside and asked him why he shot Huband, and Legenza replied it was because Huband reached for his gun. Misunas replied that he was disgusted with their violent ways and was through with the gang, and also that he and his wife then walked out on being any part of the Tri-State Gang. Aside from seeing Mais and Legenza during their trials, Misunas and his wife never saw the other gang members again.[275] Misunas told the court that Legenza "turned yellow" the moment he had a gun pulled on him and that is why he shot Huband. "I'm not a killer," explained Misunas, who glared at Legenza, "who was regarding him with steely eyes." Misunas said, "'I've never wanted to kill anybody'…. Again, his face was working with emotion. He was obviously much wrought up."[276]

To counteract Misunas's testimony, Robert Mais and Marie McKeever attempted to save Legenza by discrediting Misunas and making him out to be Huband's killer. McKeever swore that Misunas told her that he was the triggerman in the holdup at Washington's Union Station, where a guard was wounded, and that he was the one who shot Huband in Richmond. Mais testified that Misunas had visited him at his mother's home in Philadelphia, saying that Misunas urgently wanted to borrow money from Mais. He had shot a man in Washington and killed a man in Richmond and needed money to get away.[277]

Under cross-examination by Richmond prosecutor T. Gray Haddon, Mais admitted that he had made several "business trips" between Washington and Richmond and carried a pistol because he was "interested in alcohol." Mais said that he first met Legenza at the Union Station in Washington and understood that Legenza was "in the same business." After Mais was dismissed, Misunas was recalled to the stand and vehemently denied he had "confessed" to Mais and said that Mais's story was a complete lie.[278]

Two witnesses from New York were produced for the defense. Thomas Brescia, who operated a restaurant and boardinghouse on Pearl Street, testified that Legenza was eating supper in his establishment on the night of March 8 and couldn't have been in Richmond. He produced a gold bracelet, which he said was given to Brescia by Legenza as a gift for Brescia's wife, which was entered into evidence. Brescia explained that Legenza gave him the bracelet for his wife in appreciation for the credit Brescia had extended Legenza for weeks at a time on his lodging and meals bill. The bracelet was

conveniently inscribed and dated inside "to Clara Brescia, from Thomas, March 7, 1934." Brescia's story was corroborated by William Garber, also of New York, who said that he served a corned beef and cabbage dinner to Legenza on the evening of March 8 and was present the previous day when Legenza gave Brescia the bracelet.[279]

It is interesting to speculate what motivated Brescia and Garber to come to Richmond and give this testimony, which was so clearly false. Mais and McKeever were obviously motivated to save their fellow gang member, and their testimony was transparent. The two New Yorkers, however, had either been threatened or paid to perjure themselves. This is one of the junctures in the story of Mais's and Legenza's trials when the touch of Antonio "Tony the Stinger" Cugino can be sensed. Cugino was capable of producing corrupted witnesses in New York and sending them south to Richmond. Brescia and Garber gave their testimony and presumably returned to their lives in New York, having done their coerced duty in a futile attempt to cloud the prosecution's case before the jury.

Predictably, Legenza sat impassively through the whole trial while his former confederates named him as Huband's killer. Recapping the trial, a Richmond newspaper noted that the courtroom was filled with spectators after the recess for dinner the night before. "Legenza, who had maintained a blank expression throughout the long trial…also relaxed for the first time. He smiled and chatted freely with spectators who came up to talk to him. He said he thought he was getting a fair trial, but believed the newspapers had been 'unfair' in referring to him as an alleged gangster. 'Why do you call me a gangster?' he disingenuously asked a news reporter. 'I'm no gangster.'"[280] Despite the brief conviviality, everyone soon returned to the very serious trial at hand.

Haddon, the Commonwealth's attorney, was assisted by Charles Tinsley, who summed up the evidence in the Huband slaying as "the foulest, most outrageous crime ever committed" and asked the jury to bring in a verdict of death. "If you do not inflict capital punishment in this case," Tinsley thundered, "the electric chair should be abolished in Virginia. It should be removed from the penitentiary and used no more." Haddon also spoke, reminding the jury that "if you believe he was an accomplice in the crime, he is just as guilty of murder as if he had actually pulled the trigger."[281]

Defense attorney Charles Moss, in an impassioned plea to the jury, admitted that the crime was a dastardly offense against society but asked the jury to consider the source of Misunas's testimony: a confessed fellow gangster. Moss continued to impugn Misunas's testimony as having been

bought with a promise of leniency. Haley Shelton, the other defense attorney, also pleaded for mercy. Now Walter Legenza's fate was in the jurors' hands.

The jurors in Walter Legenza's murder trial took little time coming to a decision. After deliberating a mere thirty-four minutes, they reached their verdict: guilty of murder in the first degree. Almost as quickly, Judge John Ingram sentenced Legenza to die in the electric chair. "Legenza, who sat imperturbably throughout the fifteen and one-half hours of his life and death ordeal, betrayed no sign of emotion when the verdict was read." Another account also noted Legenza's demeanor: "Legenza, a thin, dark little man with cold blue eyes, remained passive while the jury's verdict of death was read." His sentence would be carried out on October 22, 1934.[282] Mrs. Huband and her daughters, who had attended the trial of her husband's killer from the beginning, also betrayed no emotion as they filed from the Hustings courtroom.[283]

On August 22, a bold headline announced the guilty verdict in the *Richmond News Leader*, "Legenza Awaiting Transfer to Death House," over an awkward and what proved to be a hugely premature subtitle, "Jury Quickly Writes Finis to His Career."[284] Thanks to a reporter's search of Richmond court records, it was determined with a hint of civic pride that Legenza was the first white man to be sentenced to the electric chair by a completely Richmond jury. "Electrocution was substituted for hanging in Virginia twenty-six years ago and of the 140 persons who have paid the supreme penalty in the chair at the state penitentiary apparently only four were sent there from a Richmond court room."[285]

The Virginia electric chair, built by prison labor, was housed behind the high walls of the State Penitentiary, only blocks away from the courtroom where Legenza was found guilty. If Legenza's execution had proceeded as scheduled, he would have been only the seventeenth white man executed since the chair was first used in 1908. The last white man executed in Richmond had been a murderer in 1927. "Altogether, 152 persons have been electrocuted at the penitentiary." The public was reminded during Legenza's trial that "[o]ne hundred and thirty-six were Negroes, including one woman." The Virginia electric chair had sat idle since the previous October, when Frank Mann was executed for a murder he committed in Nansemond County.[286] There was a peculiarity in the Virginia law, however, and if his lawyers, Moss and Shelton, didn't tell Legenza of this, he could have found this critical piece of information in the newspaper:

Legenza probably will be held under guard at his cell at the city jail for several weeks, it was indicated today. Under section 4942 of the penal code, criminals sentenced to death in the electric chair cannot be transferred to the penitentiary death cell until thirty days before the date of electrocution, and the transfer may be postponed until fifteen days before the date of the death march.[287]

If he were to allow himself a small pang of envy, Legenza may have sighed as he read on the same front page as the news of his electrocution that robbers "working with the precision of a ballet chorus" had ambushed an armored truck in Brooklyn, yielding $427,000, worth almost $7 million today.[288] The wildly successful truck heist stood in painful contrast to the botched holdup Legenza led in Richmond, where a man was needlessly killed, the loot turned out to be worthless, and all concerned were either ratting out their colleagues, had been shot to death, or were facing the electric chair. More likely, however, Legenza probably spent little time reflecting on the Brooklyn heist. He still had a role to play in Mais's trial, and the same people outside Richmond who had attempted to furnish Legenza with an alibi might also have a hand to play.

Once the verdict was delivered, Legenza's defense attorneys immediately submitted appeals on the grounds that the rules of evidence were evaded, and Charles Moss said he would file a bill of exceptions and seek a new trial. At the same time, he and Haley Shelton had to prepare for the trial of Robert Mais, scheduled to begin five days after Legenza's sentencing. [289]

In Goochland County, Club Forest owner J.C. Herbert announced that the club would not be rebuilt as previously planned. Evidently with the successful prosecution of Legenza and in the face of Mais's upcoming trial, the time for a gang headquarters outside of Richmond was rapidly passing. Though the place established by gangster Herbert Myers (aka Brooks) was only open for a year, Myers still frequented the club after its sale to Herbert. According to newspaper reports, members of the Tri-State Gang were known to have used the club as a rendezvous "when they came here from Washington to negotiate deals in bootleg liquor and to plan truck hold-ups and other robberies in the vicinity of Richmond."[290]

But as soon as "Wanted" notices were distributed for Myers, it was the beginning of the end for "the gay night resort." Goochland authorities remained "completely baffled" as to the reason the club was destroyed, and J.C. Herbert said that he had no enemies whom he suspected of the

crime. He also denied that he had been pressed for a "loan" to help fund the defense of Mais and Legenza, or that, upon refusing, his property had been blown up. Herbert, in fact, stoutly denied that he was acquainted with any member of the gang and no doubt wished his connection with nationally famous gangsters and their friends would simply go away.[291]

Chapter 10

MAIS ON TRIAL

O n August 27, a pool of prospective jurors was assembled for the trial of Robert Mais. A panel of jurors, mostly Richmond businessmen, was chosen by noon, scarcely ninety minutes before the trial opened. In contrast to his steely partner Walter Legenza, Mais was in disarray when he appeared in court to enter his plea. Described as "obviously nervous…face is flushed, his eyes were red as if he had been weeping," Mais had come into the courtroom with his police escort and in the company of Marie McKeever, with whom he had a few minutes of privacy in a witness room. McKeever, who was not charged after the arrests in Baltimore, was described as "a striking young woman, who was dressed in a black dress with a big white bow at the neck."[292] When the clerk asked Mais how he pleaded, guilty or not guilty, Mais, in his nervous confusion, repeated the phrase "guilty or not guilty" but quickly pleaded "not guilty" with the help of his lawyer, Charles Moss.[293]

The following day, Mais regained his composure. Perhaps the newspaper reporter was comparing Mais's appearance with the thin, grim Legenza and the hulking and pasty Misunas when he wrote, "Mais, who is only 28 years old and lacking the physical characteristics commonly associated with gangsters, was neatly dressed yesterday and seemed in complete possession of his faculties after his first flurry of nervousness."[294]

The trial of Robert Mais for murder began on Tuesday, August 28, 1934. Haley Shelton, who had acted as Charles Moss's associate in the Legenza trial, immediately invoked the wrath of Judge Ingram with

his attempts to force a mistrial. Shelton asserted that he had the "right to state a false matter on cross-examination." Judge Ingram blasted the lawyer from Goochland County, using the word "fraud" several times: "I don't want to hear that kind of fraud in this court. Sit down. If you state a false matter in this court and let me know, you'll never state anything else here as a lawyer. It is the most outlandish statement I have ever heard from a respectable lawyer. It's enough to make anybody sick."[295] Shelton immediately asked the court to declare a mistrial, maintaining that the judge's

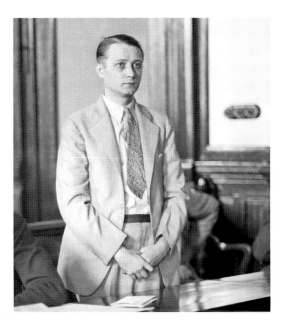

Robert Mais stands before the judge, Richmond Hustings Court, August 1934. The deceptively boyish-looking Mais, in suit and tie, was no stranger to the courtroom. But in Richmond he was far from home—and this time he was on trial for murder. *Dementi Studio, Richmond, Virginia.*

public reprimand of Mais's lawyer was prejudicial to Mais's ability to get a fair trial. Judge Ingram accused Shelton of trying to force a mistrial by lawyerly maneuvering and declared that the trial would continue, making it abundantly clear that Shelton was on thin ice in the Hustings Court even before the trial had barely begun.

Lenore Fontaine was expected to return to the witness stand in Mais's trial and describe how she overheard him tell Marie McKeever the details of his flight from Richmond in the egg truck, following the Huband killing. It was after this conversation, she said, when Mais shot her and left her for dead.[296]

One figure absent during Legenza's trial was Elizabeth Mais, Robert's mother, but she was certain to be there during her son's trial. During a newspaper interview at her room in a Richmond boardinghouse on Franklin Street, Mrs. Mais declared that her son was innocent: "My boy never could have done anything like what they charge him with doing." Although she had come to testify on his behalf, she said that her son told

her he did not want her to "get mixed up in his trial in any way" and recalled how little "Bobby" went to work at age twelve to help his family and his widowed mother.[297]

Little did Mrs. Mais or "Bobby" know how mixed up in his trial she would soon become or the serious crimes she would be jailed for because of Bobby's actions. The confusion and despair over her son's life is best heard in Elizabeth Mais's own voice, captured in the verbatim testimony she later gave before a Richmond grand jury: "My God as my judge. All I know is just from the time the boy was shot that I worried all the time because I didn't want to stay in Richmond, but the boy wanted me to stay here.... I know nothing about their business. I never knowed [sic] anything from the time the boy left home.[298]

Next, defense attorney Charles Moss announced that Legenza would later be testifying in his partner's trial and was careful to conceal exactly what he would say in Mais's defense.[299] Since Legenza had nothing to lose, some people expected that Legenza would "shoot the works" with regard to some witnesses or another sensational crime.[300] Instead, Legenza violently attacked his former friends and gang members out of court, during a jailhouse interview with a Richmond newspaper. Lenore Fontaine, he said, far from being a victim of the Tri-State Gang, was in fact a full accomplice in the crimes for which he and Mais were being tried. Legenza said that she was actually behind the wheel of one of the cars used to ambush Huband and his truck on the overpass near Broad Street Station. Misunas, Legenza said, was a "rat" who had turned against his friends several times and was completely untrustworthy as a witness, being willing to say anything to save himself from execution. It was Misunas, Legenza maintained, who shot and killed Huband.[301] And it was also Misunas, Legenza insisted, who was the leader and brains of the Tri-State Gang.[302]

At some point in his story, Legenza said that he had been "kidnapped" by a postal inspector named DeWaard in Elizabeth, New Jersey, and taken to Washington for trial, which resulted in a ten-year sentence for safecracking. Despite wanting to return to the simpler crime of burglary, six months after his escape from prison in Lorton, Virginia, Legenza found himself sleeping in the back of a car parked in a garage behind Club Forest. "Dutch" Misunas was the one who steered him away from his profession of choice, safecracking, Legenza maintained, and to a higher level of criminality. Lenore Fontaine, said Legenza, was a liar and a career automobile thief who, with her boyfriend "Big George" Phillips, had stolen "hundreds" of cars from the Washington area and sold them in Canada. "I've done a lot

of things, but I didn't do any murder," Legenza maintained, "and the only witnesses they got shouldn't be believed."[303]

While telling his story, Legenza was assisted by Mais and his girlfriend Marie McKeever, who sat behind him, helping him to express himself. Legenza's English was heavily loaded with a Polish accent, to the point that he had a hard time making himself clear. The reporter taking down Legenza's tale took a look at the gangster's partner, who seemed "little more than a boy" as he gazed through the bars, and McKeever patted his arm. By contrast, the reporter noted that Legenza appeared fearless.[304]

As star witness in both the Legenza and Mais trials, Arthur Misunas was still sequestered for his own protection at the Henrico County Jail, only a few blocks from where his former partners were housed. A reporter for the *Richmond News Leader* painted an image of Misunas straight from a Broad Street movie palace poster: "Misunas, broad-shouldered, heavy in build, in appearance is a typical gangster. His empty blue eyes bulge beneath his forehead. His mouth is fixed in a permanent sneer."[305] Misunas had a formidable appearance, befitting his tough life among tough men, both in the Merchant Marine and as a gangster. Neither his involvement in the Washington holdup, where he shot a guard, nor his part in the Tri-State Gang's murder of Huband was in dispute. He seemed to have few illusions regarding his chances at trial if he did not cooperate, throwing himself on the mercy of the court in exchange for his forthright testimony. Misunas repeatedly denied that he had made a deal with the prosecution in either Legenza's or Mais's trials, saying, "If the jury believes I should go to the chair for what I did, I am willing to go."[306] Misunas's fate and his sentence would be determined only after the big gangster's testimony and the conclusion of Mais's trial.

Strategically, any delay in Mais's trial would likely benefit his defense team, especially in view of the lightning-fast pace by which Legenza had been judged guilty. "The Mais trial progressed slowly in comparison with the trial of a week ago, which was completed in 17 hours," explained the *Washington Post*. "The State's evidence was practically the same as that of the Legenza trial, with the exception that the previous trial first sought to prove that Legenza was the trigger man. In this trial it has emphasized that participation in a highway robbery is punishable to the same degree as is murder."[307]

Assistant defense attorney Haley Shelton, following his earlier skirmish with Judge Ingram, again called for a mistrial after Misunas let slip that he had been with Mais on another "job." This comment was against the judge's instructions prohibiting any references to other crimes.[308] Despite

Shelton's objections, the second day of the trial continued smoothly, with the fashionably dressed Lenore Fontaine finally testifying, after fainting the day before.

A newspaper photo from that morning of the trial shows Fontaine in the act of answering the prosecution's questions. "Mrs. Fontaine appeared to have recovered from the attack of 'nerves' that she suffered yesterday while waiting to testify," reported the *Richmond News Leader*. "Dressed in a striped frock in which blue predominated, and wearing a chic navy blue hat, she smiled cheerfully as she stepped into the witness chair. She spoke in a clear, fresh voice, but with a marked French accent."[309] As captured in the newspaper photograph, Lenore Fontaine conveys a certain cynicism in the slightest curl of her upper lip and the arch of her eyebrow. She had good cause to be cynical. In her court testimony, she was forced to travel in her memory back to the little apartment outside Philadelphia, where the drunken Mais almost took her life. She would have again heard Mais's voice as he asked McKeever, "shall I put one in her head and finish her?"[310]

Then it was Marie McKeever's turn to be sworn in as a witness for her sweetheart's defense. She swore that Robert had been with her in a Washington hotel the day of the Huband killing and the robbery of the Federal Reserve truck. She also tried to completely discredit Lenore Fontaine, testifying that Mais did not shoot her. Fontaine, claimed McKeever, had shot herself in a fit of grief after the death of her boyfriend, William "Big George" Phillips. McKeever claimed that Fontaine had spoken of killing herself and on several occasions had mentioned a suicide pact that she had with Phillips.[311]

When Robert Mais himself took the stand in his own defense, he painted an innocent, benign picture of the apartment he shared with Fontaine and McKeever. He testified that he was playing with a puppy in the next room when he heard a shot and that he and McKeever rushed in to find Fontaine shot and lying on a bed [like Madelyne Whelton in Richmond]. He quoted Fontaine crying melodramatically, "Marie, I'm sorry I caused you so much trouble." He emphatically denied shooting the French Canadian girl, testifying, "I have no reason whatever for wanting to kill her."[312]

Mais likewise had his own version of his capture in Baltimore, spinning a tale of police brutality. He said that Legenza had invited him to drive into town, and when he got in the car, he happened to notice that his partner had an automatic pistol. Two blocks from the house where they lived with McKeever, the two men came upon a police roadblock. A Baltimore cop stepped out from behind a truck and aimed a machine gun at them. "I was dumbfounded," recalled Mais from the stand. "Before I could do anything,

the officer began firing. He cut the windshield out of the car with bullets." At that point, Mais said, he and Legenza jumped out of the car. Mais tripped and fell. He said that while he was on the ground a policeman came up and gave him a burst with the machine gun. With his lawyer's help, Mais then stood and pulled up his shirt, revealing the six bullet wounds that had kept him in the hospital for the past several weeks.[313]

Lieutenant Feehley, a Baltimore police detective, followed Mais to the stand and stated flatly that, in contrast to Mais's rather innocent story, he had actually been shot while running away from the car. He added that there had been not one but two pistols: one was found on the ground beside Mais and the other inside the car.[314]

Legenza's testimony during his partner's trial was just as contrived as Mais's had been. He recounted his aversion to firearms in the tone of a workingman whose professional code disallowed that particular tool: "In a stick-up, somebody is likely to get hurt. If you carry a gun, you may be forced to shoot. When you rob a safe, you're not hurting anybody. If you're caught, you can return the money. But if you kill a man in a hold-up he's dead. You can't give back his life. I never wanted to hurt anyone."[315]

An entire lifetime of fabricating falsehoods must have made Legenza a believable liar. The fact that the slightly built gangster with the Polish accent had recounted his entire criminal career probably made his story more credible, at least to the press. "During the course of his testimony," reported the *Richmond News Leader*, "the mild looking little man revealed an amazing record of robberies and 'stick-ups' in which he has taken part."[316] Any sympathy that may have been generated by describing the "mild looking little man" on the witness stand would have been dispelled by a direct look into his dead-level gaze. One glance would be an instant reminder why, despite his claims of innocence, Legenza had been found guilty of murder in the same courtroom only a week before.

As for Lenore Fontaine, Legenza attempted to discredit her testimony by describing her as being in love with her fellow informant, Arthur Misunas, "but I told her she had better leave Dutch alone or he would get her in trouble," Legenza offered in an avuncular tone. He said that he gave Fontaine sixty dollars to spend on clothes for her return to Canada and "a hundred dollar bill to sew in the lining of her coat." Far from being the person who probably urged Mais to kill Fontaine, Legenza tried to present himself as her protector and benefactor. It was only when he was back in New York, Legenza testified, that he had heard "a couple of guys" on the subway talking about Fontaine being shot.[317]

Perhaps Fontaine was determined to turn the tables and ensure Mais's own violent execution though he had failed at hers. Fontaine's time with Phillips and their gang life may have hardened her to the point that revenge was foremost in her mind, and she may have welcomed the opportunity to paint Mais as monstrous as possible for the jury to ensure he got the "hot squat." In the background of one newspaper photo, not twenty feet beyond where Fontaine is shown sitting on the witness stand, Mais sits at the defense table. His straw boater is on the desk where he sits, fingers clasped before him, and he leans forward with apparent concentration. The accused and the prosecution, the spectators and the witnesses, are all dramatically lit by the morning sun streaming through the courtroom's east-facing windows. Mais's face is half in shadow as he listens attentively while the fabric of his life is gradually and inexorably unraveled by his former partners in crime, Fontaine and Misunas. As the day progressed, the machinery of the court ground on, darkening shadows moved across the room, and the last waves of hope drained from Robert Mais like a receding tide.[318]

During the jury's deliberations that afternoon, the men who sat in judgment of Robert Mais all voted for the death penalty—except one. Before the trial even began, W.H. Kelly Jr., a maintenance worker for the City of Richmond, had been confronted by a stranger as he came out of the Shadwell Pharmacy at Boulevard and Broad. The man stopped Kelly on the sidewalk and thrust a note into his hand. He read it. The message was clear: if he was selected for jury duty and voted for the death sentence, the unthinkable would happen to him and his family. "You know what is best for you," the stranger cautioned. "Yes, I guess I do," Kelly whispered. The man snatched the note from Kelly's hands and fled. The next day, Kelly was selected as one of the jurors in Mais's trial.[319]

"I may not have another day to live," Kelly lamented to a reporter after the trial as the jury panel was dismissed. "I'm sorry I served on the jury, and wish I had made some excuse to get off."[320] Kelly had been face-to-face with Mais's "friends," as Mais called them, and believed that they would carry out their threat if the gangster went to the electric chair. The shattered and burned pink stucco ruins of Club Forest were a clear warning to the unwise. Mais, of course, denied that anyone had threatened Kelly on his behalf. Anyway, Mais remarked, J.R. Briggs—who happened to drive through the ambush site seconds before Huband and Meade drove up and who had testified that he spoke to Mais only minutes before Huband's shooting—would have been a far better candidate for coercion. "If my

friends had wanted to hurt anybody," Mais explained, "they would have got to Briggs before he testified that he saw me in the hold-up."[321]

While the Mais jury was still in deliberation, Kelly was confronted by his fellow jurors for his stubborn insistence on a life sentence. In the end, he was forced to admit that his opposition to the death penalty had been coerced. Just the act of threatening a prospective juror could have been grounds for a retrial for Mais. Not only were these faceless gangsters now actually in Richmond, they also seemed perfectly willing to use threats and violence in attempting to influence the court. Mais's unnamed confederates were obviously following the trial closely, and their actions ran from the dramatic (the bombing of Club Forest) to the highly personal (waylaying a prospective juror on the street and corrupting his verdict).

The jury was out for four hours, during which Kelly confessed his stance about the death sentence. In the end, the panel was unanimous. Mais's lips curled into a bitter smile when he heard the verdict read to the court: "We find the accused guilty of murder in the first degree and fix the penalty at death." The ensuing silence in the courtroom was broken by sobs from Marie McKeever, who sat just a few seats behind him in the courtroom. "They're sending me to the chair because I was a friend of Legenza, who already had been sentenced to die," Mais declared, "and Legenza got the rap because he was framed by federal officers who knew he had robbed post offices but couldn't get enough evidence to convict him." "Sure it was a frame-up," Legenza interrupted. "Misunas was lying when he said I was the trigger-man in the hold-up. The Fontaine woman lied, too."[322] Mais and Legenza were returned to the cell they shared at the Richmond City Jail.

In the Henrico County Jail awaiting his own sentencing, Arthur Misunas was trying to think of anything but the electric chair. Among his diversions were interviews with reporters like the *News Leader*'s Paul Donald, who was taken by Misunas's taste in literature. Misunas, probably feeling that he had done about as well as he could to save himself by testifying against his former partners, was in an expansive mood. "A confessed gangster who reads good books is an anomaly," Donald gushed, "but one who prefers the classics to 'this modern tripe,' is a fabulous creature whose existence is almost incredible."[323] Misunas, described as "looking more like an untutored truck driver, or stevedore," had been offered some adventure and light romance books by a Henrico court official. The next day, Misunas returned them with his thanks, asking instead for something a little weightier: "*Plutarch's Lives*, perhaps, or something by Plato or Aristotle."

This was in contrast, the reporter continued, to his testimony against Mais and Legenza, where Misunas "slaughtered the king's English in every sentence. His statements were studded with grammatical errors. Hearing him speak, spectators in the courtroom assumed that he was illiterate."[324] While Misunas disclaimed the value of modern fiction and the virtues of the ancient classics, Richmond's Judge Ingram went to Cleveland for a week, leaving the gangster's fate undecided.[325]

Dr. Paul Candler, an intern serving at the Richmond jail, had been treating Mais's gunshot wounds while the gangster was locked up. He recalled a rare moment of gallows humor that Mais displayed in the days following his trial. "I have been treating Mais for the six machine-gun wounds inflicted by the police who captured him outside Baltimore. Mais still carries this lead in his body and the other day when I had finished dressing the wounds he grinned and asked whether all this lead in his body would short-circuit the current when he was electrocuted in November."[326] Although probably in constant pain, the impression was that Mais was nevertheless still game, fully aware of his desperate situation, and capable of doing something about it.

The police, the newspapers, and the city itself breathed a sigh of relief that two murderous gangsters had been convicted and sentenced to death and that the third was safely behind bars in the Henrico County Jail. Richmond had not, however, returned to that age of innocence it had enjoyed before the arrival of the Tri-State Gang. A newspaper editorial on the day following Mais's conviction reflected the unspoken: Robert Mais and Walter Legenza were not alone, and whatever remaining elements of the Tri-State Gang existed were still operating and making things happen in Richmond. "The trials of Legenza and of Mais have brought to Richmond some very undesirable witnesses," intoned the *Richmond News Leader*. "We shall be glad to see them depart." The sanitizing effect of the electric chair must have appealed to the editor, even if forever ending the story of Mais and Legenza sold fewer papers. "In the opinion of this conservative old community, nothing is gained by temporizing with criminals of the anti-social type…every convicted murderer of this breed should, in our opinion, be sent to the electric chair."[327]

The self-congratulatory tone of the *News Leader* continued with an article trumpeting the upcoming eradication of Mais, calling it a "stern warning to gangsters expecting to find 'easy pickings' in Virginia and other Southern states is seen by Virginia editors in the punishment meted to Walter Legenza and Robert Mais…. The entire Commonwealth was now on alert, and looked to the capital to set a standard of judicial response to crime." The

article also reprinted praise from other Virginia cities. The *Charlottesville Daily*, as quoted in the *News Leader*, found the verdict in Richmond "impressive and salutary...Impressive...because these trials were held at a time when the whole American bar was anxiously considering the question of crime suppression; salutary, because the results speak to cowardly and cold-blooded assassins everywhere in the only language they can understand."[328]

On the page opposite those laurels from around the state was an article about a recent review of jails in Virginia. Many jails are characterized as "high standard" or "clean and well managed." Inspectors who visited the Richmond City Jail in late 1933 and early 1934 rated it: "Improved method and equipment, old dark jail. Medical service satisfactory."[329] That "old dark jail" and its guards, methods, and procedures, all dozing under the Marshall Street Viaduct, would soon be tested.

Chapter 11

THE NEXT MOVE

It was no secret: food served to inmates in the Richmond City Jail was lousy. Even the federal inspectors, who came down on the train from Washington in 1934 to approve the city facility as suitable for holding federal prisoners, said that the food was lousy. They were appalled at what Richmond Sheriff J.D. Saunders stoutly termed "my method of feeding prisoners." Saunders had gone to Washington to talk about the inspectors' problems with the Richmond jail, but in the end he angrily rejected the whole subject. "I was then shown a form," Saunders stubbornly recalled, "that they required of jailers who had federal prisoners in jail. Each one was to have a toothbrush and an independent plate, cup and saucer, and such as that. I didn't read it. I handed it back to them and I told them no, I wouldn't conform to that at all. That was the end of it."[330]

According to Saunders, the inspectors' visit and their unsatisfactory report was simply the result of bad timing: "The last inspector got there and I didn't see him. He got there when we had beans and sometimes beans are cooked all to pieces. Sometimes they are cooked more done than others." Complaints from Washington about the "bean soup," as Saunders termed it, and other jail food provoked an angry defense from Saunders when he was called to testify before the grand jury: "I didn't think they ought to be fed like unfortunate people in alms houses. If they don't like the fare in jail, let them stay away from there."[331]

The bean gruel the inspectors saw and Saunders's unwillingness to conform to federal standards were among the things that led to the condemnation

of the Richmond jail in the inspector's report. Any inmates under federal custody in the Richmond facility were immediately moved to the Henrico County Jail several blocks away at 2117 Main Street.[332] Like the city jail, the Henrico lockup, built in 1893, was also ancient, but for many reasons it was judged more secure and better administered, primarily because the Henrico sheriff made sure that it met federal standards.[333]

Happily for inmates of the Richmond jail, there was an alternative to Saunders's fare, and it was available for sale right inside the building. The sheriff's son, John H. Saunders, ran a small convenience store there where inmates could buy food items. "That is another thing the federal government objected to," recalled Sheriff Saunders with considerable irritation.[334] "They actually went so far," he continued, "this man who made the report, to think that the store was run there and the prisoners fed poorly in order that the prisoners might purchase supplies, something to eat from the store.... They went as far as that."[335]

In his store, John Saunders stocked pies, bread, canned meat, chewing gum, cigars, cigarettes, and Coca-Cola; he made a small profit after paying the trustee who actually ran the store. When asked why inmates should have to buy their own bread, Saunders responded that many wanted white bread, which was served only twice a week. Otherwise the prisoners ate cornbread.[336]

Contraband whiskey was also available, although not from the store. It came into the jail in various ways. At one point, jailer Sheriff Saunders recalled, a bootlegger was discovered pouring whiskey into a hose that protruded from the cracked sidewalk outside the jail, and it was collected in jars in the jail basement.[337] Moonshine was also sometimes available, but most of it was legal, "ABC store" whiskey.[338] For Mais, a former bootlegger, dealing alcohol in the jail must have seemed a natural thing to do. Given his experience in the "alcohol business," he soon had a monopoly on incoming liquor. Lawrence Davis, who was serving his sentence in the city lockup at the same time as Mais and Legenza, described whiskey being brought in by visitors ("there was always a line of people there") or trustees who would smuggle in the whiskey. "The niggers would bring it in their shirt and get up close to the bars and get talking and naturally, being a trusty, they wasn't watched so very close."[339] When Davis was asked, "Did you ever get any whiskey direct there yourself?" he replied, "No sir, I paid for whiskey that come in through the fellow Mais."[340]

Not only was whiskey available at a price, but Richmond's inmates also did not have to put up with jail food or pay the inflated prices for pies and

potted meat in the jail store. Boxes and bags of canned goods were often sent in by mail or delivered to them from outside the jail. Lawrence Davis got food deliveries; so did Mais and Legenza. In fact, Robert's mother would often bring her son packages of food and milk bottles filled with hot coffee. Davis was asked, "Did you ever see any tin cans delivered there to prisoners?" He replied, "Oh, yes, sir. I have got quite a few myself, canned goods and canned food and stuff like that. Who were those cans delivered by? Practically every visitor that would come, if they brought in any food at all, mostly it would be canned goods that they would bring."[341]

None of this lax procedure was lost on Mais and Legenza. Their cell was well stocked with cigarettes, coffee, and canned food rather than the jail swill. They even drank whiskey as they played cards in the evening. As former inmates of jails and prisons up and down the East Coast, the two must have been hugely unimpressed with the Richmond jail, especially after the tight security they had experienced in Baltimore and Alexandria. Their time spent in lockups, jails, courts, and penitentiaries would have given them an accurate gauge of the relative strength of any given institution that held them.

Both gangsters, talking to their fellow inmates for hours on end, must have also heard about the Richmond jailbreak the year before, in December 1933. At a pivotal moment, when jailer A.H. Johnston opened the door to the tier in order to take trash out of the cells, three prisoners assaulted him. One inmate, serving a sentence for murder, grappled with Johnston, while the two others simply rushed by and then ran through the jail's offices, out the front door (secured from entry but not from exit), down the steps, and onto Marshall Street. Herbert Floyd, a deputy sergeant of the Hustings Court, was in the jail office at the time and was astonished to see the two men run through and out the front door of the jail. Luckily, he came to his senses quickly enough to catch one of them several blocks away, near the Mayo's Bridge, and the other was eventually arrested. No doubt Mais and Legenza made careful note of the story and realized how easy it would be to flee the jail once the inner tier doors were opened.[342]

It is not hard to imagine Legenza's blank expression as he robotically went through the motions of incarceration: stand here, put your hands out, wait, move over here, lights out. Behind his impassive expression, he was taking everything in, calculating, making mental notes and gauging distances. He had already broken out of the Lorton jail the year before, so he knew how to reconnoiter and play the odds of escape. He counted jailers, noted their shift changes, memorized the jail's layout, and talked it over with Mais. They listened carefully to the story of the two prisoners who had rushed the jail

doors and escaped, and at that point, Mais and Legenza no longer simply spent their idle hours playing cards. Instead they began to plan their own departure from the Richmond jail.

Whatever the odds of breaking out, they were better than the odds the two men faced if they simply waited for their scheduled executions. The electric chair was waiting for the two Philadelphians only fifteen blocks from where they sat, and it was only a peculiar ordinance that kept them in the jail in Shockoe Valley that prevented them from being moved to the far more secure precincts of the Virginia State Penitentiary.

Gone were the squads of heavily armed professionals that guarded Mais and Legenza before they were returned to Richmond. Their jailers here would have been rejected by any other metropolitan police department. In contrast to the high security of the Baltimore jail, the guards at the Richmond City Jail were almost all uniformly old and unfit. Some were partially deaf and others physically weak. Sheriff Saunders gave an account of each of his employees at the jail, and the roll of partially deaf and infirm jailers was extensive. A.H. Johnston, for example, was a fifty-year-old man disabled from "infantile paralysis" (now known as polio).[343] Saunders attempted to explain that many of his staff (some of whom had been born just after the Civil War) simply performed support and maintenance jobs at the jail. Saunders tried to rationalize his ring of weak jailers by saying, "My deputies down there are not guards," but that he relied instead on the armed personnel in the jail office or the police detailed to the jail for any brute force that kept the facility secure.[344]

Referring to Mais and Legenza, Saunders finally blurted out, "I wasn't expecting anything like this."[345] When asked if he had ever had two criminals like Mais and Legenza under sentence of death in his jail, Saunders's response reveals what the term "gangster" meant in the 1930s: a professional class of criminal, acting as part of a greater criminal enterprise, and usually very violent. "Never had two," Saunders replied. "I have had one on many occasions. I never had as many as two and I never had any gangsters. This is my first experience with gangsters."[346]

Moving discreetly around Richmond, always in the background, Marie McKeever remained an unknown entity to the Richmond authorities because she had not been directly implicated in any crime. After the trials, she was still permitted to see her boyfriend, but it was clear that she had been involved with the Tri-State Gang and that surely she had acted in collusion with Mais and Legenza. But to what extent was a mystery. As

one jail official recalled, "Mr. Moss or Mr. Shelton assured me it was necessary for her to see [Mais and Legenza] about raising funds...for their proposed appeal.... I have since learned that she saw them, but only after being stripped and searched and taken to the jail by Sergeant Sterling from police headquarters."[347]

Lawrence C. Davis, age twenty-four, became Marie McKeever's improbable companion on a trip to Lynchburg to meet someone there. His account of the trip is somewhat disjointed and confused for several reasons, not the least of which is due to his purchase of pint bottles of whiskey along the way. Nevertheless, his testimony may hold the key to who was trying to save the lives of Mais and Legenza, even as they were only days from execution. Davis, who had been serving jail time in the city lockup for several weeks, drank and played cards with the two gangsters and apparently either won their confidence or, more likely, was identified as a dim young man who would do unwise tasks for money.

On September 7, 1934, Lawrence Davis walked down the tier where he had been confined, put his tie back on and strode forward to his release from jail. He had been arrested, as he later put it, "with suspicion of having a stolen automobile in my possession."[348] As Davis walked confidently toward the door of the jail tier, he passed Mais, who called him over and asked him to deliver a note to his mother. Mais gave him twenty-five cents for the streetcar, and Davis found Mrs. Mais on the front porch of her rooming house on Franklin Street. He gave her the note and heard no more of his former fellow inmates until two days later, when Marie McKeever approached him on the sidewalk at Franklin and Second. She asked him if he would drive her to Lynchburg if she were to rent a car, and he agreed.

After several missed meetings and miscommunications, Davis said that he returned to Mrs. Mais's rooming house, where he was given a package and told to meet Miss McKeever at Eighth and Marshall Streets. When he saw her, Davis remembered that he didn't have a driver's license, so his brother-in-law rented the car. Davis bought a pint of whiskey at a store on Lombardy Street and Floyd Avenue for a dollar, and the unlikely pair, Davis and McKeever, finally set off for Lynchburg, heading south across the Mayo's Bridge and west on Hull Street Road.

In recalling his trip, Davis commented that "we went on and the next place we got to was Bueno Vista."[349] The surprised interrogator challenged him: "You went by Amherst? Buena Vista is on the other side of Lynchburg." Davis agreed, "Captain Wright showed me that on his map," he went on, unconcerned that he and McKeever wound up in a town forty miles beyond

Lynchburg. "I don't know how we happened to go that way," Davis stated flatly, "but that is the way we went."[350]

It was late that night by the time they arrived at Buena Vista, on the far side of the mountains from Lynchburg, so McKeever instructed Davis to get two rooms at the hotel there. The next morning, they left for Lynchburg. They arrived at about 8:30 a.m., and Davis was feeling thirsty. "I had about that much whiskey in this pint bottle that I got here in Richmond so I started to drinking it and she told me not to drink it up there, to throw it out. It was [while we were] going into Lynchburg and I threw that out going over a long bridge."[351]

It was raining when they arrived in Lynchburg. Ms. McKeever directed Davis to the Hotel Carroll and told him to wait outside while she went in. When she "finally came back down the steps…there was some gentleman with her, a real nice dressed man, nice looking man. They stopped in the middle of the steps, just enough to keep out of the rain, and I don't know whether they was having an argument or not but anyway when this man finished he kind of hit his hands together like whatever he said was final. He walked on and went in the opposite direction."[352] McKeever came back to the car where Davis had been waiting and told him to wait a bit longer, that she would be back in a few minutes, so he stayed in the car.

Marie McKeever never did come back. Davis got bored and bought a sandwich, then asked a cab driver where he could get a drink. He was directed to a nip joint where he had two drinks, came back, and still no McKeever. After several hours, Davis started back to Richmond alone. At some point, he picked up two hitchhikers and drove with them as far as Farmville, where they bought a small bottle of whiskey and split it on the way back to Richmond. Upon reaching the city, Davis saw a friend named Vaden, who told him that his brother-in-law was worried that Davis (now long overdue in the car rented in his brother-in-law's name) had gotten drunk and wrecked the car. While Davis and his friend Vaden were talking, Vaden noticed the package that Mrs. Mais had given him on the back seat floor of the car. They opened it to discover two old revolvers, one badly rusted with the grip taped together. Davis sold one for a dollar and a bottle of whiskey and then got nervous and threw the other one out of the car at Foushee and Main Streets.

Davis's boozy trip finally ended with a lecture from his brother-in-law, who had to pay for the extra mileage on the rental car. Davis said that he was also threatened by a local Richmond tough, Faye Green, who warned him that he'd better get those two revolvers back or, as he put it, "You have got a couple of guns that a lady left in the car that belonged to some boys in jail."[353]

After that, Davis said, "I didn't hear no more from this fellow, the McKeever woman, or anybody. I never heard no more from the case one way, shape, or form until the Saturday that this accident happened at the jail. I was at 28th and Marshall fixing a flat tire when I heard the first announcement over the radio."[354] No one was more mystified than Davis about the real nature of Marie McKeever's meeting with the "nice looking man" on the hotel steps in Lynchburg. The entire trip was seen through the lens of many bottles of whiskey bought along the way, but even from that blurred perspective, Davis still didn't know why he had simply been left on the street in Lynchburg. "Whether this McKeever woman got out of the car and intended to leave me, I don't know but if she intended to leave me I don't understand why."[355]

Most intriguing is the identity of the man he saw talking to McKeever. This neatly dressed figure who gestured so emphatically with his hands may very well have been Anthony Cugino, operating behind the scenes and at a safe distance from Richmond. A visiting gangster from New York might well have had the stylish appearance that Davis noted and would have stood out on the streets of Lynchburg, Virginia. The rusty revolvers "that belonged to some boys in jail" may have been rejected early on because of their condition. Whatever that dapper man said, it apparently prompted a radical change in McKeever's plans, to the point that she abandoned her drunken driver and found another way back to Richmond.

Anthony Cugino had lost a finger when he was shot during an abortive prison break at the Maryland Penitentiary, so he knew the seriousness of an attempted escape and the possible consequences involved. He was also on Philadelphia's "most wanted" list for his involvement in several murders, so he could ill afford to be anywhere near Richmond and the heat surrounding the trial of his friends Mais and Legenza. Most telling of all was a 1935 newspaper article that noted flatly, "Cugino was reputed to be the real leader of the Tri-State Gang ostensibly led by Robert Mais and Walter Legenza." So if this was Cugino in Lynchburg, he was likely there to help craft a plan to free his comrades.[356]

In their *Complete Public Enemy Almanac*, crime historians William Helmer and Rick Mattix define Cugino's criminal character plainly enough, saying that he was "most noted for the extreme treachery he displayed in murdering some of his own crime partners to avoid sharing the loot."[357] They do not explain his relationship to Mais and Legenza, saying only that Cugino was a "gang leader, bandit and murderer, allegedly affiliated with the Tri-State Gang."[358] The drunken, confused Lawrence Davis may have had the only glimpse, through his rain-streaked windshield, of the man behind the Tri-

State Gang on that afternoon in Lynchburg—a player who directed events through the gang moll Marie McKeever.

On September 26, McKeever was back in Richmond, where she was picked up by police and charged with being "not of good fame." The charges would be dropped, it was explained, if she left Richmond immediately. The "pretty, 34-year-old friend of Robert Mais" had been seen around the city, having street-corner conferences with unknown persons. That activity was suspicious, the police said, but did not involve malice toward the star witness for Mais and Legenza's defense.

McKeever, who had been living for the past month at the William Byrd Hotel, at Davis Avenue and Broad across from Broad Street Station, packed her bags and prepared to leave town. "This is the world's worst." McKeever told a reporter, "They arrested me last night for absolutely no cause. I believe that Robert has a fine chance to get off and I'm doing my best to raise this money for legal expenses." Then she added, in a rather innocent-sounding tone (considering the time McKeever had spent with Legenza in the car, on the run, and in various hideouts), "I'm not so sure about the other man." The Richmond newspaper article about McKeever's arrest pointed out her statement about that "other man," noting that Legenza apparently had to accept his death sentence: "It is understood that appeal proceedings in his case have been dropped."[359]

Back at the Henrico County Jail on Main Street, the burly Arthur Misunas, who had given the most damning testimony about his former gang members, waited for his sentencing. Described as "invariably cheerful," Misunas continued to charm reporters with such behavior as reading the classics, which belied his gruff, thuglike appearance. "Fine footwear is the particular fad of Arthur Misunas," wrote a reporter who saw the prisoner on Friday, September 28. When he was complemented on the shoes he was wearing with his jail uniform, Misunas stooped and ran his hand over the leather. "I bought these shoes in Richmond more than a year ago," the big gangster recalled fondly. "I had them on my feet when I left town. Sort of curious, isn't it, how I picked out this same pair to wear the day they brought me back to Richmond. Yes, these same shoes that took me away a free man brought me back a prisoner."[360] The reporter gushed that there was no more quiet and orderly prisoner in the Henrico lockup than Misunas and credited his cheerful demeanor to the light sentence he hoped to receive in exchange for his testimony.

In contrast to the jovial Misunas, it is difficult to imagine the mindsets of Robert Mais and Walter Legenza as they lived out their days under death

sentences. Both had been convicted in record time after very brief trials. In spite of Club Forest's ominous destruction and the brazen attempt to influence a jury member, their conviction was not unexpected, nor was there any sympathy for them among the general public. Their lawyers, Moss and Shelton, were preparing an appeal, but the inmates had no news of any progress in that effort. They knew the date when they were to be transferred to the State Penitentiary, from which no escape was likely, and they knew that they were scheduled to die a horrible death.

And yet, with their days ostensibly drawing to a close, they continued to play poker and sell whiskey in the heat of the Richmond jail, as though their phantoms had already returned from the State Pen to casually preside over the jailhouse game. Legenza, hard-eyed and unflinchingly pragmatic, listened to the local yokels and small-time grifters and drunks who wound up in the "old Bastille" at the bottom of the hill below the viaduct. One visitor gave a snapshot of Mais and Legenza in jail: "I walked down the aisle to see these people and Legenza was promenading. He was very clean, dressed in a blue uniform, if you will call it that, and clean shaved and promenading the cell from one end to the other in a very deep study, apparently. Mais was in the upper bed."[361] Mais, who still bore bullets in his back, was uncomfortable and often in pain. "Mais was sick," recalled the jail's storekeeper, John Saunders, "He was all crippled up with seven bullets in his shoulder, doubled over, and he laid down most of the time he was in jail."[362]

Orris D. Garton, the Richmond detective who had followed the Huband case from the first day and had gone to get Mais and Legenza in Baltimore, was highly suspicious of the pair, even while they were locked up. "When those fellows back in there would see me they would do just exactly like a fox," recalled Garton upon seeing the pair in jail. "I don't think they paid any particular attention to which cell. They would go and duck in a cell out of sight."[363] Garton was especially concerned that the two gangsters were being kept in one cell together during the entire time they were incarcerated in Richmond. "If I had been in charge, Brother, I would have kept them in them cells and one in one place one in another where they could not have talked because it is so easy for two of us to plan a scheme where we couldn't do anything if we were separated."[364]

Garton also found it alarming that the two men seemed unconcerned about their upcoming demise. "In other words, they don't look like a man who has been sentenced to the electric chair. They were talking and didn't seem to be worried. You take anybody, if he is the right man and sentence him to the electric chair, he is going to worry a certain amount. They didn't

Saturday Evening Post advertisement for Hormel Canned Chicken, January 4, 1930. This is the same kind of canned chicken that was shipped to Mais and Legenza during their stay in the Richmond jail. It was only after the two men shot their way out of jail that officials realized that the innocuous-looking can had held the key to the gangsters' bloody escape. *Author's collection.*

look like that. They didn't seem as if they had that on their minds."[365] For an experienced cop like Garton, who was familiar as anyone was with Mais and Legenza, he knew instinctively that the conditions were all bad and the signs were all wrong.

Mais had complained to one of his jailers, a man named Thomas O'Conner, about a parcel post delivery he was waiting to receive, to add to the growing larder of canned goods that he and Legenza were accumulating in their cell. After delivering some of the latest shipment to the cell door, O'Conner returned later and told Mais, "Here is some more stuff that just came in." In a prescient moment, another nearby inmate later recalled, "Bob Mais said that is what he was looking for" as he accepted the package through the bars.[366]

The oddly shaped tin contained a cooked chicken, promoted by its manufacturer, Hormel. "Whole chicken that's better in 4 new ways. Chicken is now the quick, easy, healthful home meal—for mansion or kitchenette," trumpeted an ad for the product in the *Saturday Evening Post*. "Ready cooked, Whole Chicken—that might be served cold—fried in 5 minutes—roasted in 15."[367] The unusual can, with its colorful label showing a beautifully roasted chicken on a platter, had drawn the attention of some of the jail staff. "Two or three of the guards were examining it

and saying something about canned chicken," recalled one of the jailers, Officer W.A. Moore.[368]

Earnest Covington had been in the Richmond jail since earlier that summer and was in cell number six, four doors down from cell two, where Mais and Legenza were kept. Covington had enjoyed some of their largesse and was occasionally invited to have some of the coffee that Mrs. Mais delivered in milk bottles or to sample the canned goods that they kept in a footlocker in their cell. At times, there would be as many as six men in the cell, enjoying canned treats as a relief from Sheriff Saunders's dreadful "bean soup."[369]

Covington was curious about the canned chicken, never having seen one before. On Friday, September 28, the same day that Misunas was holding forth on the virtue of quality footwear, Covington approached Legenza about the chicken. When asked later if he was anxious to get some chicken, Covington recalled:

> *Yes, in fact I wanted to see it opened. I asked Legenza about the chicken. We usually ate together and I never looked back in the box they kept the canned goods at the foot of the bunk. I thought it ought to be there and we were sitting down there and getting ready to eat supper and I said, "How about that canned chicken, George?" We called him George Legenza and I don't remember the exact words I told him but I asked about the chicken, what did it taste like, and he said, "Damn it, you have ate sardines, haven't you?" I said, "Yes, but chicken don't taste like sardines." He said, "It is like other canned stuff." I said, "Vegetables or anything like that are better before they are canned than they are after they are canned." He said, "You have ate chicken, haven't you? It is just chicken." I said, "Let's eat it now?" He said, "Oh well, we will eat that tomorrow," and when he gives you an answer it is final with him.[370]*

Detective Garton grew increasingly apprehensive about the indifference he observed in two condemned killers at the city jail. Adding to his worries was the fact that when Marie McKeever left town, she had left two wigs in her room at the William Byrd Hotel. Like sensing a change in the air and hearing a rumble of distant thunder, for a cop like Garton the wigs were emblematic of something criminal, something disturbing about to happen in Richmond. He knew instinctively that Mais and Legenza were the source of his misgivings, even though they were in jail.

On the morning of Saturday, September 29, 1934, while Ernest Covington sat in the city jail anticipating his first taste of canned chicken,

Detective Garton was downtown in the same City Hall courtroom where Mais and Legenza had been convicted. "I came upstairs and talked with Tom Miller, Deputy Clerk in here, and showed the same wigs that I was just referring to…and told him that I was scared that something was going to happen down there, that I did want to get this fellow Legenza on over to the Penitentiary. So about that time he said, 'Well, I don't know. Major Euwell [*sic*] said it would cost extra for three guards over there so they are going to take them over on the second [October 2].' I said, 'Tom, I would like to see them over today.'"[371]

About that time, Garton noticed a commotion through the courtroom's glass doors. Police officers were rushing down the stairs, outside, and across Broad Street to police headquarters in the City Hall annex. Garton turned back to Miller. "Tom, it is too late," he said as he grabbed his hat and ran for the door. "I will bet they have gone."[372]

Chapter 12

JAILBREAK

The boys were going to the chair—that much was obvious—but defense attorney Charles Moss still wanted to get paid. He and his associate Haley Shelton had done their best under difficult circumstances, but there were too many eyewitnesses to Huband's murder and too much outrage that this type of crime had taken place in Richmond in the first place. Once Mais and Legenza were arrested in Maryland and brought back for trial, their jurors must have felt obligated to send the two gangsters to the chair. Legenza—with his long criminal record, his thin alibi, and his Polish accent that pegged him as an outsider—had been a particularly tough sell to the jury of conservative white businessmen, who needed little convincing that Legenza was a murderer. The result was a nearly instantaneous guilty verdict.

While Mais and Legenza had little money for their defense, it quickly became obvious that others were working behind the scenes on their behalf. People like John Kendrick, Morris Kauffman, and James Winn all played shadowy roles in support of their partners who now sat in the Richmond jail. They had even managed to recruit people from the fringes of Richmond society—like Faye Green, a truck hijacker in his own right, and the clueless and drunken Lawrence Davis, who drove Marie McKeever to Lynchburg. Even farther in the background, unseen but still plotting to help the two jailed gangsters, was Anthony Cugino. "Tony the Stinger" was about to take a hand in Mais's and Legenza's fates.

Attorney Moss later admitted that he had met many times with Marie McKeever, but it was impossible to say whether or how involved he and

his assistant were with anything other than his clients' legal representation. Moss later recalled making between twenty and twenty-five trips to the jail to speak to Mais and Legenza to formulate their defenses, meeting them in a conference room just outside the jail tier.[373] After their convictions, Moss met with them again regarding a possible appeal but apparently let them know that if he were to continue it would be an additional expense. As he explained it, "Mr. Shelton and myself were at the City Jail possibly a week or four or five days before that and, in conference with Mais and Legenza, they told us that they were expecting a man who had plenty of money to come to Richmond to pay the balance due for taking the appeal in their case."[374] The lawyers had already been paid $225; $775 was due for the appeal.[375] Moss agreed to meet "the man with plenty of money" at the Richmond jail on Friday, September 28, in order to collect his payment.[376]

Moss waited in the jail conference room from 3:00 p.m. to 4:00 p.m. "After he did not show up," he said, "I asked them to let me see the boys to see what the trouble was, that the man did not show up with the money."[377] Mais and Legenza were both brought out to the conference room to talk to Moss, and as before, the two prisoners were led from the tier to the conference room without handcuffs or leg shackles. When Moss asked them what happened, the two gangsters assured him that their benefactor was coming and would be there the next morning. They said that even if the money did not arrive, by then they would have a list of people to wire for money, so it was imperative they see him, no matter what, at 10:00 a.m.[378]

Moss dutifully returned the next morning. "I waited there until about twenty minutes after ten o'clock, waiting and looking for this man to show up with the money to take the appeal." Moss walked into the jail office to use the phone and called his stenographer to ask if anyone had called for him. No one had called, so Moss turned to the jailers and said:

"Well, let me see the boys. I want to see what in the world is the matter," the man hadn't shown up. So they went on to get the boys, and as was the usual custom, I went on in the room there.[379]

I sat down in the chair a minute and then I got up and looked out of the window. I was expecting to go to the football game. I had gotten tickets for my wife and myself to go to the football game and it looked like it was cloudy and I was standing there looking out the window when I heard some feet approaching and I turned and just as I turned they had gotten about two steps in the door and were turning and I saw this man Legenza fumbling in here as he was turning and quick as a flash he turned

and started to firing and when he did I jumped down under the table and crawled up in the corner where the trunk is and got behind the trunk and I never heard so many shots in my life. It sounded like a young war to me.[380]

Everyone in the jail, stunned by the gunfire, stood frozen to the spot. Deputy Sergeant John Selph, who was unarmed, had been called upstairs from the jail basement moments before, with orders to stand in the corridor near the conference room door. He recalled seeing Mais and Legenza, without handcuffs or leg irons, brought to the barred door that led to the tiers and led into the corridor by jailers Johnston and Duke. As he got near, Legenza pulled a pistol from his pocket, shouted, "Stand back!" and immediately started shooting. His first round caught Selph in the stomach. Stunned, Selph reached down and held the wound. "It burned like fire, and I said, 'I am gone,' and I backed back and I didn't see any more that happened at all."[381]

Richard Duke, another jailer, had been behind Mais and Legenza as they walked from the tier to the conference room. Johnston walked to one side, and Officer William A. Moore stood in the distance in the doorway leading to the jail offices. Duke recoiled at the roar of the guns (both Mais and Legenza were shooting) and backed up toward the tier door and out of the way. Although he was unarmed at the time, the sixty-five-year-old Duke did know that two shotguns were kept in the secretary's office, just inside the jail's front door. When asked why he hadn't grabbed one of these guns to try and stop the escaping pair, the portly Duke stammered, "I will tell you now I didn't have time. They [the inmates] had gone then. I knew I couldn't run, I was so excited.... I had gone back. When they commenced to shooting, Mister, I had gotten out and gone back."[382] Duke—old, fat, unarmed, and frightened—had already admitted to investigators that he couldn't see very well.[383] He would have been useless against the armed and determined Mais and Legenza, who were literally shooting their way out of the jail and on to freedom.

Jailer A.H. Johnston, likewise not up to the chase, remembered being in the office with attorney Moss and Officer Moore. Moss looked at the clock. He was tired of waiting for the mystery man who was supposed to pay him, and said, "Let me see those boys." He received Mais and Legenza from Duke at the door to the tier and walked beside them, Duke trailing behind, toward the conference room door. Officer Moore stationed himself at the metal door between the jail offices and the corridor that served the tiers and the conference room, where Moss seated himself.[384]

Johnston recalled that Legenza made the first move, shouting either, "Stand back!" or "Let's go!" and immediately shot Officer Selph. Mais was standing right beside Johnston as the deafening gunfire filled the corridor. "I couldn't see his gun," Johnston explained, "but I slapped at him and struck his hand and after that I don't know where anybody went or what they done but after they crossed the door going into the office leading to the entrance I followed them." Just as the pair went through the far door to the office, Mais wheeled around and fired back into the room.[385] For Johnston to get as far as the jail office to see the escapees at the far door, he would have had to pass the wounded and bleeding Officer Moore, who clung to a railing that ran around the basement stairwell.

Seconds before Mais and Legenza emerged through the door to the tier, Officer Moore had been outside the jail, talking to Patrolman William Toot. Both men had been detailed to the jail since the arrival of Mais and Legenza. Toot, who was stationed outside the jail, stood on the entrance steps and called over to Moore, asking for change for a half dollar. Moore said, "Bill, I can't talk to you now, they are bringing these prisoners out." Toot said, "All right, go on back," and Moore took up a post in the doorway between the office and the main jail corridor.[386] Looking up the corridor, Moore saw the group of men coming toward him: Johnston, Duke, Mais, and Legenza, while Selph waited at the conference room door.

Abruptly, the hallway filled with deafening explosions and gun smoke. Moore remembered Legenza calling out something like, "Get out there" or "Look out there," and then immediately shooting Moore. "I stood there momentarily but I was dazed. I hardly knew what to think because I was struck…I never fell." Confused, Moore drew his revolver, but instead of attempting to follow Mais, Legenza, and Johnston through the door he had been guarding, Moore went deeper into the jail and away from the gunfire, holding himself up on the stair railing. A black prisoner approached and called two others, and they helped the wounded policeman into the conference room, where Moss was still cowering under the table.[387]

Johnston peered through the smoke that filled the jail office and saw Officer Toot, still standing at the top of the entrance steps. "As I got near, in sight of the door, the glass door to the front, I saw Mr. Toots [sic] standing at the door with his right hand up on the glass in that position and the other one apparently on the knob of the door."[388] The peculiar arrangement of the locks on the Richmond jail doors made it very easy to walk out of the building but impossible to come in, so Toot could not get in to stop the fleeing gangsters.

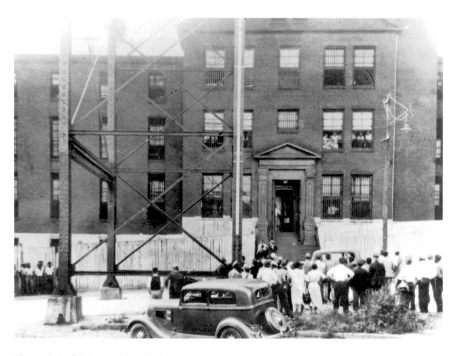

View of the Richmond City Jail on the morning of Saturday, September 29, 1934. A crowd gathers for news of the jailbreak that had taken place a short time earlier. Richmond detectives keep the crowd away from the spot where Officer Toot was fatally shot. Notice the steel beams of the Marshall Street Viaduct, which straddles the jail from above. *Valentine Richmond History Center.*

Thomas Shinault, a mechanic at a city-owned repair shop on the north side of Marshall Street, across from the jail, had been chatting with Toot just seconds before the first shot from Legenza's pistol came through the glass on the jail's front door. Shinault had just lent Toot fifty cents, and Toot had crossed the street and walked up the steps to the jail, only to be met by gunfire. The mechanic saw the flash from Legenza's pistol through the window: "I was looking at the glass when it splashed." Shinault, riveted to the spot, watched as "Legenza shot him [Toot] twice in the back or on the side. Legenza came out and Mais kind of pushed right around him [and] when he did he grabbed Toots by the right hand."[389]

Toot managed to get off several shots with his service revolver that went wild, but then he collapsed in the jail's doorway, blocking the entrance with his body. Johnston moved Toot inside through the hall and into the office to get him away from the front door. The loud gunfire and confusion right outside her office, followed by the sight of the bloody Toot being pulled past

118

the door, was too much for the jail secretary, who became hysterical. "When I carried Mr. Toots over across the room Miss Johnson, the lady that stayed over in the other office—she was hollering 'Let me go, let me go home!' I got her out and she went upstairs with the Matron."[390]

Another city employee, Albert Godsey, also witnessed Toot's shooting. He was a blacksmith and also worked in the city repair facilities under the Marshall Street Viaduct. He was coming down the sidewalk in front of the jail and was within thirty feet of its steps when the shooting began:

> *After he shot Mr. Toots twice, Legenza hit him in the face with his fist like that and then he walked right down the steps right by me. I was standing, I reckon, about thirty feet from them and they come out and both of them held their guns on me like that…They walked down the steps, stood on the steps like this, looked down the street and up the street and when they turned their back to me and were going up the side of the fence I went up in the jail window, tried to get in the door and couldn't do it. Mr. Toots when he went in the door opened the door with this hand here and fell in the door kind of this way and Mr. Johnston, one of the deputies, caught his head, you know, and then I was at the window [of* the entrance door]. *I couldn't see any more from that door. I ran to the window and said, "Give me a gun and I will get them both"…They didn't give me one. Mr. Johnston couldn't get to the gun on account of Mr. Toots' feet…. I couldn't get the gun and I followed them to where they went to.*[391]

When Godsey got to the corner of Jail Alley and Marshall Street, Mais and Legenza were about sixty feet in front of him, and one of the gangsters was "fooling with the gun."[392] This was probably Legenza changing magazines and reloading his pistol, not knowing how many more rounds had been expended inside the jail but preparing to shoot as many people as it took to make good his escape.

Mais couldn't move very quickly, even knowing that he was finally free and on the run for his life. Legenza slowed his pace to match his partner's as they made their way up the cobblestones of Jail Alley. "I seen them until they got to the top of the hill and one started to go east and the other started to go west and they bumped into each other and one kind of staggered this way and the little one, the one that is crippled like this—I don't know his name—got the bullets in his back and he couldn't go fast and when they went, the one with the bullets in his back didn't go no faster

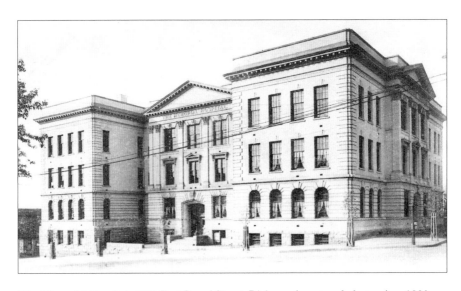

The Memorial Hospital, 1201 East Broad Street, Richmond, postcard photo, circa 1930.
Madelyne Whelton died here in January 1934 after being shot by Herbert Brooks at
the Traveler's Hotel. This is also where the three men who were shot during Mais and
Legenza's jailbreak were brought for treatment in September 1934, as well as where Officer
William Toot died soon afterward. *Author's collection.*

than this, just like that," said Godsey, moving his hand slowly to indicate
how unsuited Mais was for an escape on foot.[393]

Another witness, J.W. Hough, was standing at the corner of Fifteenth and
Broad Streets and saw the two escapees coming up Jail Alley toward Broad.
"At first I thought they were a couple of drunks, as the one behind staggered
as he ran. As they neared me the younger of the two fell practically at my
feet. I looked down at him and recognized him as Robert Mais. He got to
his feet and both of them started crossing Broad Street. In the middle of
the street Mais fell again and narrowly escaped being run over by a car."[394]
Hough watched as the two men, each dressed in blue shirts and overalls,
tried unsuccessfully to stop cars in Broad Street. Giving up but still desperate
for transportation, Mais and Legenza went south on Fifteenth Street and
came upon a mail truck by the curb.[395]

Postal workers Joe Richardson and H.D. Moon had just delivered
a package and were preparing to pull out into the street when the two
identically dressed men with pistols saw them and ran over to them. Mais and
Legenza dragged Richardson and Moon out of the cab of their mail truck
and drove east three blocks to Eighteenth and Grace Streets, then pulled
over. E.T. Carpenter was just parking his Hupmobile when he was startled

to see a man on the running board beside him, holding a pistol to his face. "I started yelling, which I think caused them to get a bit excited," recalled Carpenter. Had he known what had just transpired a few blocks away at the Richmond jail, he would have handed his car over immediately. Instead, he locked the brake and threw the keys out into the street. Legenza jerked him out from behind the wheel, while Mais scooped the keys off the pavement. The pair started the car and sped off down Grace Street to Twentieth Street and turned north. "I ran to the telephone and notified police and I haven't seen my car since," said Carpenter, who added ruefully, "I had four gallons of gas in the car."[396] Carpenter's Hupmobile, with Robert Mais and Walter Legenza in the front seat, from that moment simply vanished from the streets of Richmond.

The three wounded men left behind in the confusion at the Richmond jail were bundled into cars and taken the short distance to Memorial Hospital on Broad Street, the same facility where Madelyne Whelton died months before. Of the three, Toot's injuries were the most serious, and he died on October 3. "His name should be added to the long list of policemen who fell at the post of duty. Heroes of peace as much as the heroes of war," commented the *Richmond News Leader*.[397] The largest manhunt in Virginia since the panic surrounding Nat Turner's Rebellion in 1831 was now taking place.[398]

Chapter 13
THE FALLOUT

Far from Richmond, Mais and Legenza were like wraiths, dead men abroad in the world of the living. Now, after their escape from Death Row, each meal, each cold beer, each drag on a cigarette was some kind of miracle, each a little blessing visited on a life beyond the realm of goodness or mercy. The mere sensation of the wind on his face from the car window must have impressed even the otherwise phlegmatic Legenza. As he and Mais drove northward out of Richmond after so many months of close confinement, the broad vista of the woods and farmlands along the highway must have seemed astonishing in scale, and the prospects unfolding on the road before them filled with potential.

The intensity of a life suddenly liberated from certain death must have been made all the more vivid by not giving a good goddam who they had to kill along the way. Robert Mais and Walter Legenza were not living on borrowed time; they were living on stolen time. To a lifelong thief like Legenza, the sight of Richmond disappearing in the rearview mirror must have been both the ultimate heist and the sweetest revenge on an entire city determined to kill him.

On the other hand, they had no illusions. The two escapees (and Marie McKeever, who by now was probably traveling with them) knew that each stop along the way could be their Alamo and every car they hijacked their catafalque—like the bullet-riddled Ford that Bonnie and Clyde drove on their last day in May 1934. Like Bonnie Parker, Marie McKeever, who had long been involved with the Tri-State Gang, would not be immune to the

Grave of William Toot, Oakwood Cemetery. Officer Toot, the only man at the Richmond jail who tried to stop the escape of Mais and Legenza, paid for his bravery with his life. Author's photo.

bullets of "the laws," as Bonnie referred to police. For McKeever and her two companions, menace was everywhere: in the headlights of a car in the rearview mirror, in a stranger's long gaze at an intersection or in a flat tire that could prove fatal. The three surviving members of the Tri-State Gang were the phantoms of the mid-Atlantic, both seen and unseen. On October 23, a newspaper in Frederick, Maryland, reported that the men were observed "in a small automobile headed toward Baltimore from Washington" and glumly reminded its readers, "Legenza was scheduled to have been executed today."[399]

As the manhunt continued, President Franklin Roosevelt spoke about the Richmond escape in a press conference, saying that he had conferred with U.S. Attorney General Homer Cummings about the status of federal prisoners being held in local jails, and Cummings reported that the Richmond jail had been found inadequate and all of those prisoners had been moved to the Henrico jail. The president assured the public that federal prisoners would be held in secure, well-equipped facilities. The implication was that the Richmond jail was substandard and its authorities inept.[400]

A week later, the big news in the Richmond papers was the arrest of Lillian Holley, the warden at the Crown Point, Indiana, jail where John Dillinger had escaped the previous March. Fingerprint expert Ernest Blunk, who was taken as hostage in the jailbreak, had already been indicted by a grand

Many spent shells and bullets were recovered from the Richmond jail after Mais and Legenza's escape. The two large lead .38-caliber bullets came from Officer Toot's revolver. The smaller slugs and spent shells came from the two .32 automatics used by the gangsters. *Author's photo, Library of Virginia.*

jury investigating the escape, but by then the charges against Holley had been dismissed by a local judge, who called the entire story "a comedy of errors."[401] When the escape first occurred, the *Times-Dispatch* harshly criticized the jailers in charge of Dillinger. Now, it was Richmond's turn to bear the shame of letting two killers loose again, and city officials who read about Holley's investigation by a grand jury must have begun to worry about what could happen to them.

The "Proceedings of a Special Grand Jury to Investigate the Escape of Robert Mais and Walter Legenza" took place in the same Hustings courtroom at City Hall where the escapees had been tried and condemned.[402] Thirty-one officials at the jail, policemen, witnesses, prisoners, and former prisoners were all questioned. Everyone from Judge Ingram to McKeever's drunken driver, Lawrence Davis, was called to testify. The last one called to the stand, the one believed to be the guiltiest, was Elizabeth Mais.

Every aspect of the situation was called into question: the jail's standard operating procedures, its layout, the food, and the manner of handling of Richmond's own petty criminals, let alone famously dangerous inmates like Mais and Legenza. At every step, with every answer, the Richmond City Jail was found hugely wanting. For example, because one iron door was permanently propped open, perhaps to help bring air into the corridors, there was no way to prevent prisoners from rushing out the front door if they could elude their jailers' grasp. Had Officer Toot not been stationed there, Mais and Legenza could have simply left. One jailer admitted that the critical door had been kept open since he was first hired, in 1910.[403]

Among those closely questioned about the shooting and escape from the jail was the portly sixty-five-year-old Richard Duke, who was escorting

Mais and Legenza from their cell to the conference room to meet with their attorney, Charles Moss. Regarding Duke and his two fellow officers, an exasperated grand juror asked Sheriff J.D. Saunders, "Did the thought ever occur to you…those three infirm men, two infirm from age and Johnston, a cripple, were not proper guards for desperate criminals?"[404] Although Duke never stated his personal thoughts to the jury, he had talked to his friends about his feelings of shame and guilt. He was apparently deeply remorseful that he had on his hands the blood of his fellow jailers and the death of William Toot.

The day after his grand jury testimony, on October 13, 1934, Duke took his shift at the jail as usual and left at 6:00 p.m. He walked up Jail Alley to a Broad Street bus stop, following the same path Mais and Legenza had taken just a few weeks before. By 6:30 p.m., Duke was back at the jail, asking to be admitted because he left his keys. Deputy Sheriff John Rogers let him in, and Duke immediately stepped into the darkened, empty office just inside the front door. Rogers heard Duke say, "John, I want a drink of water," and again a pistol shot rang out in the jail. Stepping into the office and turning on the lights, Rogers found that Duke had taken one of the revolvers stored in a desk drawer, pressed it to the side of his head, and shot himself. His body, in a spreading pool of blood, lay only a few feet from where Toot had dropped to the floor during the escape. Duke, a widower, was survived by four children and a granddaughter, all of whom had lived with him on Hanes Avenue in Richmond's North Side.[405]

Although shocked by the suicide of a witness who had just appeared before them, the grand jury grimly moved on through what would be recorded in 636 pages of typewritten testimony. In the end, the members recommended firing both Sheriff Saunders and Deputy O'Conner, who brought the package containing the canned chicken to the gangsters. For her involvement in sending the two inmates the package with the two pistols inside, Elizabeth Mais was arrested under the charge of accessory to murder, both before and after the fact, and jailed.[406]

In the end, however, no one person was held accountable, no master criminal revealed, and the discoveries were only of naïvety, incompetence, and the peculiar quality of Richmond itself that dismissed professional gangsters as no more of a threat than their fellow bootleggers and petty criminals. The can with the guns was not smuggled into the jail in some theatrical subterfuge; it was delivered by parcel post, along with all the other shipments into a jail plagued with providing its inmates inedible food. The two gangsters received the canned chicken a week before the breakout, apparently feeling perfectly

secure against its discovery, at least in this jail.[407] They were only biding their time until they could lure Charles Moss to a meeting, so they could be brought from their cells to a room closer to the jail's front door.

In an editorial about the jailbreak printed under the rubric, "Face the Truth Even When It Hurts Most," the editor's weary voice seemed to speak for all Richmond when he declared:

> *But the probability seems very strong that our judicial system is entirely too trustful and easy going, that we would take long chances with prisoners, in order to save a few dollars and that as a city we stupidly permitted ourselves to be deceived by the apparent resignation of two cunning crooks to their fate. We should have had enough sense to know that men of this type would never permit themselves to be transferred to the death cell if bribery, conspiracy, arms-smuggling or murder could effect their escape. We might as well own the bitter truth: As a city, we were boobs and amateurs in dealing with professional gangsters.*[408]

One reader of that editorial who might have given a chuckle was Arthur Misunas, still whiling away his days as he awaited sentencing in his Henrico County cell. During the course of his confinement, Misunas received a package from a friend in California, and one of the items inside was a canned cooked chicken. Needless to say, gifts of chickens for prisoners in Richmond were a sore subject. "We did everything but perform an autopsy on that chicken," the Henrico sheriff said. "We aren't taking any chances."[409] Misunas may have smiled at the precautions taken by the police, but knew that he was surely a dead man if he ever managed to escape police protection and was found by Walter Legenza.

November 1, the day Robert Mais was to have been executed, came and went, but there was still no substantial progress in the hunt for him and Legenza. Two men had been arrested by police in Halifax County, near the North Carolina line, under suspicion of being the gangsters. They were finally correctly identified, but not before the frustrated police were reduced to charging them with peddling without a proper license.[410] In Philadelphia, a man feigning drunkenness reeled into a Philadelphia garage and then abruptly pulled a pistol on the three attendants. "I'm Bobby Mais and I'm wanted for four murders. I'm going to take that car and get going." A few minutes later, the same car rolled up to a delicatessen, and the lone occupant, described as looking like Robert Mais, got out and robbed the proprietor of twelve dollars at gunpoint.[411] The *Richmond Times-Dispatch* carried a story of

a Richmond police squad responding to a report that Mais and Legenza were hiding in an abandoned railroad tunnel under Gamble's Hill. The six-hundred-foot-long tunnel was a perfect place to imagine Indians, Yankees, or gangsters hiding out. "The informant told police that someone was feeding the fugitives pork chops," perhaps using Depression-era shorthand for eating well. "Police, however," dutifully reported the newspaper, "found no trace of Mais, Legenza,, or pork chops."[412]

Though the hunt for the two escapees was receiving less attention in the press, the Department of Justice announced renewed plans to kill or capture Anthony Cugino, termed "another 'kill-crazy' desperado," who was on its books for seven murders. Like others before them, the federal officials may have felt that Cugino was behind Mais and Legenza's escape and that finding "Tony the Stinger" would help locate the Richmond escapees. The three of them were known associates, and all three now had a reputation for killing men, women and the police without a moment's hesitation. The search for Cugino, "the eastern seaboard's present Public Enemy No. 1," stretched across five states but ultimately yielded nothing.[413]

The botched murder of Allen B. Wilson, a *Washington Herald* newspaper agent in Tacoma Park, Maryland, in early November, had traces of Cugino's modus operandi, but it was later discovered that the real target might have been a local gambler who was put "on the spot" by other criminals. To attack or rob his fellow criminals was classic "Tony the Stinger," but instead, two gunmen had shot down an innocent and unarmed man—a hallmark of the Tri-State Gang. Marie McKeever was reported as having been seen in the area, Maryland police announced, and her arrest was imminent on charges of being an accessory before and after the fact in the murder of Officer Toot. It was hoped that the arrest of "the notorious 'moll'" McKeever would shed light on Wilson's shooting.[414]

Two new members of the Tri-State Gang in the Philadelphia underworld were Martin Farrell and Frank Wiley. The two brothers-in-law had been serving lengthy sentences: Farrell thirteen years for larceny and Wiley ten to twenty years for robbery. The previous July, they and three other prisoners in Philadelphia's notorious Eastern State Penitentiary staged a dramatic escape through the sewer pipes under the prison. After sliding along in the sewer line for five blocks in the dark and filth, they were attacked by rats and, in a panic, burst up through a manhole into a Philadelphia street. Three were recaptured, but Farrell and Wiley, stinking and with their prison clothes in shreds, got away.[415]

Chapter 14

CRIME SPREE IN PHILLY

The hand of Anthony Cugino, reunited with Mais and Legenza, was felt once again on the wintry streets of Philadelphia. The men needed money, lots of it, and there was no more vulnerable population than their fellow gangsters and criminals, who were naturally loath to go to the police. Gangsters had often kidnapped their own for ransom, the most famous being the snatching of George Jean "Big Frenchy" De Mange, friend and partner of Owen "Owney the Killer" Madden, the New York liquor racketeer and Cotton Club owner. De Mange was held by the Vincent Coll mob and successfully ransomed, but not before Madden put a $50,000 bounty on Coll's head.[416] It was just one more affront to the underworld, the cops, and the public that led Coll to his death, well ventilated by a Thompson and crumpled in the bottom of a New York phone booth. Both Mais and Legenza knew that the underworld didn't tolerate preying on its own. It was bad for business.

In Philadelphia, bootlegger and boxing promoter Max "Boo Boo" Hoff was touring the West Coast with a stable of three fighters in November 1934. Hoff would have been the perfect target for the Tri-State Gang, as Robert Mais probably remembered quite a bit about Hoff's operation. Hoff was also canny enough to foresee the return to Philadelphia of the desperate and indiscriminately murderous Tri-State Gang. There was no time to wait for the bootlegger's return to Philadelphia. Instead, Mais and Legenza decided that Hoff's contemporary, William Weiss, a "prominent Philadelphia night life figure," was the more likely target.[417] As one newspaper concluded flatly, "Hoff could not be found, and Weiss was taken."[418]

Weiss, an "aged racketeer," was leaving his house in the Philadelphia suburb of Overbrook Hills on October 28, 1934, when he was forced into a car by three men, one of whom was described as looking like Robert Mais.[419] Weiss's home was not far from the former residence of Mickey Duffy, whose slaying in an Atlantic City hotel four years before was, according to Philadelphia detectives, undoubtedly "a result of attempting to protect Weiss from other shakedowns."[420]

In the absence of Hoff, both Mais and Legenza must have seen Weiss as the perfect target to kidnap and kill. He was an underworld figure whose family was unlikely to go to the cops. They wanted to delay or entirely avoid getting the police involved until after the ransom money was collected. In his business, Weiss had ready access to cash, likely far more than an ordinary citizen would have on hand. All of the men involved—kidnappers and victims alike—would have known one another, what they had done, and what they could do if cornered. If Weiss did recognize the three men who approached him in front of his home, he would have known them as members of the Tri-State Gang—and realized that he was a dead man. They clubbed him on the head and bundled him into a car; Weiss had little time to react.

After escaping Death Row, Legenza didn't bother with planning where to hide a kidnap victim. In his mind, the smart play was to use a couple of bullets to immediately turn Weiss from a struggling, bleeding hostage who could identify his attackers into nothing more than dead weight to be dumped out of sight. No doubt Mais concurred. His long association with Legenza must have tempered Mrs. Mais's "Bobby" into a hardened killer. He might not have even flinched at the gunshots that came from the back seat of the car as Legenza coolly shot Weiss once in the right eye, once in the left side of the head, and once in the chest.[421]

Besides Farrell and Wiley, other minor players were taking the stage in the story of the Tri-State Gang. Some may have been part of the gang's Philadelphia base before the robbery at Washington's Union Station in December 1933. Among them is William Eckart, who went along for the kidnapping of Weiss and the disposal of his body. "After he was knocked off, I got the iron weights and wire which was used to tie up his body. I got them on Legenza's order."[422] The kidnappers stopped their car on a bridge over Neshaminy Creek, north of Philadelphia. There they attached four twenty-five-pound iron weights to Weiss's body and tipped it over the railing into the water. Eckart was nervous about his role in the highly publicized crime, and watching the vicious Mais and Legenza at work, he

was probably also nervous about his fellow gang members. "I threw one of the guns in the creek a few days afterward," Eckart recalled, "but Legenza wouldn't give up his gun. He said he didn't care how many people he killed."[423]

A ransom of $100,000 was demanded and paid, but lack of word from Weiss after the ransom drop led to increasing fear he had met the "horrible death" that was threatened in the kidnappers' notes to his family.[424] With the dreadful reputation of the Tri-State Gang, "a curtain of silence [was drawn] over the inquiry into Weiss's fate. Anyone who knew anything either clammed up or left town. The chief stumbling block in the investigation has been the silence of underworld

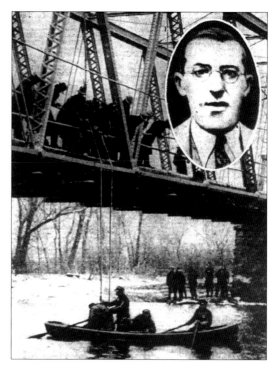

Philadelphia Inquirer photo of William Weiss and the recovery of his body under a bridge, January 1935. The October 1934 kidnapping and murder of William Weiss (inset), a member of the Philadelphia underworld, was the Tri-State Gang's desperate attempt to raise money after Mais and Legenza escaped from jail in Richmond. Months after Weiss's murder, police recovered his body from Neshaminy Creek, north of Philadelphia.

characters, presumably fearing reprisals or incrimination if they talked. More than one such individual was reported to have left Philadelphia to prevent questioning," reported the *New York Times*.[425]

While Mais and Legenza were on the run, Mais still suffered from the bullet wounds he got from police in Baltimore on June 5. Marie McKeever could do little to relieve his pain, and even though it was dangerous, he was forced to seek medical help. "The Presbyterian Hospital reported to police yesterday that a man answering the description of Mais had applied for treatment and fled when police were called. A physician reported a similar occurrence."[426] In the end, those six heavy bullets from the Baltimore policeman's Tommy gun would go with him to his grave.

On November 25, "A search for Mais, reported dying in this city of a bullet wound, was ordered from Washington by J. Edgar Hoover, Department of Justice chief, who has taken personal charge of the Weiss case."[427] At the bottom of a Bureau of Investigation memo regarding Mais and Legenza, the director angrily scrawled, "Are we making any investigation in either of these cases? If so then a J.O. should be issued. We can ignore the P.O. & local authorities if they won't work with us. They double-crossed us in Dillinger case & yet we issued J.O. & got results ourselves. J.E.H."[428]

Outrage over the disappearance and suspected murder of William Weiss extended into the underworld itself. Not only were federal agents and hundreds of policemen hunting for Mais and Legenza, rival gang killers put bounties on their heads, as well. "Speaking in the guttural idiom of the underworld, Martin Farrell said that executioners for a New York gang had been offered a prize of $3,000 each for the head of Mais, Legenza, and Marie McKeever, sweetheart of the 'killer.'"[429]

Back in Richmond, Arthur Misunas got his first taste of fresh air outside the Henrico jail when he was taken to Washington under extraordinarily heavy guard in November to testify as to his role in a robbery at the Heurich Brewing Company in Foggy Bottom in October 1933. His cooperation was part of the arrangement he had made with the court in Richmond, and only after his satisfactory performance in Washington would he know his sentence in the Huband killing. Misunas testified against John "Slim" Dunn and Sam Berlin, two minor players in the shifting roster of the Tri-State Gang.[430]

When he returned to jail in Richmond, Misunas was visited by his mother and his sister. "Mrs. Misunas, a buxom, white-haired woman, registered with her daughter at the John Marshall hotel yesterday,"[431] it was reported, and they were carefully searched by the police before being admitted to the Henrico jail. As to the inevitable topic of bringing weapons into the jail, "police took no chances of having another 'baked chicken' can, which figured in the escape of Legenza and Mais from the city jail on Sept. 29, smuggled into Misunas' cell."[432]

The winter of 1934 came in with a vengeance up and down the East Coast. Richmond recorded the coldest December in thirty years, and snow on the streets turned to solid ice.[433] The economic outlook for the city was just as cold and bleak: a Christmas charity fund came up short in contributions because of the number of destitute families. "Successive years of unemployment, of depending on charity for the very bare necessities of life, have left these neighbors of yours nothing at all," appealed the *News*

Leader.[434] To add to the misery of the cold, a funding crisis in a government home loan program threatened to force foreclosures all over the state. "Chances of these distressed home owners obtaining aid from private savings and loan associations, banks, and other home lending agencies of a private character are known to be slim," cautioned the *Richmond Times-Dispatch* in a page-one article that only confirmed the widespread misery.[435]

The hardships of that winter were put aside when news came in from Philadelphia that lit up the wire services on December 14: police had raided a house and captured several members of the Tri-State Gang. The cops received a tip that three men who had robbed a Pennsylvania National Guard armory would be driving up Germantown Avenue at a certain time with some of the stolen guns. Four detectives waited patiently until nine o'clock at night, when they spotted the car they were waiting for and pulled out behind it. Three men, one carrying a heavy suitcase, got out of the car at the Wayne Junction Station on the Reading Railroad. By mistake, the policemen took the wrong stairway, which left them facing the gangsters, but with the railroad tracks between them. The three bolted, leaving behind the suitcase. One ran off into the dark down the tracks and lost his pursuers. The other two, believed to be Mais and Legenza, rushed out into the street outside the station, left the automobile they came in, and ran off down the street. When the suitcase was later examined, it was found to be full of automatic pistols.[436]

As police inventoried the suitcase and checked out the car that Mais and Legenza abandoned at Wayne Junction, Legenza was writhing in agony only a short distance away. In the dark, and in his rush to elude the police, he had jumped off a thirty-foot concrete embankment, breaking both heels and one leg. Mais, still suffering from his gunshots and not in good shape himself, doubled back for his partner and somehow managed to lug him to an empty boxcar and boost him inside.[437]

There, Legenza was left in the cold and dark, trying to control his panting, choking in pain. He clutched a pistol, waiting for police flashlights to shine through the boxcar door. He may have heard cars gathering near the Wayne Junction Station and heard the shouts of his pursuers in the distance. Legenza was completely trapped, at the mercy of whoever appeared at the door to the steel box, and was ready to kill the first man who wasn't Robert Mais. It had been a disastrous day—the foxes had barely eluded the hounds. Lying in the cold and dark, he riveted his eyes on the rectangle of light that was the open boxcar door. Legenza was in agony and knew that he could survive only if he had all his faculties. Breaking bones in both legs was a

major blow. The game was running out, the hunters were near at hand, and the story of the Tri-State Gang was funneling down to a finish that could have only one ending.

Two very long and terrifying hours later, his partner returned for him. Mais had limped off into a residential area beyond the train station, stolen a car, and came back for his friend. The two gangsters drove off through the streets of Philadelphia.[438] Against all odds, the night and the silence closed in around them once again, and Mais and Legenza, the two most wanted men on the East Coast, disappeared.

That same night, dozens of police officers—armed with machine guns and sawed-off shotguns and accompanied by an armored car—burst open the door of Mrs. Marie Quinn's row house in North Philadelphia's Logan neighborhood. It took some time for the cops to realize that they were at the wrong address. "We finally convinced them they wanted the house next door, and they left. The next we heard was a shot and shattering glass," recalled Mrs. Quinn.[439] When the men forced their way into the correct address, they discovered two men on the first floor but also heard a trapdoor to the roof being opened by someone upstairs. The police rushed up only to shoot at the last of three men pulling themselves onto the roof. They tied up the two gangsters from downstairs and the other man with telephone wire and called a patrol wagon. Witnesses in the street reported seeing several men fleeing over the roofs of the row houses next door.[440]

Although the Philadelphia police were unusually closemouthed about who they thought was in the house, they did confirm that they had arrested Charles Zeid, who was wanted for the murder of a New Jersey policeman in September, as well as Frank Wiley, who confessed to his role in the Weiss kidnapping. Harry Seidel was caught in a nearby house, along with George Barrett and Mrs. Beatrice Wilkinson, described as Zeid's sweetheart; they also took away her children. After seeing the glass on her front door shatter inward under the shoulders of several Philadelphia detectives and hearing the rattle of a machine gun upstairs, Mrs. Wilkinson screamed, "I have three little girls up there. Don't shoot! Don't shoot!"[441] The *Richmond Times-Dispatch* labeled the incident as "Brush with Philadelphia Officers Is Victory for Gangster," a snide dig from a city whose streets had seen more than enough victories by Mais, Legenza, and their partners.[442]

Charles Zeid, a "minor henchman" of the Tri-State Gang, was wanted for killing a policeman at a brothel in Camden, New Jersey.[443] In recounting the events, the *Philadelphia Inquirer* hinted at a link between Zeid and "Tony

the Stinger" Cugino, saying that "at some time in his career Zeid had business of a sort with Tony." Zeid's story became even more sensational when, during questioning by police, the "proprietress of the house" where the shooting took place jumped to her death from the fifth-floor window of Camden City Hall.[444]

The raid on the Philadelphia row house did more than flush the two Richmond fugitives from cover and arrest five others. The house held an enormous arsenal: seven Thompson submachine guns, more than forty automatic pistols, shotguns, several revolvers, and—as the *Philadelphia Inquirer* put it—"enough ammunition to fight a pitched battle." Most of the guns among the loot were from a nighttime break-in at the National Guard Armory in Norristown, Pennsylvania, a few days before.[445]

Among the deadliest of the stolen weapons were several Browning automatic rifles. This heavy, large-caliber rifle with a twenty-round magazine was prized by both America's criminals and police for its ability to shoot through even the sturdiest car, where lesser calibers often failed to penetrate the steel bodies of 1930s automobiles. The Philadelphia cops, well acquainted with the bloody reputation of Antonio Cugino and the Tri-State Gang for settling old scores, believed that Mais and Legenza might return to Richmond with their new automatic rifles. "Police here at first," asserted the *Philadelphia Inquirer*, "thought that in the raid on the Norristown armory the gangsters were seeking weapons to wreak vengeance on Misunas, awaiting sentence in the Henrico County Jail, near Richmond."[446] The murderous Tri-State Gang was known to be so vicious and determined that such an idea was not outside the realm of possibility.

All of the men captured in the raid on the Philadelphia houses were hard cases and might be expected to keep quiet, at least for a while. Wiley and Zeid were certainly tough guys who would not easily break, but Beatrice Wilkinson, whose three young daughters were whisked away from her by a police matron, quickly folded under police questioning and divulged all the details of the Weiss kidnapping. Philadelphia police wrote down her story of how Weiss was killed almost immediately by Legenza in the back seat of the getaway car that was used to pick him up.[447]

Captain James Malone of the Philadelphia police disclosed that the raid on the houses came as the result of a chance remark by one of Mrs. Wilkinson's daughters. The girl had said to a playmate that she was "afraid to go home because there are so many men there and they are all carrying guns." When the child's father heard of this, he called police. The Wilkinson girls had also mentioned that Mais and other men had spent several weeks

in their house and had noticed that hot water bottles were constantly being taken upstairs for one of them.[448]

The police were desperate to either arrest or shoot to kill Mais and Legenza, and in their desperation to find them, they must have pressured the five people they arrested in the row house raid. Perhaps as a result of that pressure, they were told a scarcely believable story about Mais, Legenza, and the trove of automatic weapons and .45 pistols found in the house. "Emboldened by the success in kidnapping and slaughtering of William 'Hook Nose' Weiss, one-time big-shot racketeer, [the Tri-State Gang] raided and robbed a Norristown armory to obtain munitions for its assault on 'Cherry Hill,'" reported the *Philadelphia Inquirer*. Every reader of the *Inquirer* knew that "Cherry Hill" was the local nickname for the Eastern State Penitentiary.

The enormous penitentiary in the heart of Philadelphia was built in 1829, and its massive walls still loom over the narrow residential streets nearby. How the Tri-State Gang intended to storm this urban fortification wasn't explained, but the police said that there were definite plans to take the building, release all the prisoners, and kill Warden Smith for revenge. Frank Wiley and Martin Farrell were believed to have felt a special hatred for the warden. The year before, during a prison riot, Wiley viciously struck at the eyes of the warden with an inkstand and all but blinded Smith.[449]

The public was astonished at the audacity of the gang's plan to take over Eastern State, and it seemed impossible that any small group of men could penetrate the grim stone walls of the penitentiary, kill the warden, and unleash a firestorm of criminals on Philadelphia. Yet the *Inquirer* had to concede, "The assemblage of the Mais gang of killers is almost as story-book-ish as their bold kidnapping of Weiss, their raid on the armory and their ambitious plan for general jail delivery." It didn't seem so fantastic after the photos of the recovered machine guns were published and the full scope of the Tri-State Gang, with its ever-shifting headquarters and variable cast of characters, was made known. If the walls of Eastern State were to be breached, this just might be the group of killers and thieves to pull it off. "All these underworld forces were eventually to meet, in a manner yet unexplained," mused the *Inquirer*, "in this city to plan bigger, but hardly better, jobs."[450] If the citizens of Philadelphia didn't breathe a collective sigh of relief, the police department certainly did after capturing the inhabitants of the row house on Sixth Street and their cache of military-grade weapons.

Except for the guns they had with them (probably a couple of stolen government-issue .45-caliber pistols), Mais and Legenza were disarmed and their gang, for the most part, shattered. Once again the two convicts were fleeing from every policeman on the East Coast who, by now, must have seen their photographs on "Wanted" flyers. Mais certainly still suffered from his untreated bullet wounds, but now it was Legenza who was in agony with the broken bones in both legs. It would be tough to find something strong enough to overcome that pain, much less get medical help. They both knew that somewhere, out in the cold, dark streets of wintry Philadelphia, help did exist in the form of Marie McKeever. Mais, shivering and frightened behind the wheel of his stolen car, no doubt wished that she was with him there right then.

Chapter 15

ON THE RUN

The heat was on along the whole East Coast to find Mais and Legenza, but nowhere was it so hot as in Philadelphia. Sightings (real or imagined) of the gangsters in the Philadelphia area meant that police attention was directed away from Richmond. As a result, Richmonders must have felt some relief in thinking that their city was the last place the police would finally find the two murderers from the Tri-State Gang.

Police first questioned Marie McKeever, the "public" face of the Tri-State Gang, for information about her boyfriend, Robert Mais. As part of President Franklin D. Roosevelt's crime initiative, the very fact of associating with and assisting known criminals was made a serious crime in 1934. The so-called harboring charge became a valuable tool for police and the U.S. Department of Justice's Bureau of Investigation, which was trying to cut off the lines of support and supply to America's gangsters. In the aftermath of killing Bonnie Parker and Clyde Barrow in May 1934, the public saw that the authorities were no longer satisfied merely with eliminating the criminals themselves. Many members of both the Barrow and Parker families were tried the following year under the new law about harboring criminals. Some family and friends of the pair served up to two years in prison.[451]

So as Prohibition wound down after its repeal in December 1933, federal laws were tightened to quench the explosion of crime and the growth of gang activity in America. The drama of the 1930s led to the classic gangster movies of the day: machine guns chattering from passing cars, so-called rub-outs, hijackings, and oversized crime figures who used fire, guns, and

explosives to achieve their ends. Speedboats no longer streamed into the ports and deserted beaches of the East Coast bringing in booze by the barrel. It was becoming a more genteel world now, and "even those who made their money by breaking the law could buy a free pass to respectability," as one Prohibition historian recalled.[452]

The formerly shady but now respectable criminals in Philadelphia longed for the day when they were no longer threatened with kidnapping by the Tri-State Gang. Men like Max "Boo Boo" Hoff couldn't afford to have Mais and Legenza out on the streets and disrupting the delicate balance of corruption that kept him safe. Nor did he like living under threat, as it was obvious to all what had happened to Weiss as soon as he was abducted.

But for now, no one knew just how hobbled America's two most wanted fugitives were. Walter Legenza was all but immobilized by his broken legs, and though Robert Mais still suffered from his gunshot wounds, he managed to assume some semblance of leadership among surviving members of the Tri-State Gang. The slight, innocuous-looking young man who seemed more like a mere beer salesman was now a much different person. Burnished and hardened by his murder conviction, months in jail and months on the run, as well as a string of shootings, murders, and robberies, Robert Mais was now tempered to a steely desperation. Weak and wounded, and with the black drive that only a man facing death can summon, Mais managed to bring together a group of unsavory characters to break into the Indiana, Pennsylvania National Guard Armory on December 18, 1934, and steal a large quantity of ammunition.[453] His confederates must have been equally desperate to sign on with the most wanted criminal on the East Coast, especially one with a reputation of killing anyone around him who knew too much.

The *Philadelphia Inquirer* linked the robbery to Mais's hopeless deadlock on both sides of the law, speculating that he was "preparing for a fight to the finish with the law and with gangsters who have sworn to kill him."[454] A few days after the armory raid, the New Castle, Pennsylvania, newspaper noted that now, even the western part of the state was subject to a police dragnet. The *New Castle News* opined that the stolen ammunition from the nearby town of Indiana could well be used in robbing one of its own banks or payroll couriers.[455]

Sure enough, Mais and four associates, each carrying sawed-off shotguns, robbed the Philadelphia Electric Company of $48,000 in cash the next day, blackjacking a guard and firing a shotgun through a door. Sixty employees who had lined up for their Christmas pay were instead left standing with

their hands in the air in front of the cashier's cage as the robbers made their getaway.[456] The police department, just to turn up the heat, privately expressed its fear that the gang would embark on another kidnapping plan of "some one of the numerous wealthy residents in the area." Even in the aftermath of the utility company robbery, "Detective Captain James Malone was confident today the officers were on the right track. He commented tersely, 'It was one of Mais' jobs.'"[457]

The growing groundswell of public outrage, the widespread police manhunt, and the risk of retribution by Philadelphia's own powerful gangs were all increasing the already strong odds against those who were left of the Tri-State Gang. Nobody wanted to live in a city under such constant threat. Nobody needed that kind of police attention. Nobody wanted to see Marie McKeever coming in the door, hat in hand, combining her appeal for help with an implied threat of the kind that sent William Weiss to a watery grave. Above all, nobody wanted the last thing they saw on Earth to be the muzzle of a pistol—and behind it, the utterly icy gaze of Walter Legenza. The common thug on the street must have chafed under the increased police scrutiny, generated by the constant drum of new revelations, gunfights, and robberies credited to Mais and Legenza.

The National Guard began to tighten security at its armories around the clock. The precaution was taken, the adjutant general said, "to provide a leaden welcome to Robert (Killer) Mais and his gang or any who may attempt to duplicate the recent raids on National Guard arsenals in Indiana and Norristown."[458] Entry into deserted and poorly guarded rural armories was relatively simple for experienced burglars like Legenza, and the loss of this source of Browning automatic rifles and .45-caliber service pistols was a serious blow to the gang. The area of high alert around Philadelphia now extended far into the surrounding counties.

In the city itself, people became increasingly nervous, especially after reading about the planned takeover of Eastern State Penitentiary by the Tri-State Gang. The scheme to assassinate the warden and fling open the doors was beyond belief—and yet the gang had built a considerable arsenal of powerful automatic weapons, enough to arm a whole squad of men. As fantastic as it sounded, the diabolical prospect of Philadelphia's streets flooded with hundreds of running, uniformed convicts must have given the good citizens a thrill of perfect horror.

Each of these things now shaped Marie McKeever's world. Who to trust, how to pay for it, and where to go became daily problems since the gang had been rooted out from the Sixth Street houses. Now they were all worse

than simply on the run—now most of their fellow gang members were in jail and their hard-earned armory in the hands of the police. Legenza was immobilized and couldn't make it across the room, let alone run from the police. Mais no doubt still suffered from his bullet wounds after his desperate flight in Baltimore. McKeever was under constant surveillance and could be picked up at any time by the increasingly frustrated Philadelphia police.

Marie McKeever's loyalty to her beloved "Bobby" and his pal Walter was complete. She had been arrested, held, and closely questioned by the cops, back when interrogation techniques, even when questioning a woman, were seldom gentle. The knowledge that McKeever was perfectly aware of Mais and Legenza's movements was especially galling to police and could have only added to the intensity of their questioning. To endure this kind of treatment and this kind of life must have held some future promise for McKeever. The robbery of the Federal Reserve truck in Richmond (which McKeever was certainly aware of) could have been the big score that would have set them all up for life, but it turned out to be worthless. She had been with Mais throughout their trial, had been part of the planning of their escape from the jail and was a party to multiple murders. No doubt she and Bobby were in love, a love weighted with too many wrong turns and too many bad breaks—like Bobby's life, a love with an inexorable downward trajectory.

Still waiting in the dim shadows was Anthony Cugino—a man in a parked car, at someone's kitchen table, or standing on a street corner at night. His presence was still felt. He and McKeever had a history of working together, if the "handsome man" who met McKeever in Lynchburg was, in fact, Cugino. "Tony the Stinger" was himself "most wanted" by police, and because he was a gangster killer, his fellow criminals eyed him warily and probably wanted him dead. His concealed membership in the Tri-State Gang was probably no secret among Philadelphia's killers and kidnappers, car thieves and burglars. They knew it could only have been Cugino who provided the badly needed cars, money, guns, and food to Mais and Legenza. They had no one else to turn to, especially when there were rumors that powerful men who desired less drama in the streets of Philadelphia had put bounties on their heads.

Despite the odds mounting against them, Mais and Legenza found a place to stay and perhaps also a shady doctor who was willing to examine them and treat them for their pain. Still, any help would have come at a high price, because those who helped the Tri-State Gang knew that they took enormous risk of being arrested for harboring criminals or being killed themselves.

Mais and Legenza's support was dwindling, either by attrition or fear, and the only cure for that was more money.

With the growing outrage over Robert Mais and what seemed to be a ceaseless parade of robberies and gunfights with the police during the city's 1934 holiday season, on December 21, 1934, the *Philadelphia Inquirer* ran an article headlined, "Mais Often Before Court; Was Rarely Punished." Calling him "Robert Mais, bad boy from Eastwick," the newspaper continued, "his criminal career started with a charge of 'breaking and entering'—and he beat it. It is ending with the electric chair waiting to clasp him in its arms, while he indulges in a final mad career of hold-up, robbery, kidnapping, torture, and murder."[459] The term "torture" refers to a rumor that Mais and Legenza harmed Weiss before killing him, although Weiss's body had still not been found to substantiate that claim. The *Inquirer* article listed all of the charges placed against Mais, concluding, "His recent escape from the Richmond, Va., jail, after he was condemned for a hold-up killing, brought him to his present campaign of terror in this city."[460]

Christmas came and went with no sign of Mais or Legenza. Back in Richmond, the gangsters' former pal Arthur Misunas said that he looked forward to a quiet holiday in jail, "a day of comparative peace and contentment," followed by joining the other prisoners for a dinner that Henrico Sheriff ordered for them. When asked to speculate on the whereabouts of Mais and Legenza, Misunas only admitted to closely following the two men's ongoing crime spree in Philadelphia. When a newspaper reporter came to interview Misunas, the burly gangster had a Bible on the table in front of him, opened to the book of Job. Several other Bibles were displayed around his cell, obviously there to impress. As usual, Misunas charmed the reporter, who was much taken with the gangster's calm and pious state.

Misunas had only left his cell in the Henrico jail once since his arrest in San Francisco the previous August, and then only to testify in Washington, D.C. Compared to the despairing Misunas who gushed out a confession to murder just before attempting suicide, the gangster now appeared if not sanguine then at least resigned while waiting to hear his sentence for his role in the Huband killing. He felt that if nothing else would save him, his cooperation with the authorities in Richmond and Washington might spare him from Virginia's electric chair, and that was the best he could do. He would pay a high price once he was sent to the State Pen, but for now, he looked forward to that holiday dinner. "'Merry Christmas and happy New Year,' the gangster called, and waved his hand as the reporter walked away from his cell."[461]

Elsewhere in Richmond during the holidays that year, peace and calm settled over the city. Even the heart of Richmond government, City Hall, fell almost silent. On Christmas Day, the only activity was in the basement at the Police Court, where the judgment of minor offenses continued. Petty burglars and chicken thieves were the most serious criminals brought before the judge, and thirteen drunks were either given small fines or placed under bond and released. "And at noon, its only activity disposed of, the city hall settled down for a little vacation of its own."[462] Richmond police stations reported an "abnormal calm" on Christmas Day, with few arrests in the city north of the James River and virtually no one having to be locked up in all of South Richmond.[463]

At Christmas, Richmond braced for another cold wave that swept into the East Coast from the Midwest, setting new records for low temperatures.[464] The frigid wind blew across backyards and vacant lots, all frozen as hard as the cobblestone streets. The temperature may have fueled business at the city's new state Alcoholic Beverage Control stores, which set a record in sales on Christmas Eve amounting to $39,000.[465] The injured Richmond jailer William Moore was released from Memorial Hospital so he could spend Christmas at home. He had been in the hospital for months, recuperating since being shot by Mais and Legenza during their jailbreak, and was still far from well.[466]

The year's end brought Richmonders the usual introspective review and statistical analysis for 1934. For example, 275 people died by violence of one kind or another during 1934, including 40 murders, more than 40 suicides, and 84 lives lost in accidents, from suffocation to falls. Contrary to plan, no one was executed at the Virginia State Penitentiary during 1934.[467] In Philadelphia, three anonymous phone tips during the holiday season sent detectives and machine gun squads rushing into the streets in a failed attempt to catch the fugitives from Richmond, but where Robert Mais and Walter Legenza spent their Christmas holiday was unknown.[468]

In contrast to the sober assessment that ushered out the old year, the *Richmond News Leader* trumpeted the arrival of the New Year in a huge headline: "Throngs Welcome Arrival of 1935." Newspaper reporters regularly consulted "Lady Wonder, Richmond's Famous Telepathic Horse," which lived near the Richmond-Petersburg Turnpike south of the city. The horse was beloved by readers, and the start of a fresh year seemed a perfect time to consult her. A rack system in her stall of large rubber buttons enabled the horse to indicate letters of the alphabet. Like an oat-fueled Ouija board, Lady Wonder spelled out coming events, predicting Roosevelt's

reelection, war between Germany and Japan, and the return of Prohibition to Virginia. The horse even correctly spelled out a newspaper reporter's last name, primly adding "MISS" when chided about manners.[469] But if Lady Wonder had any tips as to the whereabouts of Mais and Legenza, she kept them to herself.

On January 3, 1935, Arthur Misunas was hustled from the Henrico jail on Main Street and into a car escorted by a dozen armed policemen. They brought him to the Hustings courtroom in City Hall where, a few months before, he had testified against his former gang members. Judge Ingram explained to him that because he had been held for four terms of the court, there was question as to the legality of holding him longer without sentencing. "Misunas, looking as if jail had improved his health, agreed to the motion and thanked the judge for giving him 'a breath of fresh air.'" Through his court testimony in Richmond and Washington, Misunas had cut the best deal he could. Of all of the former members of the Tri-State Gang, he alone held some prospect of freedom in the distant future. "Don't worry, Bo," Misunas assured a guard, "I'll get out of that big house some day."[470] Despite his cheerful demeanor, "Dutch" must have concealed some terrible misgivings of eventually serving among the general population of the Virginia Penitentiary, where he would be known as a "rat" who sent his notorious colleagues to the electric chair to save his own life.

With the public outcry in Philadelphia against the Tri-State Gang and widespread disgust with increased crime in general, January 1935 was not a good time for two other former gang members to receive their sentences. An exasperated judiciary reflected the frustration of a city beset with criminal activity, principally emanating from one source: Robert Mais and his gang. Subsequently, on January 16, the law fell heavily on Frank Wiley and Charles Zeid. "I understand you're pretty tough," a Philadelphia judge snarled at Wiley, "How did you like crawling through that sewer?" Wiley was returned to the Eastern State Penitentiary from which he had escaped, to serve another twenty-five to thirty years. When Zeid stepped forward for sentencing, Judge Devitt asked, "Aren't you wanted for murder in Camden?" to which Zeid replied, "I don't know anything about that." "Well," the judge offered as he imposed his sentence, "when we get through with you, perhaps Camden won't want you."[471]

Clearly, Philadelphia had had enough of the Tri-State Gang, and the gangsters were through with the City of Brotherly Love. The remaining members of the Tri-State Gang—Robert Mais, Walther Legenza, Marie

McKeever, Edwin Gale, and Martin Farrell—all retreated to New York. There McKeever unwittingly brought the hammer down on them all. Philadelphia may have become unbearably "hot" for the gangsters, but it was home and held all the local knowledge that went with it. That same knowledge and those local contacts targeted William Weiss for kidnapping and allowed the Tri-State Gang to prey on other unfortunate victims there.

At the same time, however, working from home, so to speak, made Mais and Legenza vulnerable because their habits, cohorts, and methods were becoming familiar to the police, federal agents, and local crime figures. New York was different: gangsters there could depend on its vastness and anonymity to conceal them while they hid and regrouped. It was also the largest city near Philadelphia where Legenza might find medical attention for the broken bones in his legs. That had to be an urgent concern because enough time had passed since Legenza's leap from the embankment on December 14 that his legs may have begun to set incorrectly, making him permanently crippled.

There was plenty of exciting news back in Richmond, even during the mid-January lull. A local man, Harry Cassidy of Highland Park, was an expert witness in the kidnapping case involving the toddler son of world-renowned aviator Charles Lindbergh, testifying that the handwriting on the ransom notes was indeed that of Bruno Hauptmann.[472] Next, an early report came in from Ocklawaha, Florida, of a fierce machine gun battle with federal agents at a lakeside home rented to what was first identified as the "Blackburn Mob."[473] From La Salle, Illinois, came the account of a gang of four bank robbers who killed one cashier, wounded another, kidnapped a little boy, and shot and killed the local sheriff.[474] In Oakland, California, radio operators strained to hear any report from Amelia Earhart, who was attempting to fly solo from Hawaii to the U.S. mainland. In the end, though, "through clouds, fog, capricious winds and some hair-raising silence, Amelia Earhart Putnam emerged out of Pacific skies today," it was reported on January 13, and safely landed.[475]

Earhart's successful flight was quickly overtaken by more somber news a few days later, on January 17. The "Blackburn Mob" in the shootout with federal agents in Florida turned out to be "Ma" Barker and her son Fred. The two were wanted for their involvement in the kidnapping of Edward Bremer, a Minnesota brewer and banker. After the frame house they rented on Lake Weir was riddled by machine gun fire, it was discovered that both mother and son were dead inside.[476] Alvin Karpis and Ma's other son, Doc Barker, were still sought for the Bremer kidnapping and other crimes.[477]

Other news that caught the imaginations of newspaper readers in Philadelphia and Richmond on January 17 was a prison takeover at San Quentin, California. Using guns smuggled in to them, four prisoners took six hostages after almost beating the prison warden to death. Richmonders knew well the consequences of smuggled weapons, but that same account—combined with the picture of prisoners, with hostages, breaking out of a notoriously secure prison—must have given pause to many Philadelphians who lived in the shadows of the old Eastern State Penitentiary.[478]

Meanwhile, in New York, Legenza was admitted to Presbyterian Hospital under the name of "Charles Stewart."[479] His broken legs were put in casts so they could properly heal, and he settled into clean sheets for the first time in many days, with adequate pain medication finally offering relief from the anguish that had racked his slight body for the past several weeks. Lying in his hospital bed, Legenza may have passed the time thinking about reforming the gang, making plans, and meditating on new robberies. At the same time, he must also have known how vulnerable he was, and it was only sheer luck that would allow him to remain undetected until he could at least get around on crutches. There was nothing he could do other than savor the bed and the food and hope that his alias and his story held together. He watched the nurses and doctors carefully, examining their expressions for any sign that they knew he was anybody other than who he claimed to be, because the least sign of their fright, discomfort, or suspicion would indicate that the authorities, his arrest, and the electric chair were all close at hand—no matter what he did or said.

As Legenza watched the winter light filter through the hospital windows, he must have thought about that slender chance of his future leading anywhere but back to Richmond. What would a man like Walter Legenza recall with pleasure? Perhaps with a criminal's nostalgia he recalled successful burglaries and fat heists. No good memories would have come from his time in Virginia. Late at night, immobile in his hospital bed, he might have recalled a pivotal point in his life: that argument in the woods of Caroline County where he stood holding a pistol to the two bound and frightened truck drivers, their fate hanging by a thread. Looking back, Legenza probably regretted not following his instincts and killing them on the spot. Only the incredible adrenalin rush of the Richmond jail escape would have been a bright spot in his time south of the Potomac. An occasional visit by Marie McKeever interrupted any reveries Legenza

may have had and kept him informed about the rest of the gang. But there was little news. Everyone was lying low, hoping that the police and federal agents had lost their scent in the immensity of New York.

On the west side of Central Park, in an apartment on Manhattan Avenue, Robert Mais languished as he waited for McKeever to return with a report on Legenza's progress. He was thinner now, thinner even than when he left the jail in Richmond. His hair was dyed black, and he sported a small moustache. Every day, Robert Mais applied salve to the still-festering bullet wounds on his shoulder. His only comfort was the loyal McKeever. In her he found his only shelter in a world that called for his blood at every turn, and she, Legenza, and Cugino were the only people on earth he could trust not to lead him to execution.

Unfortunately for him and his Tri-State Gang partners, Legenza's quotation, "Me, I'm against women in gangs. They always get you in trouble" was about to come true in a catastrophic way. "It appears that Legenza was right," concluded the *Richmond News Leader* on the morning of January 18, below a headline that screamed, "Mais, Legenza, Captured in New York, to Be Returned to Virginia for Execution." The article told of the investigations in New York and "how Marie McKeever, pretty sweetheart of Mais, who has stuck with the two through many harrowing months, unwittingly led federal operatives to the quarry, was revealed today."[480]

The only person who could move about freely, McKeever kept the remaining gang members united by making the rounds of their hideouts and to the hospital where Legenza was recovering. The fact was that she and Bobby couldn't manage alone and needed the last few members of the now-tattered gang to elude the law. With the demise or capture of the rest of the gang in the assault on the Philadelphia row houses, and with Legenza being out of action, the last men standing—Edwin Gale and Martin Farrell—became essential to the rest of the gang. New and able members were needed to pull the heists that would finance some form of escape, and McKeever, as part of her rounds, checked on the two men on January 16.

As a news report later described it, "Shadows trailed her and found Gale and Farrell, the former allegedly an escapee from a Florida chain gang, in a mid-town hotel."[481] With the sound of a door bursting in and a rush of bodies, Gale and Farrell's small hotel room filled up with men in suits aiming guns at them before they could react. Federal agents, New York police, and Detective "Shooey" Malone of the Philadelphia police conducted the raid. Gale and Farrell were quietly bundled off to jail without either the press or McKeever knowing what happened after she left the hotel. "There was the

usual scuffling," recalled Frank Fay, the federal agent in charge, but "it was not necessary to fire a shot."[482]

Back at their hideout on Manhattan Avenue, Mais and McKeever reviewed their latest plans in low voices, followed by a parting kiss at the door. McKeever hurried away to check on Legenza and relay any news from the rest of the gang. The apartment door shut behind her as she strode off down the hall, intent on her tasks, but instead of their next planned meeting, Robert Mais and Marie McKeever never saw one other again.

At the same door the next morning at 5:00 a.m., federal agents and their Philadelphia and New York allies approached with stealth and even more caution. Men with rifles and Thompsons lined the rooftops along Manhattan Avenue and quietly filled the halls and stairwells of Mais's apartment building. They must have even obtained a key to Mais's door, because he was asleep when Agent Fay and his men burst in. The exhausted Mais woke to half a dozen shotguns and machine guns pointed at him as he sat up in bed. The police grabbed him and relieved him of a Savage automatic pistol and a dagger hidden beneath the covers.

The sole person in that Manhattan apartment looked so haggard that the police at first were not sure they had the right man. "They found only an emaciated figure in bed. At first they hardly believed it was Mais."[483] The escaped killer said nothing but shrugged his shoulders and surrendered. The account of the arrests in the *Philadelphia Inquirer* was rich with snappy dialogue, with one detective growling as Mais was led away, "I've always contended it. Mais was just a braggart. He was always yellow. Legenza was the real brains of the gang. Mais was just a figure-head."[484] In Washington, J. Edgar Hoover immediately issued a statement praising the "splendid cooperation" with other police agencies in the capture of the last of the Tri-State Gang. As for Mais quietly submitting to handcuffs, Hoover said dismissively, "Mais was too much of a dirty rat to do any shooting."[485]

Marie McKeever was arrested once she was out of sight of Mais's apartment. At Presbyterian Hospital, Legenza was the last to be picked up. Unknown to him, he was being observed by federal agents disguised as hospital staff, who confirmed that the patient named "Stewart" was actually Walter Legenza. "We put on white coats and went through," the Department of Justice's agent Fay recalled, "after that it was simple."[486]

Motionless and looking at the ceiling in his hospital bed, Legenza may have thought about the many times in his life he had slipped from police after burglaries and heists, killings and gunfights. He and Mais had barely made it out of Richmond concealed by egg crates, he had run from the fusillade

that had killed his pal Kauffman in Philadelphia, they had made the long and terrifying ride through the back roads of Tidewater Virginia after escaping jail in a hail of gunfire, they made it out of the raid on the house in Philadelphia, and for months they had eluded the East Coast's largest manhunt. Even with two broken legs, he had somehow survived and escaped.

This time it was different. As he watched the neatly dressed federal agents and their hard-eyed associates file into his hospital room, he knew what was coming. This time, there wasn't a damned thing he could do about it. Legenza listened as the federal agents formally accused him, at gunpoint, of being Walter Legenza. No, he protested in his distinct Polish accent. He was "Charles Stewart." He was handcuffed, bundled onto a stretcher, taken off to police headquarters and fingerprinted. It was over, and the way before him was clear, straight, and hard—all downhill to the old oak chair in the little dark, windowless room at the Virginia Penitentiary.

Mais tried to barter with police, offering his information about Weiss's body and drawing a map for the Philadelphia police just before being put on the train to Richmond. But either through exhaustion or an irresistible need to lie, Mais showed the body half a mile away from the actual site. In exchange for his information, Mais was allowed to spend ten minutes with the long-suffering Elizabeth Mais, who came up to New York to see her Bobby.[487]

Unlike Mais's typically meek, nervous appearance, Legenza's fixed, trancelike expression had been noted in the grand jury testimony. Richmond Detective Sergeant Orris Garton had seen it when he tried to chat with the gangster on the train from Baltimore to Richmond. Legenza's nerve, screwed down tight, would serve him well later on. He would soon reach a point where his steely resolve was all he had left. This was not the bravado of the gangster movies. No doubt he bore this same silent, stoic look as he rode in an ambulance through the streets of New York.

No one took much notice of the ambulance or its police escort. Behind his closed eyes, Legenza may have sensed that he was no longer living in the world he had known before. He knew he was on his way south to Richmond—and to his death.

Chapter 16

END OF THE ROAD

The "Havana Limited," a night train from New York, pulled into Richmond in a cold rain at 6:10 a.m. on January 22, 1935. Among the Pullman cars carrying vacationers headed for a connection to Cuba was a private drawing room car with the shades drawn tight. In it were Robert Mais and Walter Legenza, and the railroad car was their tumbrel, taking them to their execution. The agent of the Department of Justice's Bureau of Investigation named Francis X. Fay, who was sent to New York by Director J. Edgar Hoover to arrange the transportation, was overseeing their journey back to Richmond. Hoover was concerned with security and the amount of information that was being leaked to the New York papers. He wrote:

> *I stated that at the present time we do not know how many people are involved in this matter and that the interest of justice would be better served if everybody would keep their mouths shut. I stated that we have a very definite problem on our hands with getting Mais and Legenza back to Richmond; that is in our job and if anything goes wrong we would be held for it; that the longer we hold them, the more perilous that becomes.*[488]

Upon his arrival in Richmond, Legenza was brought out of the train on a stretcher, surrounded by a phalanx of federal agents, and then quickly loaded into an ambulance. Mais emerged from the train a few minutes later and was assisted to a wheelchair and rolled after his partner. Richmond police had deliberately not been notified of the transfer, and the few who appeared at the

station seemed content to leave the matter to the federal agents. A reporter was waiting at the station, though, and he observed Mais on the platform:

> *All that was left of the debonair appearance which characterized him all through his trial here last summer was a pearl gray snap-brimmed hat. He wore an unpressed suit and a dirty shirt, open at the neck. Since the jailbreak Mais has dyed his hair and grown a small black moustache. He puffed a cigarette which the man with him removed occasionally from his mouth. The desperado was so heavily manacled that he could lift his hands to his face only with difficulty.*[489]

A newspaper photograph was taken of Mais in his wheelchair at Broad Street Station, surrounded by federal agents. Several of the overcoat-clad federal men in the image carry machine guns, and it is evident from the position of the bolt handle on the top of the Thompsons that they are cocked and ready to fire in an instant. A large battery-powered lantern that was used to search the platform sits on the sidewalk, and the agents and the porters look to one side, no doubt for the car that will follow Legenza's ambulance to the Virginia Penitentiary. Mais stares dejectedly at the ground, and his black eye was probably not the only injury he had after four continuous days of questioning by the federal agents in New York.[490] Were it light, from his wheelchair Mais could have seen the concrete overpass where Huband was killed. The whole story had come full circle, through the courts, the jails, the bloody waste of life, and back to Richmond's Broad Street Station.

The two gangsters were received at the Virginia State Penitentiary shortly after arriving back in Richmond, but hours later they were bundled into a car and a police patrol wagon and taken back to the Hustings Court, where they had been tried. The confirmation of their sentences by Judge Ingram "not thought entirely necessary legally, but city officials indicated today that they merely wished to take no chances."[491]

When Robert Mais appeared in the Hustings courtroom, a photographer was there to capture the moment his death sentence was confirmed. In the photograph, the haggard, exhausted, and heavily manacled prisoner stands before Judge Ingram's bench, surrounded by police officers. The suit he wore on the train is now gone, and he wears prison-issue clothes and a coat, with a piece of paper sticking from the pocket. On Mais's right, Captain Alex S. Wright firmly holds on to one of the prisoner's handcuffs. On the other side, Detective O.D. Garton guards Mais on his left. "Mais,

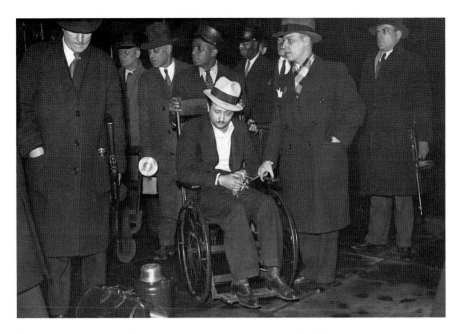

Bobby Mais returns to Richmond in a wheelchair, January 22, 1935. A dejected and manacled Robert Mais, sporting a mustache and a black eye, arrives for the last time at Richmond's Broad Street Station, surrounded by machine gun–toting federal agents. Standing to his left, holding on to him by his handcuff, is agent Francis X. Fay, charged by U.S. Justice Department chief J. Edgar Hoover to get Mais and Legenza back to Richmond and safely installed at the Virginia State Penitentiary. *Dementi Studio, Richmond, Virginia.*

his hands held tightly together, tried to put the formal legal order [for his execution] in his pocket. Captain Alex S. Wright, local detective chief, who was holding him, tucked the paper in the side pocket of the prisoner's olive convict coat."[492]

Legenza's appearance in the courtroom, half an hour later, was no more impressive than that of the broken Mais, even as he tried to keep his iron composure. "Legenza lay stolid and seemingly unhearing as Judge Ingram spoke. His eyes looked steadily toward the ceiling, but when the court order was tucked beneath his gray blanket, he closed them. All during the procedure his body shook. It was the first time that local officers had ever seen the man lose even a trace of the animal-like calm which characterized him during his trial and confinement here."[493] It was only when the steel doors of their cells on Death Row finally closed behind Mais and Legenza that afternoon that their escort finally relaxed. "As silent as they had been since the train pulled in, they waited in the

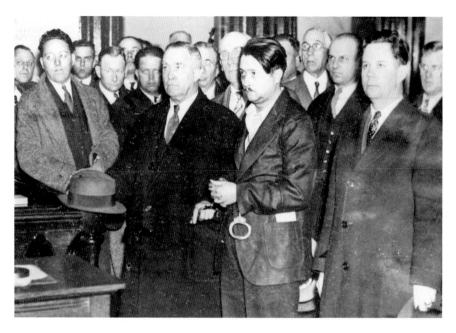

Mais surrounded in court, January 1935. Robert Mais, once again in court in Richmond, listens as the judge tells him that he has ten days to live before being electrocuted. A copy of his death warrant has been shoved into the left-hand pocket of his new prison jacket. Chief of Detectives Alex S. Wright, to Mais's right, holds on to the handcuff on Mais's wrist. Detective Sergeant Orris D. Garton, who followed the case from the beginning, stands to Mais's left. *Author's collection, wire service photo.*

anteroom for almost an hour while Fay received receipts for the gangsters and transacted other business."[494]

The ten days that were the legal minimum between sentencing and execution ran by quickly. In an effort to exonerate Marie McKeever from suspicion as being an accomplice to the escape from the Richmond jail, Mais spun an unlikely story of walking fifty miles through the woods of eastern Virginia from Fredericksburg to Alexandria, apparently in their matching Richmond jail uniforms. It was also revealed that Legenza had an aged mother living in New Jersey, but the condemned gangster said that "it would do no good bringing her here, and he would die without seeing any family members."[495]

About 150 people—including a brother and a cousin of Ewell Huband and two women—sent letters to penitentiary superintendent Youell asking permission to watch the executions of Robert Mais and Walter Legenza.[496] In contrast to the clamor for the two gangsters' executions was

the plea of eleven-year-old Miss Jean Dawson Burroughs of 1100 West Forty-third Street. Her letter to Governor George C. Peery said that Mais should be put in prison for life and have hard work to do. "That would teach him a lesson and he would realize what he has done. But whatever is done, let it be done with pity in our hearts and do not please the cruel curiosity of the public."[497]

Robert Mais and Walter Legenza must have dreaded their return to Richmond, Virginia, knowing that they would almost certainly live out their last days there. What irony to end up in this small town on the edge of Dixie, after so many triumphs in those big burly cities to the north. On the day before they were to be electrocuted, Mais and Legenza each wrote letters to be released to the public. Those letters are a tissue of lies about their criminal past, each calculated to provide alibis to the scattered remnants of the Tri-State Gang. Their very handwriting tells much about these two men on the brink of their painful and violent deaths.

Legenza's note, in looping cursive script and with many misspellings, seems more polished than one might expect from his lack of education. In essence, he denies any part in kidnapping William Weiss and accuses the Department of Justice agents of duping him into agreeing to a false confession:

> *February 1 / 35*
> *Richmond Penn, Va.*
>
> *I Walter Legenza do make this statement at 12.35 February 1st 1935, knowing that I shall die within twenty four hours and that there is no hopes of my living longer.*
>
> *To Who it may concern.*
>
> *I Walter Legenza on this date Jan 31th in the year of 1935 make this confession that at no time had I knowledge of Wiss being kidnapped and murdered at a house in Bucks County run by Mrs. B. Wilkins. I have been at this home and at no time did I see any Jewelry, Money or Wiss. While in Belleview Hospital on the second day there a Department of Justice man told me that Frank Farrell had a message for me I ask this man what it was. He told me if I would take the bleim in the Kidnapping of Wiss they would take me and Robert Mais to Phila instead of Richmond Va. Then this Department of Justice man gave me Frank Farrell confession to read it till all points were in my mind. This confession I had in my possession*

till he was relieved by an other man. The next day for eight hours that same Department of Justice man and Sup. Le Strange came for a Confession I mad[e] up one that was false to fit my part.

Walter Legenza
Witness: M. Haley Shelton[498]

Legenza also issued a rambling statement through his attorney, Haley Shelton, that began, "I want to tell the people of Richmond that I know I am going to the chair tomorrow morning." He also denied that either he or Mais had a part in the Huband murder. "I fully appreciate the fact that I have committed enough crimes under the laws of different States and also under the laws of the United States Government to put me in prison for many centuries and probably to electrocute me, but I did not kill Huband." Legenza did, however, cast guilt on Misunas and Lenore Fontaine, saying she stole the car used by "Kaufman, Phillips, Scottie and Misunas" in the Huband murder and that she actually drove one of the cars in the heist, dressed in men's clothing. In contrast to Fontaine's testimony that she didn't know how to drive a car, Legenza maintained that not only was she an "expert driver," but she also could hotwire a car better than any man he knew.

Legenza continued: "I am 42 years old and 30 years of that 42 I have been a gangster and burglar. I have associated with them almost the entire time, and all my career of crime and association with gangsters I have yet to see the gangster who is not more honorable and humane than certain members of the Department of Justice." He condemned the agents who tortured him into a confession at Bellevue Hospital in a soundproof room with "all keyholes corked." Legenza denied knowing or ever hearing of William Weiss before Department of Justice agents began asking him about the Philadelphia underworld figure that Legenza certainly kidnapped and shot through the head in the back of a speeding car. He said that somebody named "Johnson" had delivered the pistols to him in the Richmond jail but repeated the story that jailer Richard Duke had been given $200 to actually get them into the building. Pressed on this subject, Legenza said, "No, I won't talk. What do they care about me? What does anybody in Richmond care about me—an innocent man going to the chair?"[499]

After being traumatized at the Richmond jail, where he cowered under a table as gunfire roared around him, attorney Charles Moss gave up on the legal defense of Mais and Legenza. He said that he "washed his hands" of the case and would perform no further legal work for the pair.[500] His

associate, Haley Shelton, assumed the few remaining legal tasks for them. Legenza cautioned Shelton to have copies made of his statement because he believed that Shelton's office would surely be robbed by the Department of Justice and the papers stolen.[501]

Walter Legenza died as he lived, surrounding himself with a fog of aliases, half-truths, and outright lies, even with only hours to live. Those who ratted him out were cast in new roles as the real villains of the story. In Legenza's dying world, the Department of Justice and its dark methods were the ultimate evil. "The people at large don't know," Legenza said through Shelton, "but it is a fact that in the Department of Justice there is a certain department which maintains a certain number of men for the express purpose of killing and murdering any one that in any way tends to retard their undertaking to convict one whom they desired to frame."[502]

In his parting letter, by contrast, Robert Mais largely devoted his last efforts to protecting Marie McKeever. Mais had just two women in his life: his mother, Elizabeth Mais, and his girlfriend, Marie McKeever. He could do nothing more for his mother, who had thankfully left Richmond to receive his body at home in Philadelphia. She would long shed bitter tears over his loss. McKeever, however, was vulnerable to prosecution on a variety of charges besides the Hyattsville National Guard Armory break-in, and Mais knew that she was even more involved with the Richmond jailbreak than anyone suspected. The day before writing his last letter, Mais received a letter from McKeever, urging him to "be as cheerful as you can and don't worry about me" but at the same time urging him to write a statement that might help exonerate her from the Hyattsville robbery.[503] Mais also wrote a letter to Haley Shelton to accompany his "confession." He told Shelton that "Mary [sic] McKeever was arrested at the time we was in Baltimore and Legenza and my self took the full blame and now they are trying to place that charge on her."[504] He wrote, in full:

February 1, 1935
Vir. State Pen.
Richmond, Va.

Mr. Lestrange or To be turned over by you to whom this may concern.

Dear Sir:

In reference to a letter I received from Mary McKeever as to the Hyattsville armory of May, 1934. Mary McKeever at no time to the best of my

knowledge never in her life was in Hyattsville Md. She at no time knew that we was to rob this armory, and that she at no time before her arrest in June, 1934 did she see or hear of any guns taken from the armory. The robbery was committed by myself, Robert H. Mais, Walter Legenza, and another man who did not enter the place and who's name I do not care to mention at this time. Also, at no time did we discuss any robbery or holdup in her presence. I make this statement of my own free will.

Signed: Robert H. Mais

Witness: Walter Legenza
Witness: R.M. Youell, Supt. Virginia State Prison
Witness: H.E. Fitzgerald, asst Supt. Va. State Prison[505]

Observers reported that Mais grew repentant in his last days. A newspaper headline described Mais as "Once Heartless Killer Has Changed to Cringing Man" and quoted an anonymous but pragmatic guard who summarized the gangster's change of heart with, "He knows his goose is cooked."[506] Mais wrote one more note to Colonel F.W. Seiler, the Salvation Army chaplain who ministered to the two Death Row gangsters:

Dear Friend: just a few lines to let you know that I appreciate the spirit of which you come to us and try to help us in every way possible, also I have enjoyed your music and hymns in these dark hours.... I have lied, cheated, stolen and broken almost every Commandment, but I can still say that I have never murdered a man and that is one sin that I will never have to answer for. Thanking you and hoping that you will always be my friend and always give a thought to one who is trying to do right at this time and hope that sometime we may meet in the great beyond, I remain as always your friend, Robert H. Mais.[507]

Like Legenza, Mais parses the truth in this letter. His active participation in the murders of Ewell Huband, Officer Toot, and William Weiss clearly make him as guilty as his partner who pulled the trigger in each case. Mais believed that he was going to kill Lenore Fontaine when he stood in front of her and fired. Months later, as he watched her on the witness stand helping to put him in the electric chair, Mais no doubt wished that she had died. Attempted murder was probably what Major Youell was thinking of when he said cynically, "Mais said he never killed any one. The reason probably was that he was a poor shot."[508]

Though he was successful in helping the repentant Robert Mais, Colonel Seiler regretted not even having "gotten to first base" in his efforts to convince Walter Legenza to believe in the spiritual, either in this world or the next. "The 41 year-old criminal with the steel-gray eyes and the unchanging expression met his doom with the same cynicism which was his philosophy in life," reported the *News Leader*.[509]

"Colonel, I'm disappointed that you talk so much about religion," said Legenza, propped up in his cell with the two casts on his legs and still wearing the hospital garb he was given in New York. "Of course I believe in some kind of creative force," he told Seiler, "but I do not believe in such being as a Christian God. I think capital punishment is a Christian institution. But if 10,000,000 men have died before me, certainly whoever and whatever created me can look after me now. So why should I be silly enough to pray to Him?"[510]

January turned to February, and now the two men were surely done for. They had exhausted what thin chances they might have had for a delay in execution, they had said their piece, and the only thing left was that brief last day. Mais and Legenza were kept in adjoining cells on Death Row, separated by a sheet of steel that kept them from seeing each other, but they could still converse freely. Three guards on each shift, pacing back and forth in front of their cells, formed a death watch. What might they have heard the two doomed gangsters say? Reminiscing over past adventures? Those all too few moments of relaxation and pleasure? Their hideout on the Maryland shore? Late nights dancing at Club Forest, feeling flush after selling a truckload of cigarettes, or the incredible feeling of freedom as they drove out of Richmond, leaving the dolts who ran the Richmond jail far behind?

Even worse than he wanted a drink, Mais must have had an unbearable desire for the touch or even just the sight of Marie McKeever. The unyielding walls around him and the guards' constant pacing must have only added to a relentless sense of the inevitable. Mais's cell, filled with the pungent haze of cigarette smoke, must have mirrored his conflicted feelings, from visions of redemption to worries about his mother and his girlfriend.

"As far as their death cell attitude was concerned," Colonel Seiler later recalled, "there was the greatest contrast between these men, a contrast of darkness and daylight, white and black, heaven and hell. Mais showed a sweet disposition and I believe he was prepared to meet God. He spoke kindly of his mother, brother and sister." In contrast, he noted, "Legenza was the most difficult human being to talk with I ever encountered."[511]

After Legenza arrived in Richmond, the pittance he had in his possession when arrested was dutifully forwarded to the Virginia Penitentiary. "There was nothing remotely tender about Legenza. When Major Youell asked him, 'What shall I do with the 22 cents the New York police sent here as your property?' Legenza, remembering that he had in his hands probably $200,000 at one time or another, smiled a sardonic and bitter smile and said: 'Oh, keep it and buy yourself a battleship.'"[512]

How does it feel to measure one's life by hours—not days, months or years? Does the world become more vivid as life is distilled to its final precious drops? Who can really comprehend one's own obliteration and that the world will continue on effortlessly after we are gone? The saliva in the mouth, the stubble on the chin and the feel of the pulse—how can these things not continue but instead just stop as one's body is literally fried at the hands of these grim, pacing men who will live on, in spite of their own deadly deeds? How does it feel to be at the point where every moment since birth converges, funnel-like, and time itself comes to a brilliant, blinding focus?

Before that cold morning of February 2, 1935, more than 150 men and 1 woman had died in Virginia's electric chair.[513] Few witnesses to an electrocution were able to articulate the grisly details of what happened, but the process had a far different effect on the human body than the relatively benign mechanics of hanging, the previous method of capital punishment, or death by lethal injection, the one that followed. Mais and Legenza may have had jailhouse knowledge of what happens in the electric chair, but they would have heard nothing as succinct as the description of death by electrocution written by U.S. Supreme Court Justice William Brennan (served 1956–90):

> [The] *prisoner's eyeballs sometimes pop out and rest on his cheeks. The prisoner often defecates, urinates and vomits up blood and drool. The body turns bright red as its temperature rises and the prisoner's flesh swells and his skin stretches to the point of breaking. Sometimes the prisoner catches on fire, particularly if he perspires excessively. Witnesses hear a loud and sustained sound like bacon frying, and the sickly sweet smell of burning flesh permeates the chamber.*[514]

On that judgment day for Mais and Legenza, dawn rose in Richmond through a wintry haze of coal smoke and dust. First light fell on the turrets of the fantasy known as Pratt's Castle on nearby Gamble's Hill, as it had

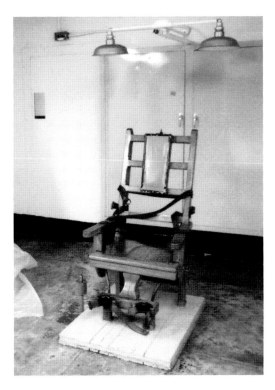

Virginia's electric chair, January 1991. In 1992, the Virginia State Penitentiary in Richmond was demolished, and the chair was moved to another prison facility outside the city. The chair and setting in this photograph, taken before that move, are the same ones that Mais and Legenza would have known in their last minutes alive on the morning of February 2, 1935. *Author's photo.*

each morning since 1854. As the sun crept along the James River Valley, it fell next on the small frame houses of Oregon Hill, across from the Penitentiary on South Belvidere Street. The high brick walls on the east side of the Pen began to glow in the winter sunrise, but the building's west portal—where the official witnesses to the electrocution of Robert Mais and Walter Legenza were gathered—remained in deep shadow. A small crowd of onlookers had gathered nearby on Spring Street, while police stood guard around the prison, shifting from one foot to the other trying to stay warm. Before long, the witnesses were brought inside under bright lights and carefully searched. Any policemen among them checked their weapons at the penitentiary armory just inside the door. A doctor came and went, after removing the plaster cast from Legenza's left leg.

Among the first men who reported to witness Mais's execution was Detective Sergeant Orris D. Garton, "whose relations with Mais and Legenza had been long and unpleasant," noted the *News Leader* in a masterpiece of understatement.[515] Garton had shared the cramped railroad compartment with the pair during their return to Richmond from Baltimore the previous summer and had worked on their capture. He had followed the

two gangsters' bloody trail from Broad Street Station to Philadelphia and New York and back to Richmond again. Garton had earned his invitation to see the story's end.

Newspaper reporters were barred from observing the electrocution, so much of what is known of those last scenes comes from the observations of the Salvation Army's Colonel Seiler. "I reached the death cell at 6:30 AM o'clock, together with the Reverend R.V. Lancaster, the prison chaplain," Seiler remembered. He read some psalms and parts of the "Sermon on the Mount" and then got his small concertina out of its case and played some of Mais's favorite hymns: "When the Roll Is Called Up Yonder," "What a Friend We Have in Jesus," and a song ironically titled, "Just As I Am Without One Plea." Seiler turned to Legenza and held the hand that had taken so many men's lives between his own. "I asked him 20 times during his last 10 minutes on earth to seek Divine mercy and forgiveness. And he never said a word."[516]

In 1908, the Commonwealth of Virginia became the fifth state to adopt the electric chair over death by hanging.[517] Virginia's chair is of a standard pattern, made of sturdy oak finished in the same yellow varnish that was once seen on wooden school desks. Rock solid, the chair's only concession to comfort is a small adjustable padded leather panel on the backrest. Above the chair, a bracket holds two shaded electric lights and the connection for the wires to the headpiece. Two half-circles of wood below the seat accommodate the straps that hold the ankles in place, and on the right side is a large grounding connector set into the concrete floor. The varnish on the armrests is worn away on the ends, the result of the grasping fingers of those 150 men and 1 woman clenching in agony as the current seared through them.[518]

Mais was the first to go, at 7:45 a.m. He emerged from his cell and, escorted by two guards, firmly walked the ten paces to the small room around the corner, his chin up and lips drawn in a hard, thin line. Upon leaving Legenza, he did not say a word—apparently any last thoughts between the two had already been expressed, and nothing more needed to be said. Mais shook Colonel Seiler's hand and said goodbye, then took his seat in the oaken chair, staring straight ahead as the straps were put across his arms, chest, and ankles. The medieval-looking spring-loaded metal headpiece, with a sponge soaked in salt water inside to ensure good contact, was put on his head and strapped under his chin.

One witness reported that Mais mumbled something inaudibly as the mask was put in place over his face. Three minutes after entering the death chamber, a guard standing in the corner of the room behind the chair threw

a switch, and two separate shocks sent Mais's body straining against the straps that held him in place. At 7:50 a.m., two physicians placed stethoscopes against Mais's hot chest and pronounced him dead.[519] William McGraw, secretary of the Virginia Prison Board, appeared in the penitentiary's reception room where the press had assembled, said, "Robert Mais went at ten minutes to eight," turned on his heels and left.[520]

Legenza would have been left alone with his thoughts for a few minutes after Mais disappeared through the door to the electric chair. What went through his mind during that time will never be known, but it was likely focused on keeping his composure. That was his specialty, and his steely attitude now sustained him at the moment he needed it most. Perhaps he first learned to block out fear and pain during those childhood beatings that he recounted in his talks with Colonel Seiler. It would have served as a foil against harsh treatment in a dozen different prisons and jails, when the questioning got too rough or when other inmates taunted the skinny gangster. He could have called on that same mental state to block the pain of his two shattered legs as he lay in that dark boxcar waiting for Mais to rescue him. And he would need every last iota of that frozen resolve to endure those last few seconds before the jailer threw the switch.

Legenza's last words were addressed to the two guards who lifted him from his cot to a wheelchair. "Handle that leg easy; it's sore," Legenza murmured. Still dressed in the hospital garb that had been provided to him in New York more than a week before, Legenza was wheeled through the door into the death chamber, where a second set of witnesses waited.

After Mais was declared dead by the attending physician, jail trustees would have removed his body, still frozen in a seated position, to a gurney in an adjoining room. Before Legenza was brought in to meet the same fate, they would have cleaned off the chair with disinfectant and mopped up any bodily fluids from the floor. As he was wheeled into the electrocution chamber, Legenza may have closed his eyes, as he did on his train ride back to Richmond, this time to avoid seeing the windowless room with that cold, hard contraption, the witnesses waiting in the shadows or the grim faces of the guards, Colonel Seiler, and prison officials. What he couldn't shut out were the muffled whispers, the footsteps that propelled him closer to the chair and the inescapable smell of burnt hair and flesh. Witnesses reported that after Mais was electrocuted, they saw a "vicious scar across his forehead caused by the burning of the copper head piece when he was electrocuted."[521] Regardless of anything he heard or smelled after his friend's demise, Legenza gave no sign.

Witness Irving N. Wharton said that Legenza appeared to be unconscious, "so steadily did he control his nerves as he shut his eyes and waited adjustment of the death straps." He continued to ignore Colonel Seiler, who was standing nearby and made several attempts to get Legenza to ask God's forgiveness. Only hours before, Legenza had told Seiler that life was like throwing dice: "Sometimes we win, sometimes we lose…it is all a gamble."[522] Legenza probably last rolled those fateful dice when he leaped off the railroad embankment at Wayne Junction. Now the crapshoot was over, the dice put away and the lights turned off—and the crowd waited to go home.

Hopefully, there was a second mask available in the death chamber so Legenza did not have to smell the stench of the one that had covered Mais's face before it was distorted by the electricity roaring through him. Once he was seated in the chair, the straps tested, and the guards backed away, Legenza braced himself in silence. The shuffling of feet nearby and the murmur of voices ceased except for the low drone of unwanted prayers as the onlookers took their places. There may have been the creak of a chair as the witnesses either leaned forward in involuntary, horrified anticipation or, like Legenza, grasped their armrests and braced themselves for what would come. A very long second or two of silence as the signal was given; one last intake of breath, and then the lightning arced across the darkness behind Walter Legenza's eyes.

Virginia Prison Board representative William McGraw again walked to the press area of the prison and made a second announcement: "Walter Legenza went at six minutes after eight." A reporter called out, "How did he go?" "I did not see him," McGraw replied gruffly, and that was that. The newspaper reporters and wire service writers rushed to their telephones and typewriters as the witnesses began to file out, some of them appearing "pale and glassy-eyed." One of them, who had watched Mais die, was described as "eyes unnaturally bright, teeth chattering." "He had plenty of nerve," the nameless witness stammered. "He murmured something while they were pulling the mask over his head, but we did not catch what he said." Then he added a simple but chilling phrase that summed up the horror of death by electrocution: "He was burned."[523]

The bodies of Mais and Legenza were removed from the penitentiary and taken to separate Richmond funeral homes. Mais's body was transported to Frank L. Bliley's at 105 West Grace Street. Legenza went to the Phaup Funeral Home several blocks farther west, at 828 West Grace, within a few blocks of 1140 West Grace, where attorney Haley Shelton and his wife, Virginia, lived.

Mais was laid out in the "crisp, blue suit" his mother had left for him during her last visit from Philadelphia. Mortician's makeup covered the burn scar on his forehead; in fact, one visitor commented that his "youthful face wore an expression of repose."[524]

With no family to look after him, Legenza lay for some time on a mortuary slab at the Phaup establishment, covered only by a sheet. According to a Richmond newspaper, a combined crowd of three thousand people ignored the cold and filed into the two funeral homes to view the gangsters' bodies. "Throngs of curious Richmonders—men, women and children—crowded past the biers of the executed gangsters yesterday afternoon and last night."[525] At Bliley's, a long line of morbid visitors filed slowly in and out. Many women wept silently as they passed, attendants said. Others approached within a few feet of the body and then hurriedly turned away. "Children under sixteen were barred from the room at an early hour yesterday," Mr. Bliley said, "but several hundreds of them of all ages came through the rooms in company with their parents."[526]

The scene was reminiscent of what happened the summer before, when thousands, including children, lined up to view the body of John Dillinger in the Chicago morgue. "When a cop suggested that a morgue was no place for a kid, the woman shot back, 'Who says so…? It'll be good for her. Teach her what happens to boys and girls that don't be good.'"[527] There may still be a few Richmonders alive today who, as children, were taken to Bliley's to see the dead body of Robert Mais. It would have been a valuable lesson in morality and the law. Mais's body was on view until late at night on the day he died, when, at his mother's direction, it was crated and put on the night train to Philadelphia.

A few blocks away at Phaup's, groups of twenty or thirty at a time were admitted to the room where Legenza was laid out. If anything could touch Legenza, if any sight could ever break through the hard shell that surrounded the man, the fastidious gangster would have been upset at the scene of his dead and burned body on display for the benefit of "the curious, sympathetic and vindictive" of the city he had so assaulted.[528] To add insult to injury, while his body was ogled by Richmonders, "an attendant obligingly lifted the covers to show the scars on the dead man's legs where the electric charge had seared the flesh."[529] Before long, Haley Shelton intervened and put an end to the grisly tableau of his former client, adding that he had talked to Legenza about the disposition of his remains, and the gangster had requested that he be buried nearby. Haley said that someone locally was making arrangements for his client's burial.

Three days after the executions, Arthur Misunas emerged from his new cell at the State Penitentiary at 7:00 a.m. and fell in line with the other prisoners assembling for breakfast. He was immediately attacked by three convicts armed with homemade knives. The burly Misunas, well aware that he was famous as a "dirty squealer," in Legenza's words, had taken the precaution of arming himself with a knife made of half a pair of scissors. Not only was he able to repel his would-be killers, he also managed to stab one of them in the stomach. The news made big headlines and threw the Tri-State Gang back into the newspapers, just as Richmond authorities must have hoped the story was over.[530]

An unsympathetic account of the attack in the *Richmond Times-Dispatch* began: "Two tough holdup men and a moron murderer, all three long-termers with escapes to their credit, momentarily revived the theory that there is honor even among thieves by attempting yesterday to kill Gangster Arthur (Dutch) Misunas."[531] The story was covered in a Maryland newspaper under the unadorned headline, "'Squealer' Is Attacked by Three Prisoners."[532] Even in far-off Nevada, readers of the *Reno Evening Gazette* read about the attack on Misunas and must have wondered, along with the country's most famous "rat," how he was going to survive two more decades of life in the pen.[533]

Linwood Geiger, Mais's Sunday school teacher, preached his former student's funeral oration at the house where little Bobby had grown up on Brewster Avenue in south Philadelphia. His "boyhood chums" and members of the Calvary Presbyterian Church surrounded Mais's flower-draped coffin. Geiger read aloud from a special delivery letter from Mais, written the day before his execution, in which Mais described himself as "never so hard-hearted as I was supposed to be, and that I never forgot my childhood days, when I used to go to Sunday school every Sunday…I would have liked to have you here with me at the last," Mais added miserably, "but I know that is impossible." He signed the note with his childhood nickname, "Bud."[534]

A cortege of twelve cars carried Mais's coffin across town from Brewster Avenue to Mount Peace Cemetery, where he was buried in a plot for three graves that had been purchased by Elizabeth Mais. His consumptive older brother, Chester, followed him to Mount Peace two years later, dead of a laryngeal hemorrhage. The two Mais brothers are buried without headstones on either side of an empty grave. Elizabeth Mais's subsequent fate is not

known, but she was not interred between her two sons at Mount Peace.[535]

It is difficult to characterize the relationship between Haley Shelton and his client Walter Legenza, but at some point they must have been close enough that Shelton promised the gangster that he would get a decent burial. The fastidious Legenza may have seen this as a postmortem reward for staying the course in his life and being true to whatever dark code he had observed. Legenza had probably been to any number of funerals in his past and developed his own notions of propriety. Shelton may have explained to his client that his in-laws owned a funeral home and that he could get Legenza buried

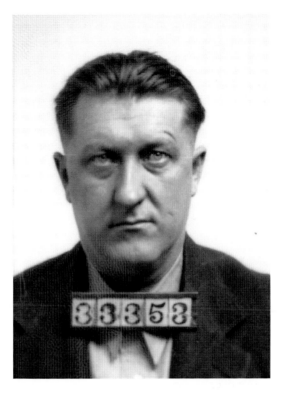

Mug shot of Arthur "Dutch" Misunas, taken upon his entrance to the Virginia State Penitentiary, February 1935. He would eventually serve sixteen years of a thirty-five-year sentence for his part in the murder of Ewell Huband at Richmond's Broad Street Station. *Library of Virginia.*

with some sense of dignity—a commodity that must have appealed to him after a lifetime spent in and out of institutions where decorum did not apply and dignity was left at the gate.

Even by rural standards, Orchid, Virginia, is a tiny place. It is not so much a crossroads as a cluster of pleasant houses, laid out on the ridge through Louisa County that carries Route 522 from Gum Spring to Cuckoo. Today, Orchid's only commercial enterprise is still the Lacy Funeral Home, established in 1872, and Haley Shelton's wife's family runs it now, as then. Haley Shelton had Legenza's body moved here from the macabre scene at Phaup's on Grace Street. A truck pulled up to the back door of Phaup's and took Legenza's body westward, through the snow-covered countryside to Orchid.

News of the arrival of the gangster's body at Lacy's spread quickly through the tiny hamlet, and nine-year-old Adelia Anne Shelton was one of those who heard it. Even people who lived out there in Orchid had been following the story of the Tri-State Gang for the past year, and everybody knew about the trial, escape, and recapture—especially since they had a local connection by way of the gangsters' defense attorney, Haley Shelton.

Seventy-one years later, Adelia Shelton Smith recalled the arrival of the body of Walter Legenza in her tiny Virginia hamlet: "Everybody around seemed to know that he was over here at Lacy funeral home. You know that Legenza is over there? That one that Haley Shelton was lawyer to? And he didn't have no where to be buried nobody claimed his body so he brought him up here to bury him." The interviewer for the oral history project asked, "What was he supposed to have done?" and Smith replied, "Oh, he kidnapped and murdered several people and all I can't remember the whole story. But I can remember those two purplish-blue spots right here on his temple that is where they put the electrode things…. The family was kind of against it but Haley Shelton didn't know what else to do with him I guess so they found a little patch right here…put him right here in the poison ivy [laughs]."[536]

The "little patch" where the Lacys agreed to bury Legenza was on the far corner of the funeral home property, almost in the right-of-way of Route 522. It is not an unpleasant spot, under some large oak trees that grew up on the neighboring property line. Cars and an occasional lumber truck rumble past only a few feet away, but there are long gaps in traffic where the only sounds come from the birds and the wind. There, in a shady corner of the yard, brushed by a few low vines and briars, is a flat stone marker, as terse as the spirit that lies beneath: "WALTER LEGENZA / FEB. 2, 1935."[537]

This tiny spot in the Virginia countryside is an unlikely resting place for a man whose life was devoid of repose. His tale twists and turns from the steppes of Poland, through Ellis Island, to a life of poverty in a Pennsylvania mining town. The boy who grew up speaking Polish, cringing under his father's hand, and collecting bits of coal to warm his family, developed into a man of desperate temperament who lived in desperate times. The rich soil of Prohibition, followed by the hungry decades of the Great Depression, germinated an army of thieves, bootleggers, hijackers, murderers, and kidnappers. Under such circumstances, a heavy curtain of lies was a basic coping mechanism for Walter Legenza. Perhaps men like Legenza are not so much evil as they are lacking in some essential human qualities. The eyes

Grave of Walter Legenza. The improbable last resting place of convicted killer and lifelong criminal Walter Legenza, in rural Louisa County, Virginia, is far from his hometown in eastern Pennsylvania. He was buried here with the help of his defense attorney, Haley Shelton. *Author's photo.*

that stare blankly at the police photographer—and us—in his mug shot speak volumes about what might have been missing in Walter Legenza. A lack of empathy or emotion and pathological lying, along with impulsive action, describes Legenza's life entirely. These traits are also the hallmarks of the classic sociopath.

THE END OF THE GANGSTER ERA

Alvin Karpis, of Chicago's Barker-Karpis gang, was fated to be the last of the classic 1930s gangsters. His arrest by the FBI in 1936 is widely regarded as the one that wrung out that unfortunate, bloody chapter of American history. Karpis is credited with being the most intelligent of all the gangsters of the period, and his biography reflects that. Aside from the fact that both Karpis and Legenza were thieves and killers, they were

men of wildly different character and intellect. Still, Karpis's summary of his own criminal career is equally fitting for Walter Legenza: "For the rest, there are no apologies, no regrets, no sorrows and no animosity. What happened, happened."[538]

AFTERMATH AND EPILOGUE

After Mais and Legenza were executed, cleanup of the Tri-State Gang continued. In Philadelphia, William Eckart agreed to testify against his two codefendants, Martin Farrell and Frank Wiley, implicating them in the murder of William Weiss. Eckart detailed Weiss's demise and the disposal of his body in the creek near Philadelphia. For the brutal murder and kidnapping that yielded only $8,000 ransom money from Weiss's wife (roughly $130,000 in today's cash), Eckart testified that "Mais, Legenza, Wiley and Farrell got $1,500 apiece. I got $500."[539] Former Tri-State Gang members John Dunn and Sam Berlin were first moved to the prison in Lorton, Virginia, and afterward were later sent to prison at Alcatraz as a result of Misunas's testimony in the Heurich Brewery robbery.[540] Charles Zeid, picked up during the raid on the Tri-State Gang's Philadelphia row house, eventually gained some small measure of fame as serving on New Jersey's Death Row with Richard Bruno Hauptmann, the convicted kidnapper of the Lindbergh baby. Hauptmann was executed in April 1936, and Zeid followed him to the chair two months later.[541]

Even peripheral players in the Tri-State Gang were rounded up. Matthew Barrow, one of Mais's friends from their old neighborhood, was described as a "Southwest Philadelphia tough fellow, who is said to have been the man who brought Mais, Legenza, Wiley and Farrell together."[542] Although Barrow's criminal role was not immediately defined for the press, a Philadelphia police lieutenant assured reporters that he "was definitely tied up with the Weiss kidnapping."[543] Barrow was immediately slapped

with a murder warrant after McKeever identified him in a Philadelphia police station.[544]

Many of these arrests and successful prosecutions were the result of Marie McKeever's efforts to trade her testimony for immunity or lenience in the various charges against her. She followed Mais's advice to "tell all, Marie, and save yourself."[545] Both McKeever and Beatrice Wilkinson, "housekeeper for the mob" in Philadelphia, traded their knowledge of the gang's activities for exoneration in the Weiss case.[546] As Barrow discovered, there was nothing left to keep McKeever from making a deal with the authorities, as there was nothing left of the Tri-State Gang to protect and she had everything to gain by bartering her testimony.

In contrast to Wilkinson, the "plump, small, clad in brown" woman pictured in court, McKeever's court appearance was that of a composed, well-prepared witness: "Marie McKeever, with her eyebrows plucked and arch, her lips scarlet against the pink and white of her face, was a most self conscious witness…'Bobby,' she said, she had known 'for five years.' In it all her voice, somewhat hampered by a touch of laryngitis, was modulated, almost cultured."[547] Despite her composure, McKeever must have blanched when she heard Martin Farrell testify: "While I was in New York I overheard a conversation that they had put $3,000 on the heads of Mais, Legenza, and Marie McKeever, that anybody who killed them would get the money."[548] Thanks in part to McKeever's testimony, both Farrell and Frank Wiley were sentenced to the electric chair on April 21.[549]

On September 9, 1934, Americans everywhere leaned toward their radios and listened to the news about Huey Long, the former Louisiana governor, senator, and presidential candidate who had just been shot and was hospitalized. That same day, Anthony Cugino hanged himself in his New York jail cell. Curiously, an article in a small Oklahoma newspaper described the many murders attributed to "The Stinger," adding, "Cugino was reputed to be the real leader of the Tri-State Gang ostensibly led by Robert Mais and Walter Legenza," and "authorities also believed that Cugino was the person who concealed two pistols in a baked turkey [sic] and sent it to Mais and Legenza while they were awaiting execution in prison in Richmond, Va."[550] A source for this information is not cited, but this one article in a far-off newspaper may confirm the hidden heart of the Tri-State Gang and how Mais and Legenza were able to escape from the Richmond jail. Ever in the background, Cugino is only glimpsed briefly in the story of the Tri-State Gang. It is only at the end, when he swung from an overhead pipe with his

shirtsleeve tied around his neck, that the veil is even partially lifted from "Tony the Stinger."

In November 1935, the last victim of the Tri-State Gang, Richmond police officer William Moore, died at his home at 4309 Forest Hill Avenue. Moore was one of the wounded who lay sprawled and bleeding as Mais and Legenza shot their way out of the city jail the previous summer. One of the three bullets that hit Moore had shattered a leg bone. After spending three months in Memorial Hospital, he had been convalescing at home but never completely recovered. After a failed attempt to return to duty in the summer of 1935, he was forced to retire on disability.[551]

Moore was buried at Mount Calvary Cemetery, not far from the grave of Madelyne Whelton, the girl who had been shot and left for dead at the Traveler's Hotel many months before and whose murder signaled the Tri-State Gang's arrival in Richmond. Who could have predicted the awful fate of the young good-time girl who wanted to break out of the claustrophobia of her father's Cary Street grocery? Who would have imagined the dire fate of the cop who was looking forward to the end of his shift? Now, their gravestones are bookends to a violent and shocking season in an unsuspecting southern city, one that thrust the national crime wave of the mid-1930s into the faces of the unwilling and the unprepared.

THEIR NAMES IN THE ANNALS OF GANGLAND

In 1936, a comic strip called *War on Crime*, by Rex Collier and Kemp Starrett, appeared in American newspapers. Collier was a valuable and sympathetic press contact who had been cultivated for the job by J. Edgar Hoover.[552] He was a good candidate to present the strip, described as "True Stories of G-Men Activities Based on Records of the Federal Bureau of Investigation," as part of a public relations effort, although a small disclaimer noted that the strip was partially fictional and was "Modified in the Public Interest."[553]

When the story of Mais and Legenza appeared in *War on Crime*, it became a lurid tale boiled down to a few daily four-panel strips. In one scene, a policeman leans over Mais's hospital bed and says, "How about that Union Station robbery at Washington—and that hold-up of the bank truck at Richmond?" Mais, smoke curling lazily from his cigarette, snarls back, "You're wastin' your time. I ain't talkative to-day!"[554] Marie McKeever herself may have seen the segment that featured one of her many police

Crime Does Not Pay comic book, 1948. "You're crazy, Legenza—you haven't got a chance of getting out of here!" The dialogue and illustrations by Bob Wood and Charles Biro in this "dime novel" capture the spirit, if not the facts, of Mais and Legenza's escape from the Richmond jail. *Author's collection.*

interviews. "Why did your pals shoot Philips' girl at Upper Darby?" a stern-faced policeman asks as he leans over "the captured paramour of Mais" in the first panel. "To keep her—from—I mean, they didn't do it! She must've shot herself!" stammers the cartoon McKeever in response.[555]

If Marie McKeever did follow herself in the funnies, it was probably from the vantage point of a new life under another name. She had ratted out everybody she possibly could and had taken every deal offered in exchange. Nevertheless, with that distinctive name, it was time to put Philadelphia behind. After federal charges against her were dropped, the canny McKeever disappeared. She knew that other gangsters would have placed a bounty on her head. After all, she had betrayed so many criminals who ended up in jail or just plain dead.

The memory of Mais and Legenza was still fresh in 1937 when the author of *American Nicknames: Their Origin and Significance* commented that since "[t]heir criminal record throughout the eastern part of the United States is comparable to that of the Dillinger gang in the Middle West, Walter Legenza and Robert Mais have been nicknamed by the police and by others the 'Dillingers of the East.'"[556] In the underworld fraternity of American gangsters, few titles could have been more flattering.

The Tri-State Gang made it into the comics again in 1948 when a fictionalized version of their story was the subject of a chapter in the comic book series *Crime Does Not Pay*. Despite the liberal use of exclamation points and overheated prose, the story in this issue managed to touch on the hard truth of "Walter Legenza the Gangster!" Legenza is described as "a sullen, murderous brute, who killed for the idiotic satisfaction he felt when he was spewing out his hatred of men with deadly lead! Nobody knows the total amount of murders he committed and no underworld counterpart ever forgot Legenza's two blood-thirsty rules: no dead man ever squealed, and women are dangerous!"[557] Like the real Walter Legenza, the fictional one is betrayed by a woman the gang tried to eliminate ("That lousy squealin' skirt—she's still alive!") and eventually winds up in what the comic strip author uniquely terms "the smoky chair" in Richmond.[558]

MISUNAS WALKS

In 1951, Arthur "Dutch" Misunas, who had famously told a guard, "Don't worry, Bo, I'll get out of that big house some day," walked out from the shade

of the brick walls of the Virginia State Penitentiary and into the sunshine of Spring Street. He had served sixteen years of his thirty-five-year sentence as an accomplice in the murder of Ewell M. Huband, getting half of his sentence set aside for good behavior and time off for years of making regular blood donations.[559] It is intriguing to think that the clothes he wore when he first went to prison might have been returned to him or that the stylish shoes he boasted of buying in Richmond, worn on the train when he was returned for trial, and stroked in the Henrico jail, may have been returned to him sixteen years later. Misunas still faced parole violation charges in Pennsylvania, but they were minor compared to what he had been through in his escape from the electric chair.

The now-demolished Virginia Penitentiary stood for generations like a concrete-and-steel Gibraltar overlooking the James River as it flows past Richmond. By 1951, the Great Depression was long over and Prohibition—with all the lives lost and all the effort and money wasted—was just an unpleasant chapter in regrettable legislation. The Second World War washed over much of the world while Misunas was in prison, and now a new conflict was raging in Korea. The tumult of the outside world was only dimly heard in the State Pen, its urgency conveyed perhaps only by the need for blood drives and the occasional newspaper.

The world moved on, but Arthur Misunas played his cards well and survived while most of his contemporaries had long been in their graves. Perhaps he returned to run a restaurant in San Francisco, where the cops had picked him up a lifetime before. Maybe his tattooed hand—that once gripped a Thompson under his coat or hoisted a beer at Club Forest—now held nothing more menacing than a spatula. Like Marie McKeever, the fifty-three-year-old Misunas had a memorable last name and had become infamous as a traitor and a rat. He, too, may have changed his name, and perhaps the middle-aged ex-gangster just sank into grateful anonymity.

MAIS AND LEGENZA ON SCREEN

The lurid tales of Mais, Legenza, and the Tri-State Gang inspired film and television writers on two occasions. In 1950, a second-rate film noir, *Highway 301*, told it as a much-altered story. If there is anything remarkable about the film, it is the unusual "newsreel" sequence at the beginning in which the governors of Virginia, Maryland, and North Carolina each speak directly

Movie still from *Highway 301*, a 1950 Hollywood film noir from Warner Bros., was directed and written by Andrew L. Stone and based on the legendary Tri-State Gang. "George Legenza" (Steve Cochran, standing at center) tells "Madeline Walton" (Aline Towne, in black dress, seated at right) to "keep your yap shut," while "Robert Mais" (Wally Cassell, standing at far left) looks on. *Author's collection.*

into the camera and give short, deadpan lectures how *Highway 301* is a valuable morality lesson for the pleasure-seeking, risk-taking youth of 1950. The segment has a peculiar effect, especially considering that a very violent film follows their monotone homilies. That film's odd opening sequence struck a chord with *New York Times* film critic Bosley Crowther:

> *The most disturbing and depressing of the many depressing things about the Strand's current Warner Brothers' shocker, "Highway 301," is the fact that governors in Maryland, Virginia and North Carolina endorse this cheap gangster melodrama as an effective deterrent to crime...the whole thing, concocted and directed by Andrew Stone, is a straight exercise in low sadism. And the reactions at the Strand yesterday among the early audience, made up mainly of muscular youths, might have shocked and considerably embarrassed the governors mentioned above.*[560]

Dark, handsome Steve Cochran plays *Highway 301*'s hard-boiled George Legenza, and Wally Cassell plays Robert Mais. Although most of the story wanders far from the facts, a few characters resemble the real persons. A

moll named "Madeline Welton," for example, tries to walk out on the gang and, of course, is shot and killed, just like Richmond's Madelyne Whelton. After many car chases, escapes, and shootouts, Mais and most of his fellow gangsters meet their fates at the hands of police. The movie ends with the death of Legenza, not only riddled with machine gun bullets in a train station shootout but also simultaneously run over by a locomotive for good measure. This is the kind of punishment that the dour governors of the mid-Atlantic states warned would be the inevitable fate of criminals everywhere. For gangsters like George Legenza in *Highway 301*, his crimes were so awful that his punishment had to go beyond mere death and on to complete obliteration.

ONE GANGSTER LIVES ON

Echoes of the Tri-State Gang were again heard in 1955 when John Kendrick was arrested in Chicago and referred to as part of the "old Tri-State Gang." Kendrick was fifty-three years old by then, and his decades of heists and murders were peppered with stretches in tough prisons like Alcatraz and Leavenworth. The days when he hung out joking and drinking beer under the oak trees at Club Forest with Bobby, George, and Dutch were long gone, but Kendrick was still as determined and deadly as he had been twenty years before.

Kendrick finally made it to the criminal hall of fame when he was added to the FBI's Ten Most Wanted List, where he fit the classic profile of a 1930s gangster: "A solid 200 pounder, standing five foot seven inches tall, with a yen for steaks, whisky, and double-breasted blue suits."[561] The bad old man still knew the drill. When the cops finally cuffed him and asked for his name, Kendrick snarled back, "Mr. No Name."[562] In 1956, Kendrick was sentenced five to seventeen years for shooting and paralyzing a man, which could have kept him in jail until 1973.[563]

When the Richmond-Petersburg Turnpike (today's I-95) was being built in the late 1950s, a wide swath of the city's building stock was demolished, cutting Jackson Ward in half and completely erasing the Navy Hill neighborhood. The resulting mountain of dirt and brick was dumped into Shockoe Valley, covering the site of the old Richmond jail, which was demolished in July 1957. The western end of Shockoe Valley is so changed today that it is impossible to point out the scene of Mais and Legenza's dramatic escape, Officer Toot's murder,

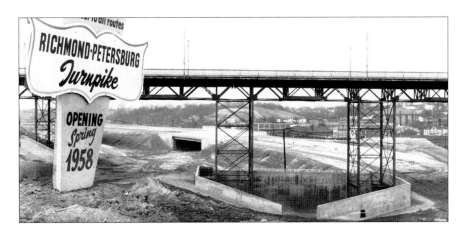

Highway Construction in Shockoe Valley, late 1950s, with the Marshall Street Viaduct still in place. Construction of the Richmond Petersburg-Turnpike destroyed the site of the Richmond City Jail. The former jail site, the area behind this sign, was covered with tons of fill dirt and buried beneath what is now Interstate 95. *Valentine Richmond History Center.*

or jailer Richard Duke's suicide. The cobblestones of Jail Alley, where the two gangsters stumbled to freedom in 1934, now lie deep below the river of cars and trucks on Interstate 95 that cross over the old site every day.

In 1959, the story of the Tri-State Gang was revisited by *The Untouchables* television series in its first season. The plot generally follows the history of the gang, with Alan Hale Jr. (who later played the Skipper on *Gilligan's Island*) appearing as "Big Bill" Phillips and Gavin MacLeod (later famous as Captain Merrill Stubing on *The Love Boat*) playing a fictional gang member oddly named "Artie McLeod." Bobby Mais, played by John Ward and described as "second in command, three time loser, San Quentin," is relegated to a minor role. William Bendix, who takes the role of "Wally" Legenza, conveys his character's intense expression and vicious demeanor but is considerably huskier than his historical namesake. *The Untouchables'* narrator, Walter Winchell, described Bendix's character in his trademark staccato style: "The leader of the gang was Wally Legenza, a pale, cold, blonde beast, untouched by any civilizing influences. The doctors at Dannemora once described him as a vicious antisocial animal, dangerous, ruthless, depraved." The TV segment opens with a hijacking, after which Legenza shoots and kills a truck driver bound to a tree.

As always in *The Untouchables*, leads are followed, clues wrung out of weak criminals, and shots exchanged, and Elliot Ness and his G-men prevail. In his effort to escape Ness and his agents during a botched ransom drop,

Legenza (Bendix) vaults over the fence of a polar bear exhibit in a zoo, breaks both legs in the fall, and cries piteously for Ness's help before the bears attack him. Winchell's breathless voice-over tells us that Legenza later died in Virginia's electric chair, but that final outcome seems a mere formality after the tough thug is reduced to a whimpering, pleading heap under Elliot Ness's withering scowl.

In June 1970, the last automobile crossed the outmoded Marshall Street Viaduct, which was demolished soon thereafter.[564] Its titanic shadow no longer moved across Shockoe Valley to mark the hours, and all traces of this tall Richmond landmark, with its massive steel superstructure and concrete pilings, have been erased.

Although the Tri-State Gang rankled Richmond for only a year, the memory of Mais and Legenza and their confederates was still occasionally recalled in the years that followed. In 1974, passenger service ended at Broad Street Station, and the concrete overpass across the railroad yard—once the scene of the Huband murder—was torn down. "Trestle With a Past" was the caption over the newspaper photograph.[565] It shows a wrecking ball working against the reinforced concrete arch where the Tri-State Gang members had once waited, smoking nervously, watching for oncoming headlights after Ewell Huband turned his Federal Reserve Bank truck off Broad Street in the last seconds of his life. Here is where Misunas, machine gun under his overcoat, winced when he heard the multiple gunshots from inside Huband's truck and where the terrified Benjamin Meade sank to the floorboards with the sound of gunshots hammering in his ears. Where that trestle once stood is now DMV Drive.

In 2004, on the seventieth anniversary of the Broad Street Station robbery and murder, a brief article appeared in the *Richmond Times-Dispatch*:

> *John Dillinger, Pretty Boy Floyd, Baby Face Nelson, Bonnie and Clyde are names ensconced in U.S. criminal folklore. All were major players in the winner-take-all crime spree of the 1920s and 1930s. In contrast, Robert Mais, Walter Legenza and their Tri-State Gang formed a minor constellation in the era of gangster stars. But when the Tri-Staters meteoric criminal careers crashed and ultimately burned in Richmond, the local impact was profound.*[566]

Interviewed for the anniversary article, Huband's daughter, Dorothy, recalled how Benjamin Meade, her father's assistant, would often come by

to check on the Huband family for many years after her father's murder, and that she was most grateful for this courtesy.[567] Meade stayed with the Federal Reserve for years after the incident and even became famous locally for his tap dancing. In his later years, Meade loved to tell about performing with Richmond's illustrious tap dancer Bill "Bojangles" Robinson.[568]

Charles Moss died in 1972, far outliving his legal associate Haley Shelton, who died in 1949.[569] Francis X. Fay, the federal agent who oversaw the arrest of Legenza and supervised the duo's return to Richmond in 1935, quit the Bureau of Investigation the same year and had a distinguished career as head of security for the Macy's department stores. He died in 1990 at the age of ninety-two.[570] His Richmond colleague, Detective O.D. Garton, had followed the story of the gangsters in Richmond from the beginning at Broad Street Station. He had shared the Pullman compartment with Mais and Legenza on what proved to be their first return to Richmond, and he knew instinctively that the city jail was no match for the secretive, brooding gangsters. Garton had stood beside Robert Mais when his death sentence was reinstated and had watched Mais die in the electric chair. The detective continued to rise through the ranks of the Richmond Police Department until he was appointed chief of police in 1947. Garton retired in 1960 after thirty-seven years of service to the city and died in 1962.[571]

As the decades rolled by, the story of the Tri-State Gang, Walter Legenza, and Robert Mais joined many other popular tales that have sprung from Richmond's long history. In 2008, a wonderfully garbled account of the gangsters' time in the city was published, describing the two criminals as "thumbing their way up Highway 301" after their escape from the Richmond jail and eventually being captured in a Church Hill home.[572]

Another imaginative, but sadly inaccurate, story about Mais and Legenza was published in 2010 by a relative of Officer William Toot. In it, "Lenora Fontaine" is presented as Mais's "former girlfriend." Further on, Mais kills a hit man sent on a failed mission to silence her and then attempts to bomb "Delaware Hospital" to eliminate the potential witness against the Tri-State Gang.[573] While the names Mais and Legenza are still recognized by some people in Richmond, what exactly they did in the city has, for the most part, entered the realm of urban legend.

In a grove of oak trees in Goochland County just off Patterson Avenue near Route 288, the ruins of Club Forest still stand.[574] Despite the passage of time and suburban sprawl around it, the wreckage of the old speakeasy and nightclub was never cleared away after it was blown up in 1934. Pieces of

The ruins of Club Forest. Dynamite and gasoline destroyed the once fashionable Club Forest in Goochland County as the trials of Robert Mais and Walter Legenza were underway in August 1934. The wreckage was never cleared away, and small sections of the famously pink stucco exterior walls still stand. *Author's photo.*

the club's famously pink stucco exterior are scattered through the woods, and only a small section of one wall still stands. The leaf litter of seventy-eight autumns mounds up over what is left of its foundation, commissioned so long ago by Herbert Myers. Beneath a large oak, the twisted remains of a metal folding chair protrude from the leaves, perhaps once occupied on the Club Forest stage by a member of Henry Bryant's Orchestra, which played there the year the club was dynamited.

That musician would have looked out over the smoke-filled dance floor packed with Goochland County locals and other couples who drove out from the city to have dinner, dance, drink, and wager at "Richmond's Most Exclusive Night Club." On the dance floor and in the back rooms would have been a few well-dressed men and women who stood out from the rest, whose shiny new automobiles sat in the parking lot next to the dusty pickups and older sedans of ordinary patrons.

The Tri-State Gang knew the place well, and it is not hard to picture them here. Bobby Mais would have been here with his sweetheart, Marie McKeever. Maybe she sat at a small table while Bobby used the pay phone

hanging from the wall in the back. Walter Legenza, not one for frivolity, would have leaned against the bar gazing blankly at the crowd. Lenore Fontaine, far from her native Montreal, stepped onto the dance floor with big "Dutch" Misunas as her boyfriend, "Big George" Phillips, scowled in disapproval nearby. Despite his size, Misunas was surprisingly light on his feet and may have enjoyed dancing in the new wingtips he bought at the Broad Street shoe store.

Three poker chips, found in the ruins of Club Forest. (Before the swastika, or fylfot cross, was subverted as a symbol of the Nazi Party, it was considered a symbol of good luck.) *J.D. Hollins Collection, courtesy of James Richmond.*

Tri-State gangsters Morris Kauffman and John Kendrick would also have been there, chasing the whiskey with a few cold beers. Hovering in the background was the club's proprietor, Herbert Myers (under the alias "Herbert Brooks"), keeping an eye on the crowd and the till as pretty Madelyne Whelton sipped cocktails with Nylah Roach. Myers's obsequious roommate, James Winn, would have been there, too, possibly circulating and bringing drinks to tables. Who knows, maybe the tough but dapper "Tony the Stinger" Cugino was also there, enjoying the safety and anonymity of this rural joint as he planned another cigarette truck heist.

With the passage of time, the image of the nightlife at Club Forest and the people who populated it moves farther away, until the lively music fades to silence and the strings of lights can no longer be seen in the dark Goochland night. The passions and thoughts of those people were just as real as ours are today, but they become harder to discern through the fog of the decades that divide us. Likewise, the facts of the extraordinary wave of crime in Richmond in 1934 have also been borne away, fading and distorting in the distance. Nevertheless, the grim reality of those crimes remains a vivid and bloody scar on Richmond's long and colorful history. This was a city utterly unprepared for that criminal onslaught, but in the end, justice—and Richmond—ultimately prevailed against Robert Mais, Walter Legenza, and the Tri-State Gang.

NOTES

CHAPTER 1: THE VALLEY AND THE JAIL

1. Although the modern Shockoe Valley is not the scene of confinement and punishment that it once was, nevertheless, as of this writing, the Richmond city jail is still located there, at 1701 Fairfield Way, about 3,500 feet north of where the first city jail stood. Due to ongoing overcrowding, plans are being discussed to build a new municipal jail on the same site.

2. John H. Wise, *The End of an Era* (Boston: Houghton, Mifflin, 1889), 80–81.

3. Samuel Mordecai, *Richmond in By-Gone Days* (1860; reprint, Richmond, VA: Dietz Press, 1944), 30–31.

4. Douglas R. Edgerton, *Gabriel's Rebellion: The Virginia Slave Conspiracies of 1800 and 1802* (Chapel Hill: University of North Carolina Press, 1993), 75–77, 105–112.

5. *Richmond Times*, "Richmond's Crowded Jail," August 18, 1895.

6. *Richmond Dispatch*, "Richmond," January 20, 1903, 1.

7. Eldridge B. Hatcher, *William E. Hatcher, D.D., LL.D., L.H.D.* (Richmond, VA: W.C. Hill Printing Company, 1915), 249.

8. *Richmond Dispatch*, "Richmond," January 20, 1903, 1.

9. *Richmond News Leader*, "Inadequacy of City Jail and Fight for Jail Farm Viewed," October 1, 1934, 13.

10. Ibid.

11. James K. Sanford, ed., *Richmond: Her Triumphs, Tragedies & Growth* (Richmond, VA: Metropolitan Richmond Chamber of Commerce, 1975), 155.

12. Ibid., 157.

13. Amity Shales, *The Forgotten Man: A New History of the Great Depression* (New York: Harper Collins, 2007), 105.

14. Marie Tyler-McGraw, *At the Falls: Richmond, Virginia and Its People*, (Chapel Hill: University of North Carolina Press, 1994), 263. Published for the Valentine, the Museum of the Life & History of Richmond.

15. Ibid.

16. *Richmond News Leader*, "Agents Arrest 280, Seize 153 Stills," January 29, 1934, 3.

Chapter 2: Walter Legenza

17. Nelson Algren, "The Captain Is a Card" (1942), in *Great Esquire Fiction: The Finest Stories from the First Fifty Years*, 68–69, ed. L. Rust Hills (New York: Penguin Books, 1983), 63.

18. *Richmond News Leader*, "Two Killers Cost City, Va., $1,000 but Still Free," October 6, 1934, 1.

19. *Richmond News Leader*, "Jury Quickly Writes Finis to His Career," August 22, 1934, 1.

20. "Proceedings of a Special Grand Jury to Investigate the Escape of Robert Mais and Walter Legenza, October 11, 1934," Richmond City, Hustings Court, vol. 1, box 924, the Library of Virginia (hereafter cited as "Grand Jury Minutes"), 264.

21. Ibid., 258.

22. "Ended Cases (Criminal Court), Qualification for Office, Pool Room Licenses, Adoption & Name Change Petitions, Ministers' Bonds, Jul–Aug 1934," Richmond City, Hustings Court, box 1130, Library of Virginia.

23. Reward poster distributed by the Post Office Department, Office of the Inspector in Charge, Richmond, Virginia, file no. 85785-D, December 10, 1934. Courtesy of the R. Pry Collection.

24. Eric Partridge, *A Dictionary of the Underworld, British and American*, 2nd ed. (New York: Bonanza Books, 1961), 691–92.

25. *Washington Post*, "1,000 Search 3 States; Killers Elude Traps," October 1, 1934, 1.

26. *Richmond News Leader*, "Alleged Slayer of Huband Has Served 8 Prison Terms," August 9, 1934, 1.

27. *Richmond News Leader*, "Legenza in Exclusive Interview Lays Plight to Former Gang Pals," August 28, 1934, 1.

28. *Richmond Times-Dispatch*, "Mais and Legenza Confessions Tell of Jail Break, Exonerate McKeever; Crowds See Bodies," February 3, 1935, 1.

29. *Fourteenth Census of the United States, 1920—Population* (Washington, D.C.: U.S. Department of Commerce, Bureau of the Census, 1920), 239. Summit Hill Borough, Carbon County, Pennsylvania.

30. *Richmond News Leader*, "Legenza in Exclusive Interview."

31. *Richmond Times-Dispatch*, "Two of the Mais-Legenza Confession Letters," February 3, 1935, 6.

32. *Richmond Times-Dispatch*, "Mais and Legenza Confessions."

33. Reward poster, December 10, 1934.

34. *Richmond News Leader*, "Legenza in Exclusive Interview."

35. Ibid.

36. *Fourteenth Census of the United States*, 239.

37. *Richmond News Leader*, "Legenza in Exclusive Interview."

38. *Plainfield (NJ) Courier News*, "Turner, Alias Legenza, and Spencer, Alias Dwyer, Easily Identified in New York Rogues' Gallery," July 21, 1926.

39. *Plainfield (NJ) Courier News*, "Police Find Accoutrements of Robber Band in House, Park Ave. So. Plainfield, Which Was Raided Saturday Afternoon," July 19, 1926, 1.

40. *New York Times*, "Rogers Gang Raid Gives Murder Clue," July, 19, 1926.

41. Ibid.

42. *Richmond Times-Dispatch*, "Mais and Legenza Confessions."

43. *Evening News*, "Car Barn Gang Being Rounded Up by New York Police," May 10, 1910, 1. Sault Ste. Marie, Michigan, and Ontario, Canada.

44. Patrick Downey, *Bad Seeds in the Big Apple: Bandits, Killers, and Chaos in New York City, 1920–1940* (Nashville, TN: Cumberland House Publishing, Inc., 2008), 80–81, 87.

45. *Plainfield (NJ) Courier News*, "Bandit Gang Under Arrest," July 21, 1926.

46. Downey, *Bad Seeds in the Big Apple*, 80–81.

47. *New York Times*, "Guilty in $29,000 Theft," November 2, 1926.

48. Downey, *Bad Seeds in the Big Apple*, 84. For online currency conversion, see http://www.westegg.com/inflation/infl.cgi.

49. *Sandusky (OH) Register*, "Pal's Gun Ends Career of 'Killer' Cunniffe as Detectives Close In," November 2, 1926, 2.

50. *Bluefield (WV) Daily Telegraph*, "Notorious Crook Caught by Police," November 26, 1926, 1.

51. Downey, *Bad Seeds in the Big Apple*, 87.

52. *Fifteenth Census of the United States, 1930—Population Schedule* (Washington, D.C.: Department of Commerce, Bureau of the Census, 1930), 212.

53. *Richmond News Leader*, "Tri-State Gang's History Reveals Hold-Ups, Murders," August 6, 1934, 1.

Chapter 3: Robert Mais

54. *Danville (VA) Bee*, "2 Gangsters Captured, 1 Is Wounded," June 5, 1934, 2.

55. *Richmond Times-Dispatch*, "McKeever Girl Exonerated by Bandit's Letters," February 3, 1935, 1.

56. Commonwealth of Virginia, Bureau of Vital Statistics, State Board of Health, Certificate of Death No. 3418, Robert Mais, February 2, 1935.

57. *Fourteenth Census of the United States*, 236.

58. Frederick Lewis Allen, *Only Yesterday: An Informal History of the 1920s* (1931; reprint, New York: Harper Collins Publishers, Inc., 2000), 161.

59. *Fifteenth Census of the United States, 1930—Population* (Washington, D.C.: Department of Commerce, Bureau of the Census, 1930), 113. Philadelphia City, Pennsylvania.

60. *Richmond Times-Dispatch*, "Mystery Veils 'Threat Note' to Mais Juror," September 1, 1934, 1.

61. United States Post Office Department, Office of the Inspector in Charge, Reward Notice, Case Nos. 64241-D, 85785-D, Washington, D.C., December 10, 1934.

62. *Washington Post*, "3 in D.C. Gang Captured; One, Shot, Is Dying," June 5, 1934, 1.

63. Grand Jury Minutes, 149.

64. *Kalispell (MT) Daily Inter Lake*, "Mother of Hoodlum Accused of Smuggling Guns into Prison," October 3, 1934, 1.

65. Grand Jury Minutes, 628–29.

66. Daniel Okrent, *Last Call: The Rise and Fall of Prohibition* (New York: Scribner's, 2010), 202.

67. Ibid.

68. Ibid.

69. United States Department of Justice, Division of Investigation, undated memo, perhaps a draft of information for a "Wanted" poster to be submitted to a printer for composing Robert Mais's bulletin. Obtained via Freedom of Information Act request on Mais, Robert.

70. Ibid.

71. *New York Times*, "Mais Arrested 23 Times," January 19, 1935.

72. Okrent, *Last Call*, 252.

73. Ibid., 252–253.

74. Ibid., 203.

75. Grand Jury Minutes, 109.

76. Reward poster, file no. 85785-D.

77. Federal Bureau of Investigation, Memo from Hoover to Special Agent in Charge, Washington, D.C., February 8, 1935.

78. *Chester (PA) Times*, "Police Reveal Names in Shooting of 'Gang Girl,'" May 25, 1934, 1.

79. *Richmond News Leader*, "Panel of 20 for Mais Trial Quickly Chosen," August 27, 1934, 1.

80. In the United States, the meaning of the term has meant "a gangster's female confederate" since the late nineteenth century. See Eric Partridge, *Dictionary of the Underworld*, 444.

81. *Tyrone (PA) Daily Herald*, "Gunman's Moll May Testify for State," February 19, 1935, 1.

82. *Hagerstown (MD) Daily Mail*, "Extradition of Gang Moll to Be Sought," February 1, 1935, 1.

83. Ellen Poulson, *Don't Call Us Molls: Women of the John Dillinger Gang* (Little Neck, NY: Clinton Cook Publishers, 2002), x.

84. Ibid., 252.

85. *Huntington (PA) Daily News*, "Robert Mais, Public Enemy of the East, Seized in New York," January 18, 1935, 1.

86. *Connellsville (PA) Daily Courier*, "Mais and Legenza Pay With Lives on 'Hot Seat,'" February 2, 1935, 1.

87. *Richmond Times-Dispatch*, "Marie McKeever Is Located, Maryland Police Announce," November 1, 1934, 1.

CHAPTER 4: THE MURDER OF MADELYNE WHELTON

88. William J. Helmer and Rick Mattix, *The Complete Public Enemy Almanac: New Facts and Features on the People, Places and Events of the Gangster and Outlaw Era, 1920–1940* (Nashville, TN: Cumberland House Publishing, Inc., 2007).

89. Ibid., 350.

90. Ibid., 358.

91. *Washington Post*, "Union Station Robbery Loot Found in Hut," December 10, 1933, 19.

92. Robert Unger, *Union Station Massacre: The Original Sin of Hoover's FBI* (Kansas City, MO: Andrews McMeel, 1997).

93. *Richmond Times-Dispatch*, "Prisoners Rush Guard, Escape from City Jail," December 22, 1933, 1.

94. *Richmond Times-Dispatch*, "Negro Fugitive from City Jail," January 5, 1934, 7.

95. Grand Jury Minutes, 84.

96. Ibid.

97. *Richmond Times-Dispatch*, "Police Seek Companion of Girl Fatally Wounded in Hotel Shooting Here," January 16, 1934, 1.

98. Ibid.

99. Ibid.

100. Ibid.

101. "Madelyne Whelton, Inquisition, Jan. 16, 1934," Richmond City, Hustings Court, Coroner's Inquisitions, 1932–35, box 421, the Library of Virginia.

102. *Richmond News Leader*, "Witness Tells Story of Whelton Shooting," January 16, 1934, 1.

103. "Whelton, Inquisition," Hustings Court.

104. Ibid.

105. The former Memorial Hospital is now part of the Virginia Department of Transportation complex on the south side of Broad Street.

106. *Richmond News Leader*, "Witness Tells Story of Whelton Shooting," 1.

107. Ibid.

108. *Richmond News Leader*, "Slain Girl's Rites Are Set for Today," January 17, 1934, 2.

109. *Richmond News Leader*, "Girl's Death Here Remains Unsolved," February 1, 1934, 2.

110. "Whelton, Inquisition," Hustings Court.

111. Ibid.

112. *Richmond News Leader*, "Witness Tells Story of Whelton Shooting," 1.

113. *Richmond News Leader*, "Reported Brooks Seen in Richmond," January 23, 1934, 3.

114. See the Inflation Calculator at http://www.westegg.com/inflation/infl.cgi.

115. *Richmond News Leader*, "Probe Cigarette Hi-Jacking Case," January 20, 1934, 1.

116. *Richmond Times-Dispatch*, "Police Seek Companion of Girl," 1.

117. Ibid.

118. *Richmond News Leader*, "Police Stage Long Chase in Gangster Hunt," May 31, 1934, 1.

119. *Hagerstown (MD) Daily Mail*, "Both Refuse Meal Before Execution," February 2, 1935, 1.

CHAPTER 5: THE CLUB FOREST

120. An excellent account of Club Forest and its place in Goochland County history can be found in James Richmond's "Gangsters in Goochland: The Fast Lives & Violent Deaths of the Tri-State Gang and Club Forest," *Goochland County Historical Magazine* 42 (2010): 12–37.

121. *Richmond News Leader*, "No Rebuilding of Club Forest," August 24, 1934, 1.

122. Richmond, "Gangsters in Goochland," 21.

123. *Richmond News Leader*, "No Rebuilding of Club Forest."

124. *Washington Post*, "D.C. Gunman Shot; Cleanup of Gang Near," July 20, 1934, 1.

125. *New Castle (PA) News*, "Recaptured Prisoner Dies of His Wounds," July 21, 1934, 2.

126. The site is now occupied by the Church of the Vietnamese Martyrs, which stands in approximately the same spot as the Club Forest filling station. The ruins of Club Forest are in the woods nearby.

127. Richmond, "Gangsters in Goochland," 29.

128. *Washington Post*, "Tri-State Gang Aids Blamed for Bombing," August 15, 1934, 5.

129. *Richmond News Leader*, "Night Clubs as Hide-Outs Here," June 6, 1934, 1.

130. *Richmond News Leader*, "Slain Mobster Former Owner of Club Forest," August 16, 1934, 1.

131. *Richmond News Leader*, "Reported Brooks Seen in Richmond," January 23, 1934, 3.

132. *Richmond News Leader*, "Girl's Death Here Remains Unsolved," 2.

133. The Hotel Rueger is today known as the Commonwealth Park Suites Hotel at 901 Bank Street.

134. *Richmond Times-Dispatch*, "Bandits Get $60,000 in Holdup Here," March 3, 1934, 1.

135. *Richmond Times-Dispatch*, "Dillinger, 'Cop Killer,' Waving Wooden Pistol, Escapes Indiana Jail," March 4, 1934, 1.

136. For a brief account of the Dillinger escape, see *Time* magazine's coverage of America's top ten prison escapes at http://www.time.com/time/specials/packages/article/0,28804,2067565_2067566_2067531,00.html.

137. Lenore Fontaine, a witness at Legenza's trial for the murder of Ewell Huband, contended that Legenza told her that he had taken part in the robbery on Ninth Street. See *Richmond News Leader*, "Legenza Implicated in $60,000 Bank Robbery," August 21, 1934, 1.

138. *Richmond Times-Dispatch*, "Ohio Official Flays Jailers of Dillinger," March 5, 1934, 3.

Chapter 6: Heist on Broad Street

139. *Richmond Times-Dispatch*, "Eye-Witness' Story Reveals Kidnap Threat," March 9, 1934, 11.

140. *Richmond News Leader*, "Statewide Hunt," 1.

141. *Richmond News Leader*, "Legenza Implicated in $60,000 Bank Robbery," 1.

142. *Richmond News Leader*, "Statewide Hunt."

143. Ibid.

144. *Richmond Times-Dispatch*, "Negro Porter Describes Slaying of Huband by Band of Gunmen," August 22, 1934, 2.

145. *Washington Post*, "Misunas Bares Tri-State Gang Deaths, Holdups," August 3, 1934, 3.

146. *Richmond Times-Dispatch*, "Eye-Witness' Story Reveals Kidnap Threat," 1.

147. *Richmond News Leader*, "Statewide Hunt."

148. *Richmond Times-Dispatch*, "News Didn't Take Long to Spread: 'They'd Killed Daddy,'" January 5, 1993, B-1.

149. *Richmond Times-Dispatch*, "Dillinger, 'Cop Killer,' Waving Wooden Pistol," 1.

150. H.L. Mencken, "What to Do With Criminals?" *Liberty*, July 28, 1934, reprinted in *Reader's Digest* 25, no. 149 (September 1934): 10.

151. Claire Bond Potter, *War on Crime: Bandits, G-men, and the Politics of Mass Culture* (New Brunswick, NJ: Rutgers University Press, 1998), 86.

152. John Baxter, "The Gangster Film," in *The Gangster Film* (London: A. Zwemmer; New York: Alex S. Barnes, 1970). Reprinted as Alain Silver and James Ursini, eds., *Gangster Film Reader* (Pompton Plains, NJ: Limelight Editions, 2007), 32.

153. Raymond Kresensky, "Dillinger Puts on a Show," *New Republic*, June 6, 1934, reprinted in *Reader's Digest* 25, no. 148 (August 1934): 29.

154. Jay Robert Nash, *World Encyclopedia of Organized Crime* (New York: Da Capo Press, 1993), 108.

155. Elliott J. Gorn, *Dillinger's Wild Ride: The Year that Made America's Public Enemy Number One* (New York: Oxford University Press, 2009), 137.

156. *Richmond Times-Dispatch*, "State Moves to Break Up Crime Gangs," March 10, 1934, 1.

157. Ibid.

158. *Richmond Times-Dispatch*, "'Dillinger Near Baltimore,' Is Police Warning," March 6, 1934, 1.

159. *Richmond Times-Dispatch*, "Discuss Radio for War on Bandits in Va.," March 10, 1934, 2.

160. *Richmond News Leader*, "Peery, Bright See No Funds for Police Radio," March 10, 1934, 1.

161. *Richmond Times-Dispatch*, "This Is Not a Wooden Pistol," March 19, 1934, 8.

162. *Richmond Times-Dispatch*, "Police Raid on Empty House Didn't Catch Bank Bandits," March 11, 1934, 8.

163. *Richmond Times-Dispatch*, "A Better Police System," March 10, 1934, 8.

CHAPTER 7: ESCAPE FROM RICHMOND

164. The agency is now known as United Methodist Family Services.

165. *Richmond Times-Dispatch*, "Bandits' Murder Auto and Mail Bags Found," March 13, 1934, 1. For comparative currency values, see: http://www.westegg.com/inflation.

166. *Washington Post*, "Misunas Bares Tri-State Gang Death, Holdups," August 3, 1934, 3.

167. *Richmond News Leader*, "Legenza Implicated in $60,000 Bank Robbery."

168. *Washington Post*, "Egg Crate Saves Life of Officer," July 29, 1934, 6.

169. *Richmond News Leader*, "Legenza Implicated in $60,000 Bank Robbery."

170. *Richmond News Leader*, "Capt. Alex S. Wright Rounds Out 40 Years of Service," March 10, 1934, 2.

171. Library of Virginia, "WRVA the Voice of Virginia," in the Radio in Virginia exhibition, accessible online at http://www.lva.virginia.gov/exhibits/radio/voice.htm.

172. *Richmond News Leader*, "Use of WRVA Is Offered to Local Police," March 12, 1934, 1.

173. *Richmond News Leader*, "May Give Radio-Call Cars to Police in Near Future," March 13, 1934, 1.

174. *Richmond News Leader*, "Dead Body Viewed for Local Bandit," March 14, 1934, 4.

175. *Richmond News Leader*, "Peery Urged to Meet Crime Wave Challenge," March 15, 1934, 1.

176. *Richmond Times-Dispatch*, "Two Are Nabbed Here in Hunt for Slayers," March 17, 1934, 1.

177. *Richmond News Leader*, "Run Down Clues in Hold-Up Here," March 17, 1934, 1.

178. *Richmond News Leader*, "No New Charges Against S.C. Men," March 19, 1934, 6.

179. *Richmond News Leader*, "Armed Outlaws Top Army, Navy Says Cummings," March 19, 1934, 1.

180. *Richmond News Leader*, "State ABC Board Planning Sales by April 2; Local Officers Sought," March 20, 1934, 1.

181. *Richmond News Leader*, "Board to Issue Beer, Wine Licenses First," March 21, 1934, 1.

182. Ibid., 1.

183. *Richmond News Leader*, "Senate to Speed Action on Bills Designed to Aid in War on Crime," March 27, 1934, 6.

184. *Washington Post*, "Young Capital Sleuth Rounded Up Dreaded Tri-State Gang," September 30, 1934, B-7.

185. *Danville (VA) Bee*, "Mais, Being Tried in Fatal Richmond Hold-up, Shot Her Girl Testifies on Stand," August 29, 1934, 3.

186. *Washington Post*, "Young Capital Sleuth."

187. Value of theft based on historic currency conversion found online at http://www.westegg.com/inflation/infl.cgi.

188. *Washington Post*, "Young Capital Sleuth."

189. *Gettysburg (PA) Times*, "Hijackers Loot Truck of $26,000 Cigarette Cargo," January 20, 1934, 2.

190. *Richmond News Leader*, "Tri-State Gang's History," 1.

191. *Washington Post*, "Young Capital Sleuth."

192. Ibid.

193. *Winnipeg (ON) Free Press*, "Canadian Girl, Caught in Web of U.S. Gang, Longs to Return to Own Land," August 18, 1934, 11.

194. *Richmond News Leader*, "Tri-State Gang's History," 1.

195. *Washington Post*, "Young Capital Sleuth."

196. *Washington Post*, "Probers Find Gun of Slain Gangster's Pal," April 15, 1934, M-15.

197. *Winnipeg (ON) Free Press*, "Canadian Girl, Caught in Web."

198. *Chester (PA) Times*, "Police Reveal Names in Shooting of 'Gang Girl,'" May 25, 1934, 1.

199. *Washington Post*, "Young Capital Sleuth."

200. Ibid.

201. *Winnipeg (ON) Free Press*, "Canadian Girl, Caught in Web."

202. Ibid.

203. *Albuquerque (NM) Journal*, "One Mad Gang's Trail of Hate Loot Murder and Love Across Three States," March 3, 1935, 17.

204. *Washington Post*, "D.C. Woman's Assailant Slain by Gangland," May 24, 1934, 1.

205. *Indiana (PA) Gazette*, "'Muscling In' Fatal to Gangster," May 24, 1934, 1.

206. *Richmond News Leader*, "Legenza Implicated in $60,000 Bank Robbery."

207. *Lake Park (IA) News*, "Philadelphia Police Issue Murder Primer," February 2, 1934.

208. Nash, *World Encyclopedia of Organized Crime*, 393–94.

209. The thirty-five-year-old Cugino was issued a license to marry Frances Ullo, age twenty-two, in January 1933. *Chester (PA) Times*, "Marriage Licenses Issued at Media [Pennsylvania]," January 16, 1933, 8.

210. *Miami (OK) News-Record*, "Gangster Accused of Eight Slayings Hangs Himself in New York Cell," September 9, 1935, 2.

211. Nash, *World Encyclopedia of Organized Crime*, 393–94.

212. *Lubbock (TX) Morning Avalanche*, "Two Men Are Ride Victims," November 2, 1933, 5.

213. *Cumberland (MD) Times*, "Killer Hangs Himself to End 'Life of Hell,'" September 9, 1933, 1.

214. *Hagerstown (MD) Morning Herald*, "Body of Gangster Tossed in Street," July 27, 1934, 16.

Chapter 8: Returned to Richmond

215. *Washington Post*, "Trio in D.C. Gang Seized; 1 Shot, Dying," June 5, 1934, 1.

216. *Richmond News Leader*, "Local Police Seek Return of Gangsters," June 5, 1934, 1.

217. *Danville (VA) Bee*, "2 Gangsters Captured," 2.

218. Ibid.

219. *Richmond News Leader*, "Gangsters Use Night Clubs as Hide-Outs Here," June 6, 1934, 1.

220. Ibid.

221. *Washington Post*, "Young Capital Sleuth."

222. *Winnipeg (ON) Free Press*, "Canadian Girl, Caught in Web."

223. *New Castle (PA) News*, "Recaptured Prisoner Dies of His Wounds," July 21, 1934, 2.

224. *Richmond News Leader*, "Arsenal Found in Car Here," August 1, 1934, 2.

225. *Richmond News Leader*, "Sun Increases Death Toll to Near 800 Mark," July 25, 1934, 1.

226. *Richmond News Leader*, "John Dillinger Starts Home in Basket," July 25, 1934, 1.

227. *Richmond News Leader*, "Haddon Requests Misunas' Return," July 25, 1934, 1.

228. *Richmond News Leader*, "Misunas Provided with Heavy Guard," August 15, 1934, 22.

229. *Richmond News Leader*, "Misunas, Friendless in Cell, Wonders If He Will Follow Pals to Death Seat," September 6, 1934, 2.

230. *Washington Post*, "Misunas Bares Tri-State Gang Death, Holdups," August 3, 1934, 3.

231. *Richmond News Leader*, "Misunas Pleads Guilty to Aiding and Abetting," August 9, 1934, 1.

232. *Richmond News Leader*, "Uses Razor Blade in Cutting Wrist," August 1, 1934, 1.

233. *Richmond News Leader*, "Misunas Declares Legenza, in City Jail, Huband's Slayer," August 2, 1934, 1.

234. *Washington Post*, "Misunas Bares Tri-State Gang Death, Holdups," August 3, 1934, 3.

235. *Washington Post*, "Alleged Killers in Bank Holdup Are Returned," July 27, 1934, 6.

236. *Hagerstown (MD) Daily Mail*, "Men Extradited to Face Charges," July 26, 1934, 12.

237. Grand Jury Minutes, 260–61.

238. Ibid., 261.

239. Ibid., 257–58.

240. Ibid., 264–65.

241. Ibid., 264.

242. *Richmond News Leader*, "Mais, Legenza Guarded Here," July 27, 1934, 25.

243. *Richmond News Leader*, "August 13 Picked as Date of Trial," July 27, 1934, 25.

244. Ibid.

245. *Richmond News Leader*, "Delay Is Refused to Mais, Legenza," July 30, 1934, 1.

246. *Winnipeg (ON) Free Press*, "Canadian Girl, Caught in Web."

247. *Richmond News Leader*, "Owner Puzzled by Blowing Up of Club Forest," August 13, 1934, 1.

248. Ibid.

249. Ibid.

250. *Richmond News Leader*, "No Rebuilding of Club Forest," August 24, 1934, 1.

251. "Owner Puzzled."

252. *Richmond News Leader*, "Legenza Trial Continued; Star Witness Hurt," August 13, 1934, 1.

253. *Richmond News Leader*, "Misunas Hints Gangmen Behind Club Bombing," August 14, 1934, 1.

254. *Washington Post*, "Tri-State Gang Aids Blamed for Bombing," August 15, 1934, 5.

255. *Richmond News Leader*, "Misunas Hints."

256. *Washington Post*, "Tri-State Gang Aids Blamed for Bombing."

257. *Richmond News Leader*, "Misunas Hints."

CHAPTER 9: LEGENZA ON TRIAL

258. *Richmond Times-Dispatch*, "Mrs. Fontaine Describes Movements of Legenza and Gang Associates," August 22, 1934, 2.

259. *Richmond News Leader*, "She Knew Too Much, Witness Says on Stand," August 29, 1934, 1.

260. *Richmond News Leader*, "Negro Porter Describes Slaying," 1.

261. *Richmond Times-Dispatch*, "Legenza Found Guilty of Murder of Huband; Will Die October 22," August 22, 1934, 1.

262. Ibid.

263. *Washington Post*, "Misunas Calls Legenza Truck Driver's Killer," August 22, 1934, 6.

264. *Richmond Times-Dispatch*, "Legenza Found Guilty."

265. *Danville (VA) Bee*, "Mais, Being Tried," August 22, 1934, 3.

266. *Richmond Times-Dispatch*, "Mrs. Fontaine Describes Movements."

267. Ibid.

268. *Washington Post*, "Misunas Calls Legenza Truck Driver's Killer."

269. *Richmond Times-Dispatch*, "Mrs. Fontaine Describes Movements."

270. *Richmond News Leader*, "Misunas' Dramatic Tale of Crime Proves High Spot of Legenza Trial," August 22, 1934, 2.

271. Ibid.

272. Ibid.

273. Ibid.

274. Ibid.

275. Ibid.

276. Ibid.

277. *Richmond News Leader*, "Legenza Awaiting Transfer to Death House," August 22, 1934, 1.

278. Ibid.

279. Ibid.

280. Ibid.

281. Ibid.

282. Ibid.

283. *Richmond Times-Dispatch*, "Legenza Found Guilty."

284. *Richmond News Leader*, "Legenza Awaiting Transfer."

285. *Richmond News Leader*, "Death Sentence First for White by Local Jury," August 22, 1934, 1.

286. *Richmond News Leader*, "Legenza Hoping to Cheat Chair," August 23, 1934, 2. Nansemond County became the independent city of Nansemond in 1972 and in 1974 was merged with the city of Suffolk.

287. *Richmond News Leader*, "Legenza Awaiting Transfer."

288. *Richmond News Leader*, "Police Boats Hunt $427,000 Hold-Up Clues," August 22, 1934, 1. For online currency calculator, see: http://www.westegg.com/inflation/infl.cgi.

289. *Washington Post*, "Legenza to Die for Murder of Truck Driver," August 23, 1934, 6.

290. *Richmond News Leader*, "No Rebuilding of Club Forest," August 24, 1934, 1.

291. Ibid.

CHAPTER 10: MAIS ON TRIAL

292. *Washington Post*, "Doomed to Die, Felon Will Aid Accused Pal," August 28, 1934, 6.

293. Ibid.

294. *Danville (VA) Bee*, "Ask Death Penalty for Robert Mais," August 2, 1934, 1.

295. *Richmond News Leader*, "State Pleads Mais Be Given Death Penalty," August 28, 1934, 1.

296. *Richmond News Leader*, "Panel of 20 for Mais Trial Quickly Chosen," August 27, 1934, 1.

297. *Washington Post*, "Doomed to Die."

298. Grand Jury Minutes, 629.

299. *Washington Post*, "Doomed to Die."

300. *Richmond News Leader*, "Doomed Man to Testify in Mais' Defense," August 28, 1934, 1.

301. *Richmond News Leader*, "Legenza in Exclusive Interview," 1.

302. Ibid.

303. Ibid.

304. Ibid.

305. *Richmond News Leader*, "State Pleads Mais Be Given Death Penalty."

306. Ibid.

307. *Washington Post*, "Girl Witness Faints; Delays Trial of Mais," August 29, 1934, 6.

308. Ibid.

309. *Richmond News Leader*, "Mrs. Fontaine Accuses Mais of Shooting Her," August 29, 1934, 1.

310. *Danville (VA) Bee*, "Mais, Being Tried," 3.

311. *Washington Post*, "One Gang Girl Calls Another Liar at Trial," August 30, 1934, 6.

312. *Richmond News Leader*, "Mais Case Nears Jury; Denies Part in Crime," August 30, 1934, 1.

313. Ibid.

314. Ibid.

315. Ibid.

316. Ibid.

317. *Richmond News Leader*, "Mais Case Nears Jury."

318. *Richmond News Leader*, "Faces Man She Said Shot Her," August 29, 1934, 1.

319. *Richmond News Leader*, "Mystery Veils 'Threat Note' to Mais Juror," September 1, 1934, 1.

320. Ibid.

321. *Richmond News Leader*, "Probe Report Juror in Mais Case Threatened," August 31, 1934, 1.

322. Ibid.

323. *Richmond News Leader*, "Misunas Reads Classics; Bans Modern 'Tripe,'" September 3, 1934, 1.

324. Ibid.

325. *Richmond News Leader*, "Mystery Veils 'Threat Note.'"

326. *Richmond Times-Dispatch*, "Mais and Legenza Are Believed Hiding in City, After Blasting Way Out of Jail, Wounding Three," September 30, 1934, 1.

327. *Richmond News Leader*, "Crime in the News," August 34, 1934, 8.

328. *Richmond News Leader*, "See Warning to Gangsters in Legenza, Mais Verdicts," September 4, 1934, 1.

329. *Richmond News Leader*, "Jails of Fifteen Va. Cities Better," September 4, 1934, 3.

CHAPTER 11: THE NEXT MOVE

330. Grand Jury Minutes, 447.

331. Ibid., 449.

332. Ibid., 448.

333. Richard Guy Wilson, ed., *Buildings of Virginia: Tidewater and Piedmont* (New York: Oxford University Press, 2002), 195.

334. Ibid., 451.

335. Ibid., 454.

336. Ibid., 461.

337. Ibid., 366–67.

338. Grand Jury Minutes, 603. The initials in the phrase "ABC store whiskey" refer to the Virginia Department of Alcoholic Beverage Control. Virginia has operated a monopoly of stores selling strong alcoholic beverages since the end of Prohibition.

339. Grand Jury Minutes, 604.

340. Ibid., 602.

341. Ibid., 605.

342. *Richmond Times-Dispatch*, "Prisoners Rush Guard, Escape from City Jail," December 22, 1933, 1.

343. Grand Jury Minutes, 365.

344. Ibid., 303.

345. Ibid.

346. Ibid., 365.

347. *Danville (VA) Bee*, October 1, 1934, 1.

348. Grand Jury Minutes, 626.

349. The modern spelling is "Buena Vista."

350. Grand Jury Minutes, 612.

351. Ibid., 613.

352. Ibid., 613–14.

353. Ibid., 622.

354. Ibid., 623.

355. Ibid., 625.

356. *Miami (OK) News-Record*, "Gangster Accused of Eight Slayings," 2.

357. Helmer and Mattix, *Complete Public Enemy Almanac*, 91.

358. Ibid.

359. *Richmond Times-Dispatch*, "Mais' Sweetheart Must Leave City," September 27, 1934, 3.

360. *Richmond Times-Dispatch*, "Misunas, Awaiting Trial Here, Explains Penchant for Shoes," September 29, 1934, 18.

361. Grand Jury Minutes, 474.

362. Ibid., 295.

363. Ibid., 266.

364. Ibid., 268.

365. Ibid., 276.

366. Ibid., 410.

367. *Saturday Evening Post* "Whole Chicken That's Better in 4 New Ways," January 4, 1930, 152, advertisement. The Hormel Company had just introduced canned chicken to its line of canned meats in 1928 and was quite proud of its innovative new products. See http://www.hormelfoods.com/about/history/historyOfInnovation.aspx.

368. Grand Jury Minutes, 190.

369. Ibid., 394.

370. Ibid., 397.
371. Ibid., 276.
372. Ibid.

Chapter 12: Jailbreak

373. Grand Jury Minutes, 481.
374. Ibid., 482.
375. Ibid., 483.
376. Ibid., 482.
377. Ibid., 483.
378. Ibid.
379. Ibid., 484.
380. Ibid., 485.
381. Ibid., 248.
382. Ibid., 233–34.
383. Ibid., 242.
384. Ibid., 193.
385. Ibid., 195.
386. Ibid., 179.
387. Ibid., 181.
388. Ibid., 195.
389. Ibid., 533.
390. Ibid., 211.
391. Ibid., 560.
392. Ibid.
393. Ibid., 561.
394. *Richmond Times-Dispatch*, "Mais Wounded, Fell in Street, Officer Relates," September 30, 1934, 2.
395. Ibid.
396. *San Antonio (TX) Express*, "Condemned Pair Shoot Way Out," September 30, 1934, 1.
397. *Richmond News Leader*, "Heroic Officer, W.A. Toot, Dies; Gun Refutes Rumors," October 4, 1934, 14.
398. Daryl Comber Dance, *Long Gone: The Mecklenburg Six and the Theme of Escape in Black Folklore* (Knoxville: University of Tennessee Press, 1987), 71.

CHAPTER 13: THE FALLOUT

399. *Frederick (MD) Post*, "Seek Desperados in Baltimore," October 23, 1934, 3.

400. *Washington Post*, "Roosevelt Acts to End Breaks in 'Weak Jails,'" October 6, 1934, 10.

401. *Richmond Times-Dispatch*, "Detain 2 in Dillinger Break Quiz," October 30, 1934, 1.

402. Among the jurors empanelled was Louis F. Powell, father of the future Supreme Court justice Lewis F. Powell Jr. (The elder Powell changed the spelling of his first name.) See John Calvin Jeffries, *Justice Lewis F. Powell, Jr.* (New York: Fordham University Press, 2001), 16. See also *Richmond News Leader*, "Special Grand Jury Opens Escape Probe," October 11, 1934, 1.

403. Grand Jury Minutes, 217.

404. Ibid., 366.

405. *Richmond News Leader*, "Sergeant Before Probe Jury," October 15, 1934, 1.

406. *Richmond News Leader*, "Jail Escape Urges Ouster of Saunders, Son, and O'Conner," October 27, 1934, 1.

407. Grand Jury Minutes, 408.

408. *Richmond News Leader*, "Questions for the Grand Jury," October 1, 1934, 8.

409. *Richmond Times-Dispatch*, "No 'Baked Chicken' on Misunas' Menu," October 30, 1934, 1.

410. *Richmond Times-Dispatch*, "Marie McKeever Is Located," 1.

411. *Richmond Times-Dispatch*, "Mais Reported in Philadelphia," November 8, 1934, 10.

412. *Richmond Times-Dispatch*, "Mais, Legenza Report Brings Tunnel Search," November 14, 1934, 6.

413. *Tyrone (PA) Daily Herald*, "Sharpshooters Out to 'Get' Gangster," October 27, 1934, 1.

414. *Richmond Times-Dispatch*, "Marie McKeever Is Located," 1.

415. *Anniston (AL) Star*, "Convict Break Foiled by Rats in Sewer," July 22, 1934, 1.

CHAPTER 14: CRIME SPREE IN PHILLY

416. William J. Helmer and Rick Mattix, *Public Enemies: America's Criminal Past 1919–1940* (New York: Barnes & Noble, Inc., 1998), 38.

417. *Oshkosh (WI) Northwestern*, "Hunt Kidnapped Philadelphian," November 21, 1934, 1.

418. *Winnipeg (ON) Free Press*, "Philadelphia Citizen Reported Held for $100,000 Ransom," November 20, 1934, 1.

419. *Connellsville (PA) Daily Courier*, "Racketeer Believed Slain by Kidnappers," November 20, 1934, 1.

420. *Oshkosh (WI) Northwestern*, "Fear Victim Is Slain Owning to No Ransom," November 21, 1934, 1.

421. *Chester (PA) Times*, "Farrell, County Convict, Faces Chair in Killing," January 23, 1935, 1.

422. *Philadelphia Inquirer*, "Ex-Pal Names 2 Mais Aides as Weiss Slayers," February 27, 1935, 1.

423. Ibid.

424. *Port Arthur (TX) News*, "Believed Slain," November 20, 1934, 1.

425. *New York Times*, "Weiss Still Alive, Federal Men Hear," November 26, 1934.

426. *New York Times*, "Arrest Expected in Weiss Abduction," November 25, 1934.

427. Ibid.

428. United States Department of Justice, Federal Bureau of Investigation, Robert Mais file, Memorandum, January 7, 1935. "P.O." likely refers to the Post Office, predecessor to the United States Postal Service, that would have issued the "Wanted" posters. A "J.O." is presumably a Department of Justice order or warrant.

429. *Tyrone (PA) Daily Herald*, "Bare Gang Rivalry in Killing of Weiss," March 2, 1935, 1.

430. *Washington Post*, "Court Is Arsenal as Misunas Tells of Holdup Here," November 27, 1934, 1.

431. *Richmond Times-Dispatch*, "Will Sentence Misunas Soon," December 5, 1934, 12.

432. Ibid.

433. *Richmond News Leader*, "Wind Dies Here but Florida Hit," December 12, 1934, 1.

434. *Richmond News Leader*, "Crisis Deepens in Family Fund," December 13, 1934, 1.

435. *Richmond Times-Dispatch*, "Owners of Va. Homes Facing Foreclosures," December 15, 1934, 1.

436. *Philadelphia Inquirer*, "Mais Flees; Police Raid Gang Arsenal," December 14, 1934, 1.

437. *Richmond News Leader*, "Blood and Murder Cover Paths of Pair Which End in Va. Death House Tomorrow," February 1, 1935, 1.

438. Ibid.

439. *Philadelphia Inquirer*, "Ill Girl, Mother Terrorized by Police Gang Raiders," December 15, 1934, 1.

440. *Philadelphia Inquirer*, "Mais Flees."

441. *Philadelphia Inquirer*, "Plot On 'Pen' by Killers of Weiss Foiled," December 15, 1934, 1.

442. *Richmond News Leader*, "Mais Gets Out of Police Trap," December 14, 1934, 1.

443. *Reading (PA) Eagle*, "Verdict Will Send Gangster to Chair," April 27, 1935, 2.

444. Ibid.

445. *Philadelphia Inquirer*, "Mais Flees."
446. *Philadelphia Inquirer*, "Plot On 'Pen.'"
447. *Charlestown (WV) Gazette*, "Weiss Kidnapped by Gang, Body Thrown in River," December 15, 1934, 11.
448. *Philadelphia Inquirer*, "Plot On 'Pen.'"
449. Ibid.
450. Ibid.

CHAPTER 15: ON THE RUN

451. Jeff Guinn, *Go Down Together: The True, Untold Story of Bonnie and Clyde* (New York: Simon & Schuster, 2009), 354.
452. Okrent, *Last Call*, 365.
453. *Indiana (PA) Evening Gazette*, "Armed Guard at All Armories," December 21, 1934, 1.
454. *Philadelphia Inquirer*, "New Armory Raid Is Laid to Mais," December 20, 1934, 2.
455. *New Castle (PA) News*, "Escaped Killers Being Hunted in Indiana, Pa., Area," December 20, 1934, 1.
456. *Richmond News Leader*, "Mais Believed Leader in $40,000 Holdup," December 20, 1934, 1.
457. *Indiana (PA) Evening Gazette*, "$48,000 Theft Laid to Mais Gangsters," December 21, 1934, 1.
458. *Indiana (PA) Evening Gazette*, "Armed Guard at All Armories."
459. *Philadelphia Inquirer*, "Mais Often Before Court; Was Rarely Ever Punished," December 21, 1934, 12.
460. Ibid.
461. *Richmond News Leader*, "Misunas, Safe in Jail, Silent on Mais Chase," December 24, 1934, 2.
462. *Richmond News Leader*, "Two Sentenced in Yule Season," December 25, 1934, 1.
463. *Richmond News Leader*, "Abnormal Calm Seen at Police Stations," December 25, 1934, 1.
464. *Richmond News Leader*, "Severe Cold Wave Is Sweeping East," December 26, 1934, 1.
465. *Richmond News Leader*, "Liquor Stores Gross $500,000," December 26, 1934, 1.
466. *Richmond News Leader*, "Jail Deputies Not Yet Ousted," December 22, 1934, 1.
467. *Richmond News Leader*, "275 Violent Deaths Here During 1934," December 31, 1934, 1.
468. *Richmond News Leader*, "3 Anonymous 'Tips' On Mais Are Futile," December 26, 1934, 2.

469. *Richmond News Leader*, "'Lady' Gazes at Future and Sees Va. Dry Again," January 1, 1935, 1.

470. *Richmond Times-Dispatch*, "3 Desperate Killers Housed in Quiet, Old Henrico Jail," January 7, 1935, 2.

471. *Philadelphia Inquirer*, "Two Mais Gangsters Given Long Terms," January 17, 1935, 4.

472. *Richmond Times-Dispatch*, "Richmonder, 2 Others, Link Bruno to Notes," January 16, 1935, 1.

473. *Richmond Times-Dispatch*, "Federal Force, Gangsters in All-Day Fight," January 16, 1935, 1.

474. *Richmond Times-Dispatch*, "Killers of Banker Also Slay Sheriff," January 16, 1935, 1.

475. *Philadelphia Inquirer*, "Miss Earhart Wins in Solo Hawaiian Hop," January 13, 1935, 13.

476. *Richmond Times-Dispatch*, "'Ma' Barker and Son Are Slain by Agents in 6-Hour Gun Fight," January 17, 1935, 1.

477. *Richmond Times-Dispatch*, "Gangsters Sought by Agents," January 17, 1935, 1.

478. *Richmond Times-Dispatch*, "4 Stage Break at San Quentin," January 17, 1935, 1.

479. *Philadelphia Inquirer*, "Kidnapping Foiled by Mais Arrest," January 19, 1935, 1.

480. *Richmond News Leader*, "Mais, Legenza, Captured in New York, to Be Returned to Virginia for Execution," January 18, 1935, 1.

481. Ibid.

482. *Charleston (WV) Daily*, "Federal Men Grab Mais, Four Others in New York Drive," January 18, 1935, 1.

483. *Philadelphia Inquirer*, "Kidnapping Foiled by Mais Arrest."

484. Ibid.

485. *Richmond News Leader*, "Mais, Legenza, Captured in New York."

486. *Washington Post*, "Farrell Guides Police Hunting Body of Weiss," January 22, 1935, 7.

487. *New York Times*, "Special to the New York Times: Philadelphia," January 23, 1935.

CHAPTER 16: END OF THE ROAD

488. United States Department of Justice, Bureau of Investigation, Memo from Director to Mr. Tamm, January 20, 1935.

489. *Richmond News Leader*, "Mais and Legenza…January 22, 1935," January 22, 1935, 1.

490. *Washington Post*, "Farrell Guides Police."

491. *Richmond News Leader*, "Mais and Legenza Sentenced to Die on Feb. 2," January 22, 1935, 1.

492. Ibid.

493. Ibid.

494. Ibid.

495. *Richmond Times-Dispatch*, "Mais Tells Story of Flight; Walked 50 Miles in Woods," January 24, 1935, 1.

496. *Richmond Times-Dispatch*, "Kin of Huband Plead for Places On Bandits' 'Death Watch' Jury," January 23, 1935, 1.

497. *Richmond News Leader*, "Girl, Eleven, Is First to Protest Execution," January 26, 1935, 1.

498. *Richmond Times-Dispatch*, "Mais and Legenza Confessions," 1.

499. *Richmond Times-Dispatch*, "Legenza Goes to Chair With Cynical Defiance; Mais Repentant at End," February 2, 1935, 1.

500. *Danville (VA) Bee*, "Police Trail of Fugitives Gets Colder," October 2, 1934, 7.

501. *Richmond Times-Dispatch*, "Mais and Legenza Confessions."

502. Ibid.

503. *Richmond Times-Dispatch*, "Legenza Goes to Chair."

504. *Richmond Times-Dispatch*, "Two of the Mais-Legenza Confession Letters." Mais apparently called Marie McKeever by the nickname "Mary."

505. *Richmond Times-Dispatch*, "Mais and Legenza Confessions."

506. *Dubuque (IA) Telegraph-Herald and Times-Journal*, "Once Heartless Killer Has Changed to Cringing Man," January 23, 1935, 1.

507. *Richmond Times-Dispatch*, "Mais and Legenza Confessions."

508. Ibid.

509. *Richmond News Leader*, "Mais Repentant as He Goes to His Death with Legenza Remaining Cynical to Last," February 2, 1935, 1.

510. *Richmond Times-Dispatch*, "Legenza Goes to Chair."

511. *Richmond News Leader*, "Mais Repentant."

512. Ibid.

513. William J. Bowers, et al., *Legal Homicide: Death as Punishment in America, 1864–1982* (Boston: Northeastern University Press, 1984), 514–17.

514. J. Weisberg, "This Is Your Death," *New Republic* (July 1, 1991): 23. Quoted in Craig Brandon, *The Electric Chair: An Unnatural American History* (Jefferson, NC: McFarland & Company, Inc., 1999), 205–6.

515. *Richmond News Leader*, "Mais Repentant."

516. Ibid.

517. Brandon, *Electric Chair*. Execution by electrocution is still offered to condemned inmates in Virginia as an alternative to lethal injection.

518. The author had the opportunity to inspect and sit in the electric chair at the Virginia State Penitentiary in 1991, just before the Richmond facility was demolished and the chair was removed to the new Greensville Correctional Center in Jarratt, Virginia.

519. *Richmond News Leader*, "Mais Repentant."

520. *Richmond News Leader*, "Putting of Pair to Death Is Grim and Business-Like," February 2, 1935, 1.

521. *Richmond Times-Dispatch*, "Mais and Legenza Confessions."

522. Ibid., 1.

523. *Richmond News Leader*, "Putting of Pair to Death."

524. *Richmond Times-Dispatch*, "Mais and Legenza Confessions."

525. Ibid.

526. Ibid.

527. *Stevens Point (WI) Daily Journal*, Fred Myers, "Throngs View Body of U.S.'s No. 1 Bad Man," July 24, 1934, 8; *Oelwein (IA) Daily Register*, "Thousands File Slowly Past for Glimpse of Dillinger's Body," July 24, 1934, 1; quoted in Elliott J. Gorn, *Dillinger's Wild Ride: The Year that Made America's Public Enemy Number One* (New York: Oxford University Press, 2009), 163.

528. *Richmond Times-Dispatch*, "Mais and Legenza Confessions."

529. Ibid.

530. *Richmond News Leader*, "3 Convicts Try to Stab Misunas to Death," February 5, 1935, 1.

531. Ibid.

532. *Hagerstown (MD) Daily Mail*, "'Squealer' Is Attacked by Three Prisoners," February 5, 1935, 10.

533. *Reno (NV) Evening Gazette*, "Trio Attacks Prison Witness," February 5, 1935, 1.

534. *Philadelphia Inquirer*, "Boyhood Chums Aid at Mais Obsequies," February 8, 1935.

535. Diane L. Michalowski, Secretary, Mount Peace Cemetery, personal communication with author, January 25, 2010.

536. Transcript of an oral history narrative with Adelia Anne Shelton Smith, 2007, posted by the Louisa Legacy Project. Available online at http://www.youtube.com/watch?v=1HcCqg43AsM.

537. The person who currently owns the property where Legenza is buried was very kind and helpful to the author on the two occasions he visited there. To ensure privacy, details of that location are omitted here.

538. Alvin Karpis, as told to Bill Trent, *Public Enemy Number One: The Alvin Karpis Story* (Toronto and Montreal: McClelland and Stewart Limited, 1971), 256.

Aftermath and Epilogue

539. *Gettysburg (PA) Times*, "Names Pals as Weiss Slayers," February 9, 1935, 2.

540. *Washington Post*, "Dunn, Berlin on Train Bound for Alcatraz, February 15, 1935, 1.

541. *New Castle (PA) News*, "Last Member of Gang Executed," June 3, 1936, 1.

542. *Philadelphia Inquirer*, "Weiss Death Trials Start Tomorrow," February 24, 1935, 1.

543. *Gettysburg (PA) Times*, "Police Arrest Friend of Mais," February 18, 1935, 1.

544. *Tyrone (PA) Daily Herald*, "Gunman's Moll May Testify for State," February 19, 1935, 1.

545. *Chester (PA) Times*, "Wiley, Farrell Linked Closer to Weiss' Death," February 28, 1935, 1.

546. Ibid.

547. *Philadelphia Inquirer*, "2 Gang Women Aid State Case at Weiss Trial," February 28, 1935, 1.

548. *Philadelphia Inquirer*, "2 Call Legenza Weiss Killer in Fight for Lives," March 2, 1935, 1.

549. *Laurel (MS) Leader-Call*, "Kidnappers of Wm. Weiss to Forfeit Life," April 29, 1935, 7.

550. *Miami (OK) News-Record*, "Killer Trapped by Jilted Girl Ends Own Life," September 9, 1935, 2.

551. *Richmond Times-Dispatch*, "Mais and Legenza Escape Claims Third Victim," November 3, 1935, 4.

552. Claire Bond Potter, *War on Crime*, 128.

553. *Middletown (NY) Times Herald*, "War on Crime—Legenza Is Fingered," November 30, 1937, 24.

554. Ibid.

555. Ibid.

556. George Earle Shankle, *American Nicknames: Their Origin and Significance* (New York: H.W. Wilson Company, 1937), 303.

557. George Tuska, "Walter Legenza the Gangster!" in *Crime Does Not Pay* vol. 1, no. 64 (New York: Lev Gleason Publications, Inc., 1947): 3–16. Comic book.

558. Ibid., 16.

559. *Washington Post*, "Tri-State Gang Member Ends Va. Jail Term," May 13, 1951, M-15.

560. Bosley Crowther, "Standard Crime Film," *New York Times*, December 9, 1950.

561. *Washington Post*, "D.C. Outlaw Joins FBI's '10 Wanted,'" November 3, 1955, 44.

562. *Huron (SD) Huronite and the Daily Plainsman*, "Hunted Gunman Seized by FBI in Chicago Hotel," December 4, 1955, 19.

563. *Washington Post*, "Kendrick Gets 5–17 Years in G Street Café Shooting," February 25, 1956, 18.

564. *Richmond Times-Dispatch*, "Groth Orders Closing of Viaduct," June 26, 1970, 1.

565. *Richmond Times-Dispatch*, "Trestle With a Past," December 18, 1974.

566. *Richmond Times-Dispatch*, "Tri-State Gang's Impact in Richmond Profound," March 10, 2004, H-1.

567. *Richmond Times-Dispatch*, "News Didn't Take Long to Spread," B-1.

568. Somerville Wickham Jr., memo, August 13, 2010 (author's collection).

569. These dates were taken from the two lawyers' tombstones. Moss was buried at Dale Memorial Park in Chesterfield County. Haley Shelton is buried at a rural cemetery in Louisa County, not very far from his infamous client, Walter Legenza.

570. *New York Times*, "Francis X. Fay, 92, Former F.B.I. Agent and Executive, Dies," May 8, 1990.

571. *Richmond News Leader*, "Former Police Chief's Services Scheduled," December 24, 1962, 18.

572. Brooks Smith and Wayne Dementi, *Facts and Legends of the Hills of Richmond* (Richmond, VA: Dementi Milestone Publishing, 2008), 63–64.

573. Beth Brown, *Wicked Richmond* (Charleston, SC: The History Press, 2010), 93–97.

574. Ironically, a small side road near the former location of Club Forest bears the name "Wild Life Trail."

INDEX

ABOUT THE AUTHOR

Selden Richardson is a Richmond native who writes and lectures about the city's architecture and history and is the author of *Built by Blacks: African American Architecture and Neighborhoods in Richmond* (The History Press, 2008). He holds master's degrees from Virginia Commonwealth University and the University of Richmond and is the former archivist for Architectural Records at the Library of Virginia. Richardson lives in Richmond with his wife, Karri; their daughter, Lelia; and an obstreperous golden retriever named Wyatt.

Visit us at
www.historypress.net